Bible *journaling* made simple

An Art-Filled Journey for Creative Worship

SANDY ALLNOCK

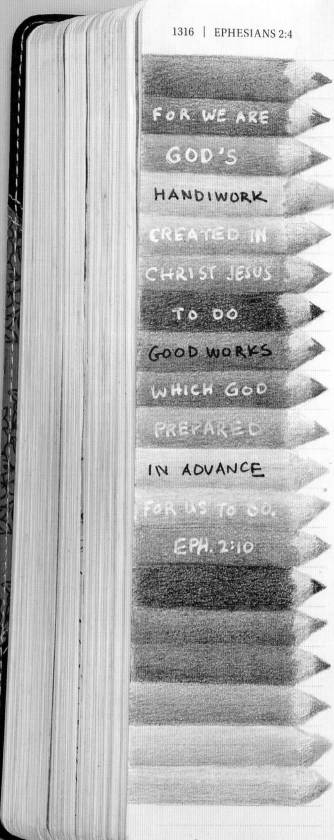

FOR WE ARE GOD'S HANDIWORK CREATED IN CHRIST JESUS TO DO GOOD WORKS WHICH GOD PREPARED IN ADVANCE FOR US TO DO. EPH. 2:10

us also lived among them at one time, gratifying the cravings of our fle following its desires and thoughts. Like the rest, we were by nature desc wrath. [4]But because of his great love for us, God, who is rich in mercy, [5] alive with Christ even when we were dead in transgressions—it is by gr have been saved. [6]And God raised us up with Christ and seated us with the heavenly realms in Christ Jesus, [7]in order that in the coming ages h show the incomparable riches of his grace, expressed in his kindness Christ Jesus. [8]For it is by grace you have been saved, through faith—a is not from yourselves, it is the gift of God— [9]not by works, so that no boast. [10]For we are God's handiwork, created in Christ Jesus to do good which God prepared in advance for us to do.

Jew and Gentile Reconciled Through Christ

[11]Therefore, remember that formerly you who are Gentiles by birth an "uncircumcised" by those who call themselves "the circumcision" (w done in the body by human hands)— [12]remember that at that time yo separate from Christ, excluded from citizenship in Israel and foreigner covenants of the promise, without hope and without God in the world. [13]B in Christ Jesus you who once were far away have been brought near by th of Christ.

[14]For he himself is our peace, who has made the two groups one and d stroyed the barrier, the dividing wall of hostility, [15]by setting aside in h the law with its commands and regulations. His purpose was to create self one new humanity out of the two, thus making peace, [16]and in one reconcile both of them to God through the cross, by which he put to dea hostility. [17]He came and preached peace to you who were far away and p those who were near. [18]For through him we both have access to the Fa one Spirit.

[19]Consequently, you are no longer foreigners and strangers, but fellow c with God's people and also members of his household, [20]built on the foun of the apostles and prophets, with Christ Jesus himself as the chief corne [21]In him the whole building is joined together and rises to become a holy in the Lord. [22]And in him you too are being built together to become a dw in which God lives by his Spirit.

God's Marvelous Plan for the Gentiles

3 For this reason I, Paul, the prisoner of Christ Jesus for the sake of yo tiles—

[2]Surely you have heard about the administration of God's grace that w en to me for you, [3]that is, the mystery made known to me by revelation, as already written briefly. [4]In reading this, then, you will be able to understa insight into the mystery of Christ, [5]which was not made known to people i generations as it has now been revealed by the Spirit to God's holy apostl prophets. [6]This mystery is that through the gospel the Gentiles are heirs to with Israel, members together of one body, and sharers together in the p in Christ Jesus.

[7]I became a servant of this gospel by the gift of God's grace given me th the working of his power. [8]Although I am less than the least of all the people, this grace was given me: to preach to the Gentiles the boundless of Christ, [9]and to make plain to everyone the administration of this m which for ages past was kept hidden in God, who created all things. [10] tent was that now, through the church, the manifold wisdom of God sho made known to the rulers and authorities in the heavenly realms, [11]acc to his eternal purpose that he accomplished in Christ Jesus our Lord. [12]

[a] 3 In contexts like this, the Greek word for *flesh* (*sarx*) refers to the sinful state of huma beings, often presented as a power in opposition to the Spirit.

through faith in h
sk you, therefore,
ch are your glory.

ayer for the Eph
For this reason I
en and on earth c
strengthen you w
st may dwell in yo
established in love
to grasp how wide
w this love that sur
d the fullness of Go
Now to him who i:
according to his
ch and in Christ Je

ty and Maturity i
As a prisoner for tl
ng you have receiv
with one another i
ugh the bond of pe
ed to one hope whe
and Father of all, v
But to each one of u
it[b] says:

When he ascended
he took many cap
and gave gifts to l

hat does "he ascen
hly regions[d]? [10]He v
he heavens, in orde
stles, the prophets,
ple for works of serv
each unity in the fa
ure, attaining to th
Then we will no lo
n here and there b
of people in their c
ill grow to become
is, Christ. [16]From
orting ligament, g

ructions for Chri
So I tell you this, a
e Gentiles do, in tl
erstanding and sep
them due to the ha
given themselves
and they are full of
That, however, is
st and were taught

The Greek for *family* (
salm 68:18 [d] 9 Or tl

Bible journaling made simple

An Art-Filled Journey for Creative Worship

Ephesians 2:10
Colored pencil

Create a memorable
design in the border of
a favorite passage as
a reminder of eternal
truths. Use the Bible's
printed lines to draw the
pencils at a consistent
size. Write the text on
top with a pen.

✷ *Web content available*

SANDY ALLNOCK

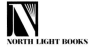

NORTH LIGHT BOOKS
CINCINNATI, OHIO
artistsnetwork.com

Contents

Matthew 21:42

Colored pencil

A simple grid of bricks colored with red or brown pencils contains a few words of a favorite verse or a treasured hymn.

✱ *Web content available*

Genesis 15:1

Watercolor pencil

Sometimes a verse acts as a bridge between two images. Since God speaks in this verse about stars in the sky and sand on the shore, they each serve as half the image with the text in the middle. (See the sketch for this design on page 67.)

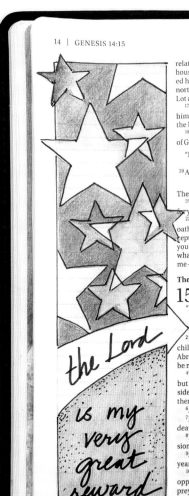

14 | GENESIS 14:15

relative had been taken captive, he called out the 318 trained men born in his household and went in pursuit as far as Dan. ¹⁵During the night Abram divided his men to attack them and he routed them, pursuing them as far as Hobah, north of Damascus. ¹⁶He recovered all the goods and brought back his relative Lot and his possessions, together with the women and the other people.

¹⁷After Abram returned from defeating Kedorlaomer and the kings allied with him, the king of Sodom came out to meet him in the Valley of Shaveh (that is, the King's Valley).

¹⁸Then Melchizedek king of Salem brought out bread and wine. He was priest of God Most High, ¹⁹and he blessed Abram, saying,

"Blessed be Abram by God Most High,
 Creator of heaven and earth.
²⁰And praise be to God Most High,
 who delivered your enemies into your hand."

Then Abram gave him a tenth of everything.

²¹The king of Sodom said to Abram, "Give me the people and keep the goods for yourself."

²²But Abram said to the king of Sodom, "With raised hand I have sworn an oath to the LORD, God Most High, Creator of heaven and earth, ²³that I will accept nothing belonging to you, not even a thread or the strap of a sandal, so that you will never be able to say, 'I made Abram rich.' ²⁴I will accept nothing but what my men have eaten and the share that belongs to the men who went with me—to Aner, Eshkol and Mamre. Let them have their share."

The LORD's Covenant With Abram

15 After this, the word of the LORD came to Abram in a vision:

"Do not be afraid, Abram.
 I am your shield,ᵃ
 your very great reward.ᵇ"

²But Abram said, "Sovereign LORD, what can you give me since I remain childless and the one who will inheritᶜ my estate is Eliezer of Damascus?" ³And Abram said, "You have given me no children; so a servant in my household will be my heir."

⁴Then the word of the LORD came to him: "This man will not be your heir, but a son who is your own flesh and blood will be your heir." ⁵He took him outside and said, "Look up at the sky and count the stars—if indeed you can count them." Then he said to him, "So shall your offspringᵈ be."

⁶Abram believed the LORD, and he credited it to him as righteousness.

⁷He also said to him, "I am the LORD, who brought you out of Ur of the Chaldeans to give you this land to take possession of it."

⁸But Abram said, "Sovereign LORD, how can I know that I will gain possession of it?"

⁹So the LORD said to him, "Bring me a heifer, a goat and a ram, each three years old, along with a dove and a young pigeon."

¹⁰Abram brought all these to him, cut them in two and arranged the halves opposite each other; the birds, however, he did not cut in half. ¹¹Then birds of prey came down on the carcasses, but Abram drove them away.

¹²As the sun was setting, Abram fell into a deep sleep, and a thick and dreadful darkness came over him. ¹³Then the LORD said to him, "Know for certain that for four hundred years your descendants will be strangers in a country not their own and that they will be enslaved and mistreated there. ¹⁴But I will pun-

possessions.
a good old age.
for the sin of th
¹⁷When the
blazing torch a
made a covena
from the Wadiᵉ
nites, Kenizzite
naanites, Girga

**Hagar and Ish*

16 Now Sar
Egyptian
me from havin
through her."
Abram agree
ten years, Sara
band to be his w
When she kn
Sarai said to Ab
slave in your a
May the LORD j
⁶"Your slave
best." Then Sar
⁷The angel o
spring that is b
have you come
"I'm running
⁹Then the an
her." ¹⁰The ange
be too numerou
¹¹The angel o

"You are now
 and you w
You shall na
 for the Lo
¹²He will be a
 his hand w
 and every
and he will li
 towardᵉ a

¹³She gave th
me," for she sai
was called Beer
¹⁵So Hagar bo
she had borne.

**The Covenant

17 When Ab
said, "I a
²Then I will ma
your numbers."
³Abram fell

The Word Became Flesh

In the beginning was the Word, and the Word was with God, and the
was God. [2]He was with God in the beginning. [3]Through him all thing
made; without him nothing was made that has been made. [4]In him was li
that life was the light of all mankind. [5]The light shines in the darkness, a
darkness has not overcome[a] it.

[6]There was a man sent from God whose name was John. [7]He came as
ness to testify concerning that light, so that through him all might believ
himself was not the light; he came only as a witness to the light.

[9]The true light that gives light to everyone was coming into the
[10]He was in the world, and though the world was made through hi
world did not recognize him. [11]He came to that which was his own,
own did not receive him. [12]Yet to all who did receive him, to those w
lieved in his name, he gave the right to become children of God — [13]ch
born not of natural descent, nor of human decision or a husband's w
born of God.

[14]The Word became flesh and made his dwelling among us. We have se
glory, the glory of the one and only Son, who came from the Father, full o
and truth.

[15](John testified concerning him. He cried out, saying, "This is the one
about when I said, 'He who comes after me has surpassed me because
before me.'") [16]Out of his fullness we have all received grace in place o
already given. [17]For the law was given through Moses; grace and truth
through Jesus Christ. [18]No one has ever seen God, but the one and on
who is himself God and[b] is in closest relationship with the Father, has
him known.

John the Baptist Denies Being the Messiah

[19]Now this was John's testimony when the Jewish leaders[c] in Jerusale
priests and Levites to ask him who he was. [20]He did not fail to confess, b
fessed freely, "I am not the Messiah."

[21]They asked him, "Then who are you? Are you Elijah?"

He said, "I am not."

"Are you the Prophet?"

He answered, "No."

[22]Finally they said, "Who are you? Give us an answer to take back to tho
sent us. What do you say about yourself?"

[23]John replied in the words of Isaiah the prophet, "I am the voice of one
in the wilderness, 'Make straight the way for the Lord.'"[d]

[24]Now the Pharisees who had been sent [25]questioned him, "Why then
baptize if you are not the Messiah, nor Elijah, nor the Prophet?"

[26]"I baptize with[e] water," John replied, "but among you stands one you
know. [27]He is the one who comes after me, the straps of whose sandals I
worthy to untie."

[28]This all happened at Bethany on the other side of the Jordan, wher
was baptizing.

How to Use *This Book*

THIS BOOK IS IN YOUR HANDS AS A GIFT FROM GOD: an invitation into a deeper relationship with Him. If you're ready to get to know the Lord in new and creative ways, buckle up. It's going to be an adventure!

It's not necessary to know how to draw or to own a lot of art supplies to begin Bible journaling. Interacting creatively with Scripture can be as simple as using colored pencils to highlight the words God has spoken. The chapters ahead will share basic ideas that can be accomplished with simple and inexpensive art mediums—it is possible to work with a small pack of pencils and have great success! That's because success isn't measured in the "fanciness" of the art, it's about your relationship with Jesus.

Bible journaling is intended to document your relationship with God and what He says to you, what you're praying about, what a pastor taught you or a thought awakened by a song. Capture your own story within the pages of your Bible, making it sing with the addition of simple color.

Whether you use this book on your own or as part of a group study, take your time. Start at the beginning, pray through the prompts and create at least one page yourself per chapter before moving on. You'll be blessed in your study and your worship, and that's what we're here for, right?

John 1:1
Watercolor pencil

A spacious universe captures the omnipresence of the Word at the start of all creation while the Scripture text is still readable through the color. See the tutorial on page 74 for a similar technique.

SUGGESTED SUPPLIES

Basic supplies are needed for the techniques in this book. They will be described in further detail in Chapter 2.

journaling Bible or other journal (see Selecting a Journaling Bible on page 30)

baby wipes	pencil sharpener
colored pencils	round brush, no. 8
copier paper	ruler
fineliner, black bleed-proof (such as a Pigma Micron pen)	sticky notes
	tracing paper
gel pen, white	washi tape
iron	watercolor paints
kneaded eraser	watercolor pencils
pencil, no. 2	

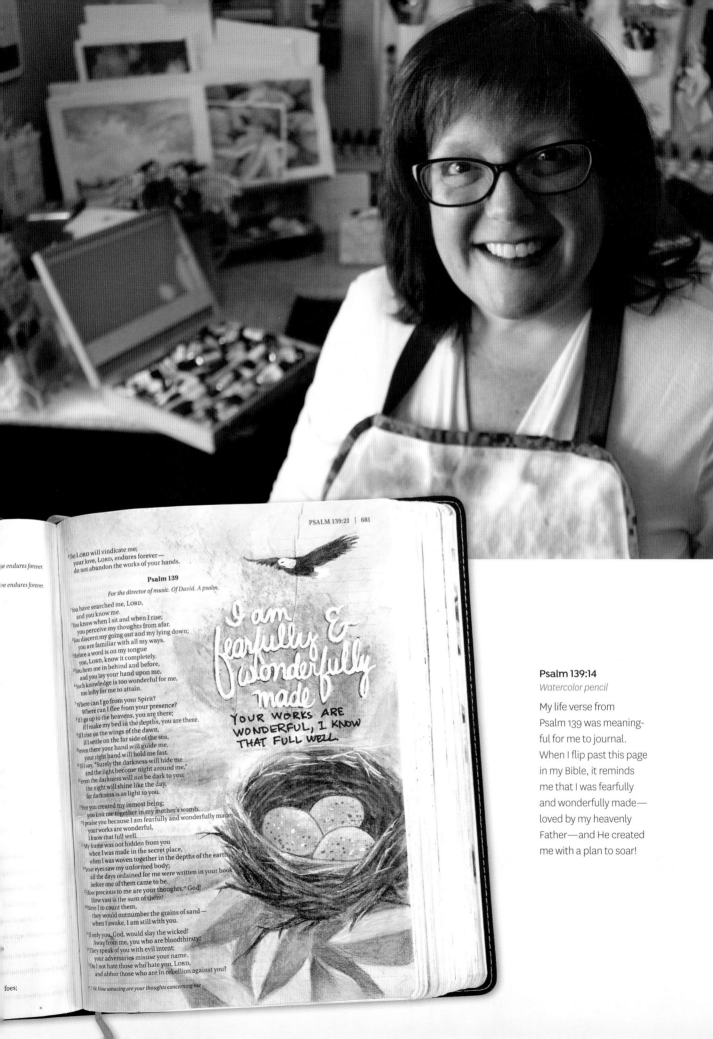

Psalm 139:14

Watercolor pencil

My life verse from Psalm 139 was meaningful for me to journal. When I flip past this page in my Bible, it reminds me that I was fearfully and wonderfully made—loved by my heavenly Father—and He created me with a plan to soar!

Introduction

ONE SUNDAY MORNING, an angel sat in the pew in front of me. He had his Bible open during the sermon and held a few colored pencils in his left hand. His right hand sketched a soaring eagle across the page as the pastor preached from Isaiah 40. Its wings spread broadly above a tree line at the bottom of the page.

I was mesmerized. I had never seen anyone draw in a Bible before.

I call this man an angel because I saw him only that one Sunday. No one else remembered him. He was a gift from God, just for me, to inspire, challenge and grow my worship life.

I went home and researched to see if more people were drawing in their Bibles. Online communities of Bible journalers had begun to appear at that time, and I tried my hand at this new-to-me form of worship, testing mediums and experimenting with styles and techniques.

The benefits to my spiritual life were undeniable: I engaged more with God's Word than I ever had before! I craved time to read the Bible, and despite my faulty memory, remembered Scriptures as I illustrated them. The Holy Spirit created a new heart within me, working His will through my art.

And I haven't been the same since.

I pray that your experience will be as revelatory as mine, whether you're new to Bible journaling or not. Allow the Lord to open your eyes and see Him in new ways as you grow in the study of the Scriptures and visually interpret them for yourself. Throughout this book I'll share my own stories with you, as well as tips I've learned to hear God and document what He says, both in words and pictures. Let's cement our relationship with our Lord so we can readily apply what He's asking us to do: become more like Jesus.

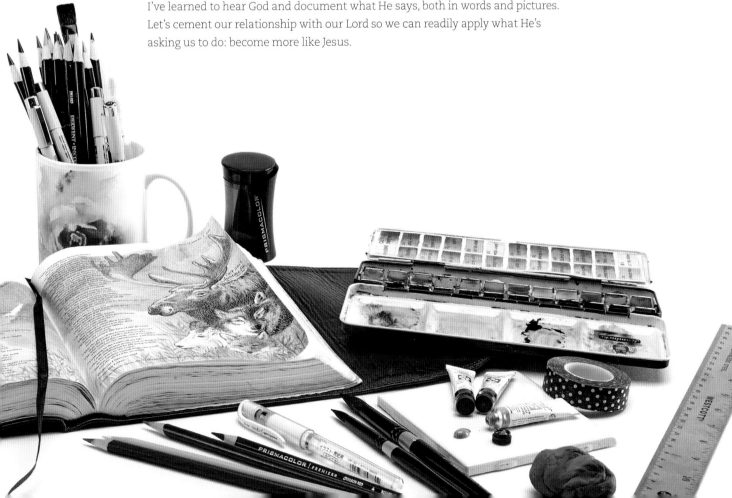

1 | Creative Worship
Preparing the Heart
for Bible Journaling

A PURE HEART

I waited all my life for a heart transplant.

Not a physical one; my ticker is just fine. But for decades I begged the Lord to give me a clean heart. A pure heart. A heart of flesh, not stone, that craves the Word of God. My time spent reading the Bible had always felt more like a duty than the act of a child who adores her heavenly Father's teachings. A spiritual mentor assured me that a regular study discipline would lead to a hunger for the Word. But . . . it didn't.

Years of trying different reading plans kept failing; I just couldn't stick with them. I was embarrassed and felt like a failure as a Christian. What was wrong with me?

Then I found the creative worship process of Bible journaling.

I now hear God in different ways than before—through a visual experience of Scripture. Words that I had never noticed jump off the page, and images and color come vividly to mind. I was never able to memorize verses or their locations before, but once I've illustrated a verse, I never forget it.

My time with Scripture is now a treasure in my day, and my soft heart loves every minute of it.

What's Your Story?

- How has God spoken to you through Scripture?
- Has it been difficult or easy?
- What change would you like the Lord to work in your heart through your creative worship journey?
- Begin a prayer journal to note your thoughts at this point in your adventure. You can look back on these notes later to celebrate what God has accomplished in you.

Psalm 51:10
Colored pencil

Bible journaling need not be serious all the time. Add a little humor to a page; whimsy can make a verse memorable!

✱ *Web content available*

God's Laundromat

PURIFYING **HEARTS** AND RENEWING **SPIRITS** SINCE FOREVER

PURE OFF RENEW RINSE

according to your great compassion
 blot out my transgressions.
2 Wash away all my iniquity
 and cleanse me from my sin.

3 For I know my transgressions,
 and my sin is always before me.
4 Against you, you only, have I sinned
 and done what is evil in your sight;
so you are right in your verdict
 and justified when you judge.
5 Surely I was sinful at birth,
 sinful from the time my mother conceived me.
6 Yet you desired faithfulness even in the womb;
 you taught me wisdom in that secret place.

7 Cleanse me with hyssop, and I will be clean;
 wash me, and I will be whiter than snow.
8 Let me hear joy and gladness;
 let the bones you have crushed rejoice.
9 Hide your face from my sins
 and blot out all my iniquity.

10 Create in me a pure heart, O God,
 and renew a steadfast spirit within me.
11 Do not cast me from your presence
 or take your Holy Spirit from me.
12 Restore to me the joy of your salvation
 and grant me a willing spirit, to sustain me.

13 Then I will teach transgressors your ways,
 so that sinners will turn back to you.
14 Deliver me from the guilt of bloodshed, O God,
 you who are God my Savior,
 and my tongue will sing of your righteousness.
15 Open my lips, Lord,
 and my mouth will declare your praise.
16 You do not delight in sacrifice, or I would bring it;
 you do not take pleasure in burnt offerings.
17 My sacrifice, O God, is[a] a broken spirit;
 a broken and contrite heart
 you, God, will not despise.

18 May it please you to prosper Zion,
 to build up the walls of Jerusalem.
19 Then you will delight in the sacrifices of the righteous,
 in burnt offerings offered whole;
 then bulls will be offered on your altar.

Psalm 52[b]

*For the director of music. A maskil[c] of David. When
Doeg the Edomite had gone to Saul and told him:
"David has gone to the house of Ahimelek."*

1 Why do you boast of evil, you mighty hero?
 Why do you boast all day long,
 you who are a disgrace in the eyes of God?

[a] 17 Or *The sacrifices of God are* [b] In Hebrew texts 52:1-9 is numbered 52:3-11. [c] Title:
Probably a literary or musical term

hostile to God; it does not submit to God's law, nor can it do so. [8]Those
in the realm of the flesh cannot please God.

[9]You, however, are not in the realm of the flesh but are in the realm of t
it, if indeed the Spirit of God lives in you. And if anyone does not have th
of Christ, they do not belong to Christ. [10]But if Christ is in you, then even
your body is subject to death because of sin, the Spirit gives life[a] because
teousness. [11]And if the Spirit of him who raised Jesus from the dead is l
you, he who raised Christ from the dead will also give life to your mortal
because of[b] his Spirit who lives in you.

[12]Therefore, brothers and sisters, we have an obligation—but it is nc
flesh, to live according to it. [13]For if you live according to the flesh, you v
but if by the Spirit you put to death the misdeeds of the body, you will liv

[14]For those who are led by the Spirit of God are the children of Goc
Spirit you received does not make you slaves, so that you live in fear agai
er, the Spirit you received brought about your adoption to sonship.[c] And
we cry, "Abba,[d] Father." [16]The Spirit himself testifies with our spirit that
God's children. [17]Now if we are children, then we are heirs—heirs of G
co-heirs with Christ, if indeed we share in his sufferings in order that
also share in his glory.

Present Suffering and Future Glory

[18]I consider that our present sufferings are not worth comparing with
ry that will be revealed in us. [19]For the creation waits in eager expectation
children of God to be revealed. [20]For the creation was subjected to frus
not by its own choice, but by the will of the one who subjected it, in hope
the creation itself will be liberated from its bondage to decay and broug
the freedom and glory of the children of God.

[22]We know that the whole creation has been groaning as in the pains c
birth right up to the present time. [23]Not only so, but we ourselves, who h
firstfruits of the Spirit, groan inwardly as we wait eagerly for our adoption
ship, the redemption of our bodies. [24]For in this hope we were saved. B
that is seen is no hope at all. Who hopes for what they already have? [25]B
hope for what we do not yet have, we wait for it patiently.

[26]In the same way, the Spirit helps us in our weakness. We do not kno
we ought to pray for, but the Spirit himself intercedes for us through w
groans. [27]And he who searches our hearts knows the mind of the Spirit, b
the Spirit intercedes for God's people in accordance with the will of God.

[28]And we know that in all things God works for the good of those w
him, who[f] have been called according to his purpose. [29]For those God for
he also predestined to be conformed to the image of his Son, that he m
the firstborn among many brothers and sisters. [30]And those he predesti
also called; those he called, he also justified; those he justified, he also gl

More Than Conquerors

[31]What, then, shall we say in response to these things? If God is for u
can be against us? [32]He who did not spare his own Son, but gave him up
all—how will he not also, along with him, graciously give us all things?
will bring any charge against those whom God has chosen? It is God w
tifies. [34]Who then is the one who condemns? No one. Christ Jesus who
more than that, who was raised to life—is at the right hand of God and
interceding for us. [35]Who shall separate us from the love of Christ? Shall t

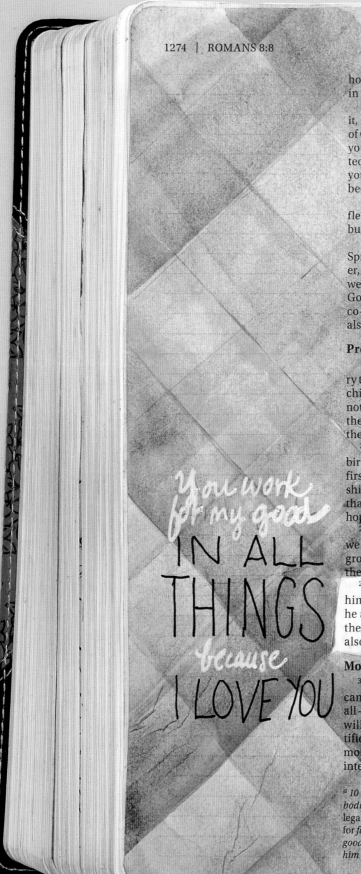

you work
for my good
IN ALL
THINGS
because
I LOVE YOU

[a] 10 Or you, your body is dead because of sin, yet your spirit is alive [b] 11 Some manus
bodies through [c] 15 The Greek word for adoption to sonship is a term referring to the
legal standing of an adopted male heir in Roman culture; also in verse 23. [d] 15 Arar
for father [e] 20,21 Or subjected it in hope. 21For [f] 28 Or that all things work togethe
good to those who love God, who; or that in all things God works together with those who
him to bring about what is good—with those who

The Secret of *Bible Journaling*

Bible journaling is gaining worldwide interest, in part because we are attracted to the beauty and truth of art. Images conjure emotions and thoughts in ways that are impactful and memorable. As children of the Creator, we have an innate desire to create, too. If we lose ourselves in just making pretty things, however, we miss the real blessing of Bible journaling.

The secret of this process is that it's not about the art.

Certainly, art is a part of it, whether in fancy drawings or simple color applications. But Bible journaling only becomes a creative worship experience when the focus is primarily on the relationship with our Lord. Capture a moment of God's tender grace that took your breath away. Document a truth from a sermon that opened your eyes. Praise Him by journaling what honoring God looks like to you. Create art that brings these things to your mind. Our lives are busy, and we leave a trail of things we should remember on the ground behind us. Instead, scoop them up and journal them. Preserve the lessons vital to our growth as Christians.

When we set aside how well we're drawing and, instead, remember that we're chronicling our lives with God so we can grasp His love more deeply, Bible journaling transforms our lives with new thinking and actions.

As we move forward on this journey, we'll definitely learn art techniques, but more than that, we'll learn more about Jesus.

Romans 8:28-30

Watercolor paints

Bible journaling doesn't require drawing skills—a beautiful background is enough to highlight a verse! The background shown here is a variation of the plaid demonstration on page 48. This book contains many ideas for simple images and backgrounds that will attract the eye while flipping through pages of a Bible, constantly bringing up God's goodness.

Develop a *Prayerful Process*

Every relationship with Jesus is unique. So is the process of Bible journaling!
Schedules, spiritual disciplines and a myriad of personal factors lead to all kinds
of study based on reading plans, word studies, sermon notes, song lyrics and
online devotionals. Whatever you're studying, include these basic elements:

Repeat
Make a habit of your creative
worship time. Plan a time each
day or each week for Bible
journaling, or create a group
with others.

Pray
By the power of the Holy
Spirit, ask God for a soft
heart, open ears and the
humility to receive truth.

Share
Show your creation to a
friend or family member,
or post a photo online and
encourage others to worship
God creatively, too.

Read
Follow any reading plan,
devotional book, or word or
topical study and jot down
words, phrases or ideas that
jump out to you.

Create
Pray before creating and
journal your reasons for
choosing the image or
colors to help you recall
God's inspiration.

Listen
Meditate on one or two chosen
phrases throughout the day.
Watch for the Lord to draw your
attention to deeper under-
standing and any visual ideas.

I begin my day with prayer and study in the morning. I carry a note with my verse for the day, seeking God's inspiration for visual interpretation, then I create in the evening. At times, the day is filled with unexpected confirmations of what was on that note. Other days, the blessing is time with the Lord—with no creation at all. I don't beat myself up if I'm not inspired to create, but I celebrate that I heard God that day!

What Is *God* Saying?

Meditation is an extended waiting period, anticipating God's inspiration. Some days, we may stare endlessly at words on a page, not grasping their meaning. *What is God telling me? How do I come up with a visual about the verse?* Meditating on a verse with some questions in mind may help a nugget bubble up as God speaks.

Any one of these categories would also make an excellent series to journal. For instance, do a study on God's character, and create a series of pages about ideas like holiness, faithfulness and love.

Psalm 119:164

Watercolor pencil

Sometimes, a whole chapter inspires an idea—like this book within a book. I created the outer frame with dark colors to allow the white gel pen journaling to show up.

✱ *Web content available*

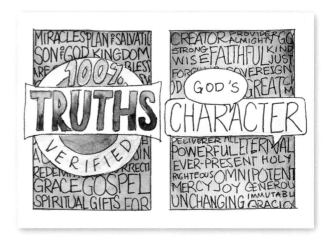

(left) Does this verse contain *eternal truths* about things like salvation, relationships, generosity or the church? What truths that I find here should change how I behave?

(right) What *characteristics* of God are represented by this verse? How is God acting and toward whom? How does that inform something I'm going through today?

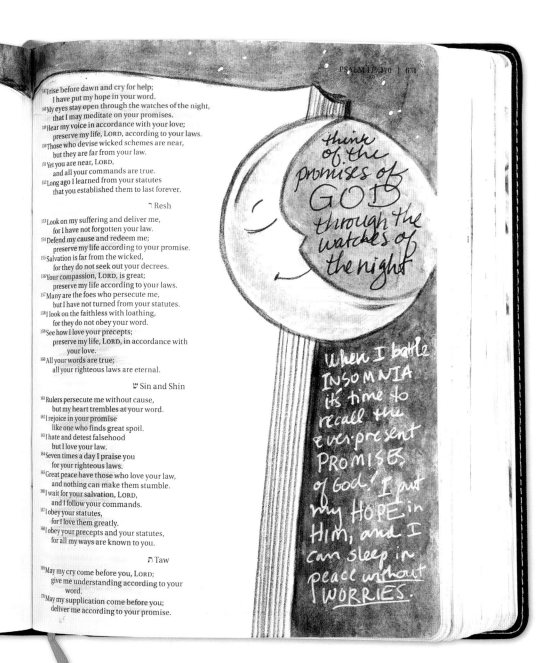

147 I rise before dawn and cry for help;
 I have put my hope in your word.
148 My eyes stay open through the watches of the night,
 that I may meditate on your promises.
149 Hear my voice in accordance with your love;
 preserve my life, LORD, according to your laws.
150 Those who devise wicked schemes are near,
 but they are far from your law.
151 Yet you are near, LORD,
 and all your commands are true.
152 Long ago I learned from your statutes
 that you established them to last forever.

ר Resh

153 Look on my suffering and deliver me,
 for I have not forgotten your law.
154 Defend my cause and redeem me;
 preserve my life according to your promise.
155 Salvation is far from the wicked,
 for they do not seek out your decrees.
156 Your compassion, LORD, is great;
 preserve my life according to your laws.
157 Many are the foes who persecute me,
 but I have not turned from your statutes.
158 I look on the faithless with loathing,
 for they do not obey your word.
159 See how I love your precepts;
 preserve my life, LORD, in accordance with
 your love.
160 All your words are true;
 all your righteous laws are eternal.

ש Sin and Shin

161 Rulers persecute me without cause,
 but my heart trembles at your word.
162 I rejoice in your promise
 like one who finds great spoil.
163 I hate and detest falsehood
 but I love your law.
164 Seven times a day I praise you
 for your righteous laws.
165 Great peace have those who love your law,
 and nothing can make them stumble.
166 I wait for your salvation, LORD,
 and I follow your commands.
167 I obey your statutes,
 for I love them greatly.
168 I obey your precepts and your statutes,
 for all my ways are known to you.

ת Taw

169 May my cry come before you, LORD;
 give me understanding according to your
 word.
170 May my supplication come before you;
 deliver me according to your promise.

think of the promises of GOD through the watches of the night

When I battle INSOMNIA it's time to recall the ever-present PROMISES of God! I put my HOPE in Him, and I can sleep in peace without WORRIES.

(left) Is there *instruction* in this verse for behavior? How should I react in light of it? Are there actions the Lord is asking me to take? Will I take a step of faith and trust Him?

(right) What new *thoughts* do I have because of this verse? Does it seem like God "rewrote" the verse since I last read it? What would it mean if He's calling those words out to me today?

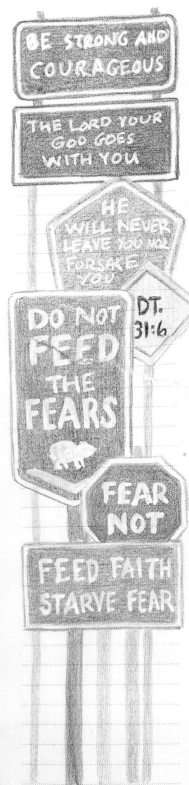

and your children may live [20]and that you may love the LORD your God, listen to his voice, and hold fast to him. For the LORD is your life, and he will give you many years in the land he swore to give to your fathers, Abraham, Isaac and Jacob.

Joshua to Succeed Moses

31 Then Moses went out and spoke these words to all Israel: [2]"I am now a hundred and twenty years old and I am no longer able to lead you. The LORD has said to me, 'You shall not cross the Jordan.' [3]The LORD your God himself will cross over ahead of you. He will destroy these nations before you, and you will take possession of their land. Joshua also will cross over ahead of you, as the LORD said. [4]And the LORD will do to them what he did to Sihon and Og, the kings of the Amorites, whom he destroyed along with their land. [5]The LORD will deliver them to you, and you must do to them all that I have commanded you. [6]Be strong and courageous. Do not be afraid or terrified because of them, for the LORD your God goes with you; he will never leave you nor forsake you."

[7]Then Moses summoned Joshua and said to him in the presence of all Israel, "Be strong and courageous, for you must go with this people into the land that the LORD swore to their ancestors to give them, and you must divide it among them as their inheritance. [8]The LORD himself goes before you and will be with you; he will never leave you nor forsake you. Do not be afraid; do not be discouraged."

Public Reading of the Law

[9]So Moses wrote down this law and gave it to the Levitical priests, who carried the ark of the covenant of the LORD, and to all the elders of Israel. [10]Then Moses commanded them: "At the end of every seven years, in the year for canceling debts, during the Festival of Tabernacles, [11]when all Israel comes to appear before the LORD your God at the place he will choose, you shall read this law before them in their hearing. [12]Assemble the people — men, women and children, and the foreigners residing in your towns — so they can listen and learn to fear the LORD your God and follow carefully all the words of this law. [13]Their children, who do not know this law, must hear it and learn to fear the LORD your God as long as you live in the land you are crossing the Jordan to possess."

Israel's Rebellion Predicted

[14]The LORD said to Moses, "Now the day of your death is near. Call Joshua and present yourselves at the tent of meeting, where I will commission him." So Moses and Joshua came and presented themselves at the tent of meeting.

[15]Then the LORD appeared at the tent in a pillar of cloud, and the cloud stood over the entrance to the tent. [16]And the LORD said to Moses: "You are going to rest with your ancestors, and these people will soon prostitute themselves to the foreign gods of the land they are entering. They will forsake me and break the covenant I made with them. [17]And in that day I will become angry with them and forsake them; I will hide my face from them, and they will be destroyed. Many disasters and calamities will come on them, and in that day they will ask, 'Have not these disasters come on us because our God is not with us?' [18]And I will certainly hide my face in that day because of all their wickedness in turning to other gods.

[19]"Now write down this song and teach it to the Israelites and have them sing it, so that it may be a witness for me against them. [20]When I have brought them into the land flowing with milk and honey, the land I promised on oath to their ancestors, and when they eat their fill and thrive, they will turn to other gods and worship them, rejecting me and breaking my covenant. [21]And when many disasters and calamities come on them, this song will testify against them, because it will not be forgotten by their descendants. I know what they are disposed to do, even before I bring them into the land I promised them on oath." [22]So Moses wrote down this song that day and taught it to the Israelites.

[23]The LORD gave this command to Joshua son of Nun: "Be strong and courageous, for you will bring the Israelites into the land I promised them on oath, and I myself will be with you."

God is already aware of your abilities and your fears, but even more, He knows the possibilities He has placed within you. The Lord knows how this Bible journaling adventure will improve your relationship, and He'll walk beside you every step of the way.

Overcoming *Fear*

Perfect love drives out fear (1 John 4:18). Since God and His love are at the heart of Bible journaling, why do we become afraid? Purchasing a new Bible just for journaling is often one big step that takes away the fear of ruining the book you've come to love over a lifetime. But fresh new pages can be daunting. Here are a few tips to help you over that hurdle:

FEAR OF MARKING IN THE BIBLE
For those not used to note-taking or highlighting in the Bible, making that first mark can feel daunting. Try creating on the unimportant pages first: the introduction, the title page or the index.

FEAR OF DRAWING
This book is written with non-artists in mind. We'll start by creating backgrounds, which do not require an ability to draw. If your confidence rises, the instruction will help you grow your art skills with simple images. But remember that it's perfectly okay to fill your Bible with simple backgrounds, too.

FEAR OF LETTERING
Your handwriting is your handwriting—rejoice in it! The journaling is about your relationship with God and should be chronicled in your own style. Time and practice will help you improve; I've filled sketchbooks with practice verses to increase my own confidence.

Deuteronomy 31:6
Colored pencil

Colorful signage break up the verse into critical phrases and add other memorable quotes on the topic.

Ephesians 4:32
Colored pencil

A drawing can be simple stick figures. What it means is more important than how it looks!

Comfort Zones

Not all Bible journaling has to be created in a Bible. Comfort level should be assessed by each journaler based on personal desires, doctrinal teachings and family traditions. Most journalers purchase a separate journal or Bible just for their art; see Selecting a Journaling Bible on page 30 for more information on the different types available.

Bible journaling is a way for people of all personalities, styles and comfort levels to enjoy creative worship. Some people even utilize multiple journaling methods depending on mood, topic or season of life.

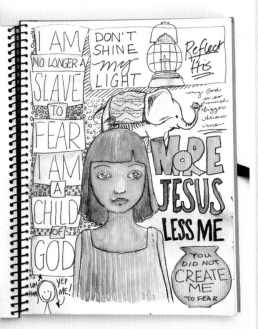

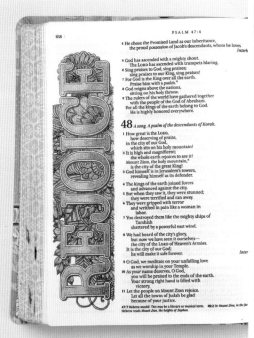

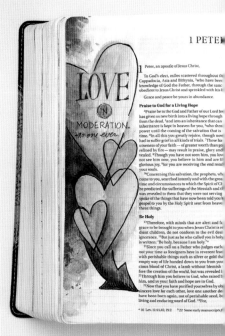

Sketchbook
Stamping and pen with watercolor paints

Journals
Purchased or handmade journals—even old hymnals—are great options for Bible journaling. Test various mediums since papers vary widely.

Psalm 48
Colored pencil

Preprinted
Several publishers offer Bibles with up to 500 pieces of printed art to color and paint in the sidebars of the pages.

1 Peter 1:22
Watercolor paints

Columns
It's common to see art created in the standard 2" (5cm) columns of journaling Bibles, with drawings in the margins away from the printed text.

✱ *Web content available*

This book focuses on styles, mediums and techniques that

1. permit text to remain visible through applied color;
2. limit or eliminate bleed-through;
3. do not require page prep, such as gesso;
4. promote Bible journaling as an inexpensive venture.

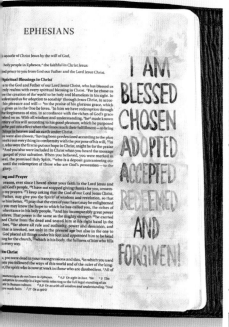

Ephesians 1:3–14
Watercolor paints

Page Backgrounds
Full page transparent backgrounds integrate the printed text, and the Scripture remains readable through the color.

✱ *Web content available*

Psalm 98:4
Acrylic

Covering Pages
Adventurous Bible journalers take advantage of having a special Bible for their art by covering everything except a focal verse.

Psalm 127:5
Mixed media

Scrapbooking
Dimensional items can be added to a Bible, including photos of family being prayed for, sentimental prayer cards and other embellishments.

Fruit of the Spirit

During the writing of this book, "Fruit of the Spirit" was the focus of my studies. Watch for chapter themes, page samples and devotionals that address each of the fruits!

"How can I be sure I have Jesus inside me?"

The question shouldn't have surprised me. That day I was a panelist at an event held at our local women's prison. The incarcerated women had been told they could write down any question about Christianity, and we'd do our best to answer.

I took a deep breath and silently prayed. I stood far outside my comfort zone, but I led my first-ever out-loud prayer, inviting attendees to pray after me to receive Christ and be filled with the Holy Spirit. It was a tender moment.

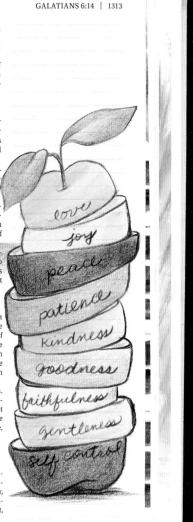

[7]You were running a good race. Who cut in on you to keep you from obeying the truth? [8]That kind of persuasion does not come from the one who calls you. [9]"A little yeast works through the whole batch of dough." [10]I am confident in the Lord that you will take no other view. The one who is throwing you into confusion, whoever that may be, will have to pay the penalty. [11]Brothers and sisters, if I am still preaching circumcision, why am I still being persecuted? In that case the offense of the cross has been abolished. [12]As for those agitators, I wish they would go the whole way and emasculate themselves!

Life by the Spirit

[13]You, my brothers and sisters, were called to be free. But do not use your freedom to indulge the flesh[a]; rather, serve one another humbly in love. [14]For the entire law is fulfilled in keeping this one command: "Love your neighbor as yourself."[b] [15]If you bite and devour each other, watch out or you will be destroyed by each other.

[16]So I say, walk by the Spirit, and you will not gratify the desires of the flesh. [17]For the flesh desires what is contrary to the Spirit, and the Spirit what is contrary to the flesh. They are in conflict with each other, so that you are not to do whatever[c] you want. [18]But if you are led by the Spirit, you are not under the law. [19]The acts of the flesh are obvious: sexual immorality, impurity and debauchery; [20]idolatry and witchcraft; hatred, discord, jealousy, fits of rage, selfish ambition, dissensions, factions [21]and envy; drunkenness, orgies, and the like. I warn you, as I did before, that those who live like this will not inherit the kingdom of God. [22]But the fruit of the Spirit is love, joy, peace, forbearance, kindness, goodness, faithfulness, [23]gentleness and self-control. Against such things there is no law. [24]Those who belong to Christ Jesus have crucified the flesh with its passions and desires. [25]Since we live by the Spirit, let us keep in step with the Spirit. [26]Let us not become conceited, provoking and envying each other.

Doing Good to All

6 Brothers and sisters, if someone is caught in a sin, you who live by the Spirit should restore that person gently. But watch yourselves, or you also may be tempted. [2]Carry each other's burdens, and in this way you will fulfill the law of Christ. [3]If anyone thinks they are something when they are not, they deceive themselves. [4]Each one should test their own actions. Then they can take pride in themselves alone, without comparing themselves to someone else, [5]for each one should carry their own load. [6]Nevertheless, the one who receives instruction in the word should share all good things with their instructor.

[7]Do not be deceived: God cannot be mocked. A man reaps what he sows. [8]Whoever sows to please their flesh, from the flesh will reap destruction; whoever sows to please the Spirit, from the Spirit will reap eternal life. [9]Let us not become weary in doing good, for at the proper time we will reap a harvest if we do not give up. [10]Therefore, as we have opportunity, let us do good to all people, especially to those who belong to the family of believers.

Not Circumcision but the New Creation

[11]See what large letters I use as I write to you with my own hand! [12]Those who want to impress people by means of the flesh are trying to compel you to be circumcised. The only reason they do this is to avoid being persecuted for the cross of Christ. [13]Not even those who are circumcised keep the law, yet they want you to be circumcised that they may boast about your circumcision in the flesh. [14]May I never boast except in the cross of our Lord Jesus Christ,

[a] 13 In contexts like this, the Greek word for *flesh* (*sarx*) refers to the sinful state of human beings, often presented as a power in opposition to the Spirit; also in verses 16, 17, 19 and 24; and in 6:8. [b] 14 Lev. 19:18 [c] 17 Or *you do not do what*

Galatians 5:22
Colored pencil

The Fruit of the Spirit can be illustrated in any number of ways. Here a graphic pencil drawing labels fruit slices with the spiritual titles.

✳ *Web content available*

"If you gave your life to Jesus just now or at another time," I said, "you can trust 100 percent that He loves you and lives in your heart—and He wants to make you just like Him."

A hand went up. "How can I be like Him?" I read to her from Galatians 5:22:

But the Fruit of the Spirit is love, joy, peace, patience, kindness, goodness, faithfulness, gentleness and self-control.

"These fruit are Christ-like traits," I continued. "Look for them to grow in your behavior, thoughts and attitudes, and nurture each one."

As I sat down, I silently thanked God for His help. These were answers from a much smarter person than I—but Jesus had just spoken, and I knew it.

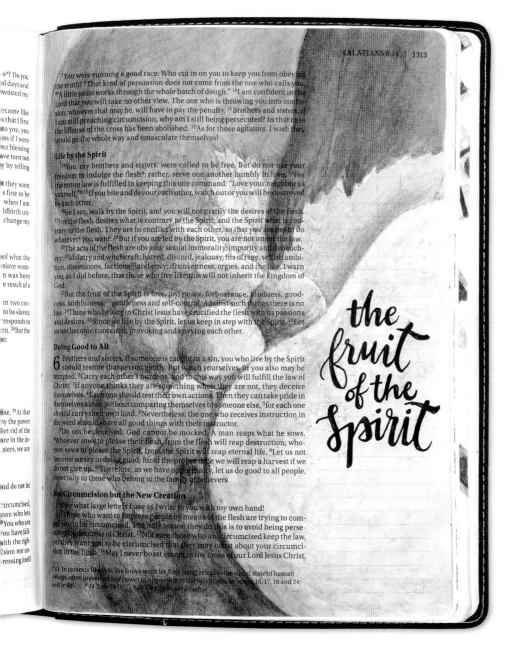

Galatians 5:22
Watercolor pencil

A full-page drawing in watercolor pencil, with color moved using the baby wipe method (see Watercolor Pencil Tips on page 36), gives this page an artistic feel.

Minitutorial: Keep an Idea Log

Over time, build your own bank of ideas to use when inspiration strikes you. These don't need to be complete ideas. Just jot down partial thoughts that catch your notice so you can come back to them later. You can keep your idea log as a text list or as a notebook full of doodles. Items in my lists include:

1. Full or partial verses for journaling
2. Song lyrics that catch my attention
3. Phrases from sermons
4. Quotes from books

You may also wish to keep a list of images to explore in your journaling. Consider items like hot air balloons, sheep, a suitcase—simple-shaped items that might work with a verse someday.

How to Use This Book for *Independent Study*

MAKE A PLAN

Develop a schedule that fits your own commitment for how often you'd like to create. Will you study in the morning and create in the evening, or vice versa? Are you aiming for one page per day? Per week? Set a calendar reminder on your phone to keep you on track.

GATHER SUPPLIES

The coming chapter discusses supplies. Read through each section and decide what suits you. Gather your chosen supplies into a basket or box to have handy when it's time to create. You may wish to pick up a journal to get started while awaiting the order of your journaling Bible.

BEGIN AT THE BEGINNING

The lessons in this book build on one another, so follow them chapter by chapter. Step-by-step tutorials begin in Chapter 3, with three per chapter—one in each of the three suggested mediums. Each tutorial can be adapted for the other mediums, too. See the tips included for each technique.

SHARE!

Take your journaling Bible to church with you and share with others. You'll encourage others by sharing what God has shown you. You may even discover friends who would enjoy getting together to create in their Bibles, too.

Snap a photo of your creation and share it on your favorite social media with #biblejournalingmadesimple. You can also search this tag to see what others are sharing. The pages shown here were created during a trip to Alaska and act as a memory of the trip as well as a celebration of God's creation.

You can see these Bible pages in more detail on page 38.

Bible Journaling *with Groups*

Pray with interested friends first, then choose a date and location to begin your group meetings. You could meet weekly or twice a month, at church or at someone's home. Order a copy of this book and a pack of colored pencils for each member. Alternatively, ask each person to purchase the book.

Assign Chapters 1 and 2 for reading prior to the first meeting, and leave enough time for members to purchase a journaling Bible and art supplies.

INAUGURAL MEETING

Open in prayer, then share your thoughts and excitement with the group as encouragement. Ask everyone to introduce themselves:

- What is your Bible journaling or art experience? (None is okay!)
- What is your favorite Scripture verse?
- What encouragement did you receive from Chapters 1 and 2?

Show one or two of your own pages and explain what your thinking was behind them. Share the results of any medium test you completed.

To "baptize" members' new journaling Bibles, have each person color the very first page in the Bible—the one with only the title printed—to get a feel for working on the thin paper. Doodling is fine at this point. This exercise is simply about making a mark in the book, which can be nerve-wracking!

Encourage questions and relay that you may not know the answers yet, but you'll all learn together. Assign Chapter 3 to study for the next session. Each person should attempt one of the techniques with any verse they choose by the next meeting.

Paper Hearts

Provide some cut-out hearts for everyone to trace if they're stumped about what to create! These can be purchased or cut by folding a piece of cardstock in half and cutting half a heart with scissors.

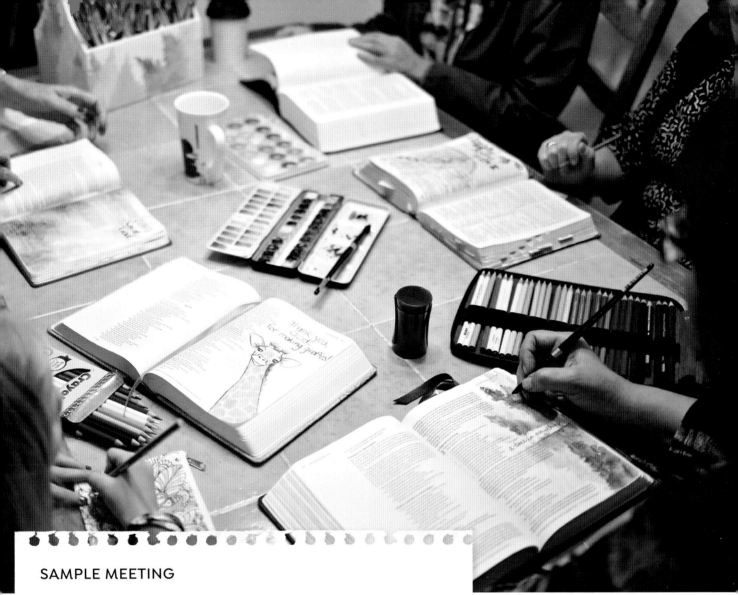

SAMPLE MEETING

Opening: Join together in prayer.

Sharing (15 minutes): Allow group members to share their work and what it means—what God said to them, how the page was created and what they learned from it. In a large group, ask only a few to share and take turns each week so everyone participates.

Learning (15 minutes): Take turns giving a demonstration from the past week's lesson. It can be an exact representation of a tutorial in this book or an adaptation. It can also be a small portion of a page, in the interest of time.

Creating (1 hour): Next, it's time for everyone to create! Members can use another tutorial from the chapter or a technique seen from another group member. If discussion lags, suggest each table discuss the What's Your Story? questions at the start of each chapter.

For next week: Assign the next chapter, and ask everyone to create a page based on one of the tutorials.

Closing: Close in prayer.

Gather with a group of friends to share and learn together. In this group, even a young child shares her wisdom.

A group could complete this book in nine meetings of 1½ hours each:
- Inaugural meeting
- 7 regular meetings
- Wrap-up celebration to share experiences and plan ongoing group meetups

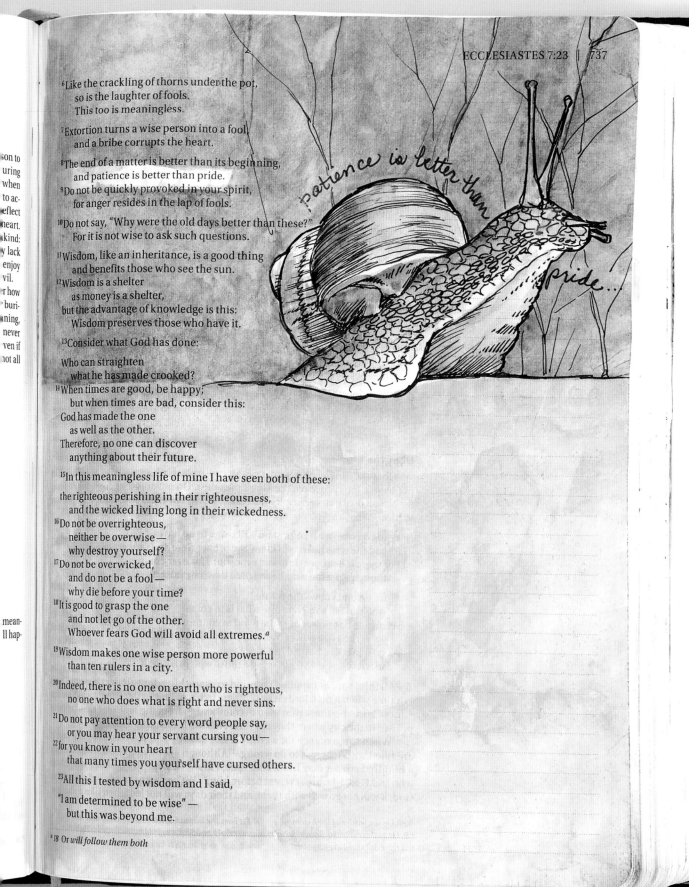

patience is better than pride...

⁶Like the crackling of thorns under the pot,
 so is the laughter of fools.
 This too is meaningless.

⁷Extortion turns a wise person into a fool,
 and a bribe corrupts the heart.

⁸The end of a matter is better than its beginning,
 and patience is better than pride.
⁹Do not be quickly provoked in your spirit,
 for anger resides in the lap of fools.

¹⁰Do not say, "Why were the old days better than these?"
 For it is not wise to ask such questions.

¹¹Wisdom, like an inheritance, is a good thing
 and benefits those who see the sun.
¹²Wisdom is a shelter
 as money is a shelter,
but the advantage of knowledge is this:
 Wisdom preserves those who have it.

¹³Consider what God has done:

Who can straighten
 what he has made crooked?
¹⁴When times are good, be happy;
 but when times are bad, consider this:
God has made the one
 as well as the other.
Therefore, no one can discover
 anything about their future.

¹⁵In this meaningless life of mine I have seen both of these:

the righteous perishing in their righteousness,
 and the wicked living long in their wickedness.
¹⁶Do not be overrighteous,
 neither be overwise —
 why destroy yourself?
¹⁷Do not be overwicked,
 and do not be a fool —
 why die before your time?
¹⁸It is good to grasp the one
 and not let go of the other.
 Whoever fears God will avoid all extremes.ᵃ

¹⁹Wisdom makes one wise person more powerful
 than ten rulers in a city.

²⁰Indeed, there is no one on earth who is righteous,
 no one who does what is right and never sins.

²¹Do not pay attention to every word people say,
 or you may hear your servant cursing you —
²²for you know in your heart
 that many times you yourself have cursed others.

²³All this I tested by wisdom and I said,

"I am determined to be wise" —
 but this was beyond me.

ᵃ 18 Or will follow them both

Preparing for the Journey
Recommended Supplies and Tools

PATIENCE VERSUS PRIDE

I've always understood that patience is an important part of learning something new. I've never expected to breeze through a first exercise class or to master chemistry in my freshman year. I know I need to practice patience while I learn and grow.

When it came to creating art in my Bible, however, patience was lacking. Despite being a professional artist, I'd see a beautiful Bible page made by someone else and dismiss my capacity to ever accomplish it, or look at my own work and feel inferior. I'm embarrassed to admit that I'd post my pages online and obsessively check to see how many likes they garnered, beating myself up if a post didn't hit a quick home run.

One morning during my prayer time, God asked me, "Who are you doing this for?"

I'd missed the point. I was more worried about creating art that would be popular than about worship that would please God! That led to a year of fasting from viewing Bible journaling art online as I developed my own style and my own process with the Lord. Talk about an exercise in patience! But it paid off as I learned to experience Bible journaling as worship in a way that would deepen my relationship with Jesus.

Ecclesiastes 7:8
Watercolor paints

Any subject matter is fair game for a Bible-journaling page, even a patient snail. This was the perfect illustration for the admonition to be patient and wait on the Lord, rather than be prideful and seek human approval. A common image like a snail also carries the memory of this truth into a walk in the garden. In this drawing, watercolor paint was used on the page, and the snail sketched on top with a black Micron pen.

✱ *Web content available*

What's Your Story?

- Are you willing to be patient with yourself as you learn what God wants to accomplish in your life?
- Can you forego the urge to compare your work with others and let Jesus take the wheel in this adventure of Bible journaling?
- Do you have a lack of confidence in yourself as a creative person?
- Will you ask your Christian friends to pray for you in that area?

Selecting a *Journaling* Bible

Modern Bibles are all printed on approximately the same quality of paper, with the largest variance being white versus cream color. Decades-old Bibles or dollar-store Bibles may be printed on newsprint-style paper; technique results will vary in those. Online searches for "journaling Bibles" reveal a wide variety of styles. The type you choose is entirely a personal choice. You can see the book website to research Bible purchases.

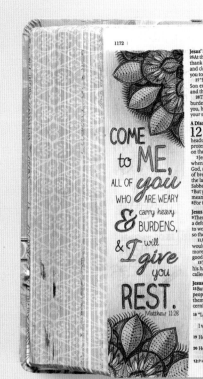

Matthew 11:28
Colored pencil
Inspire Bible

Preprinted Bibles

These Bibles are printed with about 500 pieces of line art and text in the margins, while also leaving many pages available for your own art. If working on preprinted pages, make a deliberate effort to study the Scriptures so the Bible doesn't become just a coloring book.

Select a Bible with either your favorite translation or an alternate translation that would allow you to study the fuller meaning of a verse.

In this book, a variety of journaling Bibles with the New International Version (or NIV) translation are used. Mediums shown are targeted to those with the least chance of any bleed-through on standard Bible paper.

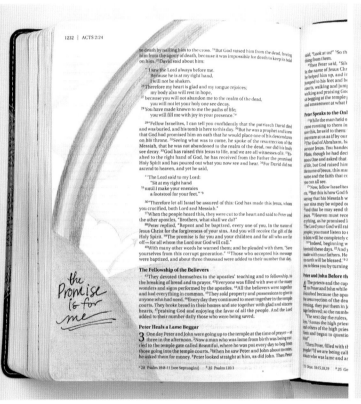

Acts 2:39
Colored pencil
Journal the Word Bible

Journaling Bibles

The vast majority of journaling Bibles have approximately a 2" (5cm) margin on every page, with or without lines. Art can be contained within that column, or it can interact with or cover the Scriptures.

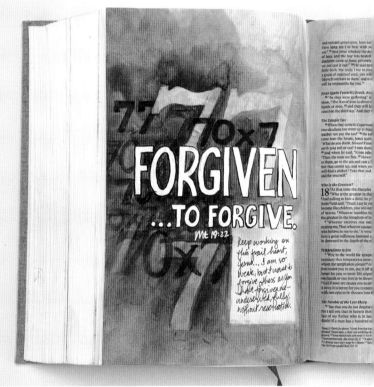

Matthew 18:22
Watercolor
Interleaved Bible

Interleaved Bibles

For those with big ideas, an interleaved Bible offers a full blank page in between each printed page. It makes this Bible thicker (as it has twice the amount of paper), but it offers a large area in which to create art.

Testing *Mediums*

In this book, three mediums—colored pencils, watercolor pencils and watercolor paints—are used. Generally, most brands do not bleed through the thin Bible paper. (If publishers printed on heavier paper, we'd need a wagon to haul around God's Word!)

Before using any new medium, test it out on a page of the paper you'll be using, either on the table of contents or the index pages (if in your Bible). Place a piece of white copier paper behind the test page to protect it and doodle with the test mediums, noting which brands and colors are used in the swatches. Test several of the colors. Typically, light colors do not bleed but darker hues may. Leave the test pages in the Bible as a reference.

Wait for any medium to dry fully before declaring it a success or a failure. Wet mediums will make the paper more translucent, and once dry, the results might look different.

If a medium surprises you and bleeds unexpectedly, just stop for a moment and breathe. You'll be fine. There's no way to repair bleeding, but it'll be a learning moment! Always keep copier paper underneath any pages you're working on, just to be safe.

[19] Meanwhile, the high priest questioned Jesus about his disciples and teaching.

[20] "I have spoken openly to the world," Jesus replied. "I always taught in synagogues or at the temple, where all the Jews come together. I said nothing in secret. [21] Why question me? Ask those who heard me. Surely they know what I said."

[22] When Jesus said this, one of the officials nearby slapped him in the face. "Is this the way you answer the high priest?" he demanded.

[23] "If I said something wrong," Jesus replied, "testify as to what is wrong. But if I spoke the truth, why did you strike me?" [24] Then Annas sent him bound to Caiaphas the high priest.

Peter's Second and Third Denials

[25] Meanwhile, Simon Peter was still standing there warming himself. So they asked him, "You aren't one of his disciples too, are you?"

He denied it, saying, "I am not."

[26] One of the high priest's servants, a relative of the man whose ear Peter had cut off, challenged him, "Didn't I see you with him in the garden?" [27] Again Peter denied it, and at that moment a rooster began to crow.

Jesus Before Pilate

[28] Then the Jewish leaders took Jesus from Caiaphas to the palace of the Roman governor. By now it was early morning, and to avoid ceremonial uncleanness they did not enter the palace, because they wanted to be able to eat the Passover. [29] So Pilate came out to them and asked, "What charges are you bringing against this man?"

[30] "If he were not a criminal," they replied, "we would not have handed him over to you."

[31] Pilate said, "Take him yourselves and judge him by your own law."

"But we have no right to execute anyone," they objected. [32] This took place to fulfill what Jesus had said about the kind of death he was going to die.

[33] Pilate then went back inside the palace, summoned Jesus and asked him, "Are you the king of the Jews?"

[34] "Is that your own idea," Jesus asked, "or did others talk to you about me?"

[35] "Am I a Jew?" Pilate replied. "Your own people and chief priests handed you over to me. What is it you have done?"

slapped him in the face.

[4] Once more Pilate came out and said to the Jews gathered there, "Look, I am bringing him out to you to let you know that I find no basis for a charge against him." [5] When Jesus came out wearing the crown of thorns and the purple robe, Pilate said to them, "Here is the man!"

[6] As soon as the chief priests and their officials saw him, they shouted, "Crucify! Crucify!"

But Pilate answered, "You take him and crucify him. As for me, I find no basis for a charge against him."

[7] The Jewish leaders insisted, "We have a law, and according to that law he must die, because he claimed to be the Son of God."

[8] When Pilate heard this, he was even more afraid, [9] and he went back inside the palace. "Where do you come from?" he asked Jesus, but Jesus gave him no answer. [10] "Do you refuse to speak to me?" Pilate said. "Don't you realize I have power either to free you or to crucify you?"

[11] Jesus answered, "You would have no power over me if it were not given to you from above. Therefore the one who handed me over to you is guilty of a greater sin."

[12] From then on, Pilate tried to set Jesus free, but the Jewish leaders kept shouting, "If you let this man go, you are no friend of Caesar. Anyone who claims to be a king opposes Caesar."

[13] When Pilate heard this, he brought Jesus out and sat down on the judge's seat at a place known as the Stone Pavement (which in Aramaic is Gabbatha). [14] It was the day of Preparation of the Passover; it was about noon.

"Here is your king," Pilate said to the Jews.

[15] But they shouted, "Take him away! Take him away! Crucify him!"

"Shall I crucify your king?" Pilate asked.

"We have no king but Caesar," the chief priests answered.

[16] Finally Pilate handed him over to them to be crucified.

The Crucifixion of Jesus

So the soldiers took charge of Jesus. [17] Carrying his own cross, he went out to the place of the Skull (which in Aramaic is called Golgotha). [18] There they crucified him, and with him two others—one on each side and Jesus in the middle.

[19] Pilate had a notice prepared and fastened to the cross. It read: JESUS OF NAZARETH, THE KING OF THE JEWS. [20] Many of the Jews read this sign, for the place where Jesus was crucified was near the city, and the sign was written in Aramaic, Latin and Greek. [21] The chief priests of the Jews protested to Pilate, "Do not write 'The King of the Jews,' but that this man claimed to be king of the Jews."

When reading a Bible, the eye typically ignores any text seen through the paper. This faint visibility is called ghosting and is normal.

Some mediums may cause ghosting that appears as a hazy mirrored image on the opposite side of a page, but this is not the same as bleed-through.

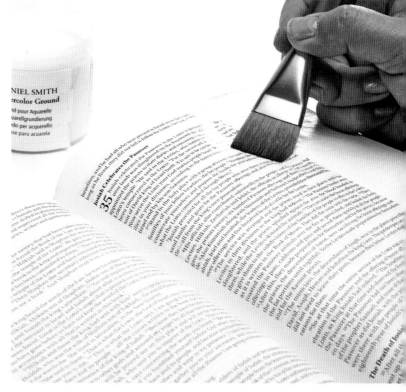

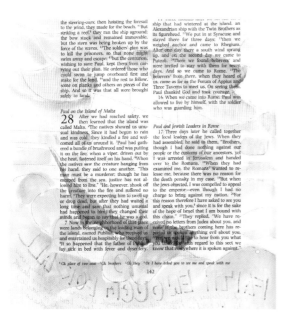

A medium that bleeds shows actual pigment on the next page and can make text difficult to read.

Experiment with the pens you have, because many brands of colored markers and pens bleed. Black Pigma Micron pens work very well, and white gel pens are a staple for Bible journaling.

Gesso, or page prep, can limit bleed-through, but it also adds to a page's thickness and creates a physical texture.

Page Prep

To help Bible paper receive mediums that bleed, gesso of some kind is required to prepare the page. This product is available in many brands, in clear and white and other colors, and in heavy (thick) and light body. Gesso is applied in a thin layer and allowed to dry for 24 hours before proceeding to paint on top of it.

This book does not show mediums or techniques that require gesso. Instead, the pencils and paints recommended are applied directly to the paper.

There are many types, brands and colors of gesso. If you choose to use it, experiment to find the one you prefer.

Colored *Pencil*

The easiest medium for new Bible journalers is colored pencil. Everyone has used a pencil before, even if just for writing, and colored pencils do not bleed through Bible paper.

The biggest difference between brands is color intensity. Artist-quality pencils have softer leads, which release more color. Other pencils have harder leads and appear lighter on the page. As with all things in life, the more we invest in supplies, the better they will work, but a pack of pencils from the dollar store is fine to start with and a minor investment. A small number of colors can stretch a long way, too!

A kneaded eraser is gentle on Bible paper, and the eraser is cleaned by "kneading" and stretching it. This easy cleaning method makes this inexpensive tool last even longer.

The sharper the point on the pencil, the better the detail. A hand-held or electric sharpener with auto-stop is an excellent investment.

Colored Pencil Tips

1 SKETCHING
Sketch the design lightly with a no. 2 pencil. Then, with a light touch and a sharp colored pencil, color in the shape. If pressed too hard, waxy pencil lead will create a sheen on the paper and become hard to work with.

2 LAYERING
Layer pencil colors on top of each other to create new colors. (See Mixing with the Color Wheel on page 39.) Light layers create a beautiful texture on the paper and allow for an infinite variety of hues, even from a small pack of pencils.

Colored pencils can be stored in cups, boxes, zipper pouches or specially-made cases. But do not drop the pencils. Dropping them will shatter the lead inside the pencil, and then every time it's sharpened, the lead will break off.

3 SHADING

Layers can also add shading, both on top of an image or around it. Experiment with slightly darker colors, or use different ones to see how they mix.

4 OUTLINING

Try leaving a white space around the image, adding extra delicacy. To let that outer color blend into the paper color, use lighter and lighter pressure, and try erasing with a kneaded eraser.

Watercolor *Pencil*

Drawing with watercolor pencil is a step beyond regular colored pencil. The motion of making marks on the page is familiar, but the watercolor trait means the pigment moves when you apply moisture.

As with regular colored pencil, artist brands are more intense than other brands. Derwent Inktense pencils are reasonably priced and have strong color. An Inktense set of twelve pencils is used throughout this book.

A pencil sharpener is important for watercolor pencils, too, so be sure to find one that works well.

Intensify the Color

Brushes and baby wipes will remove a small amount of color, so add layers of pencil to intensify the color. Allow each color layer to dry completely before adding more.

Watercolor Pencil Tips

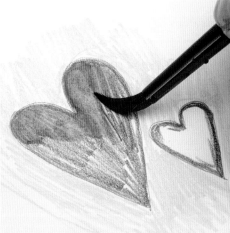

1 **DRY WATERCOLOR PENCIL**
If you plan to smooth out your watercolor pencil with water, it doesn't matter if the strokes are a little messy. If using watercolor pencils dry, they behave like colored pencils.

2 **WET WATERCOLOR PENCIL**
Scribbled watercolor pencil becomes soluble with a damp brush. Only use as much water as needed to move the color around.

DON'T *dig up* IN *doubt*

WHAT WAS *planted* IN *faith!*

Watercolor pencil is an excellent transitional medium for those who wish to attempt a little watercolor without committing to using paints. The pencils can be used alone for part of the drawing and as watercolor for another part.

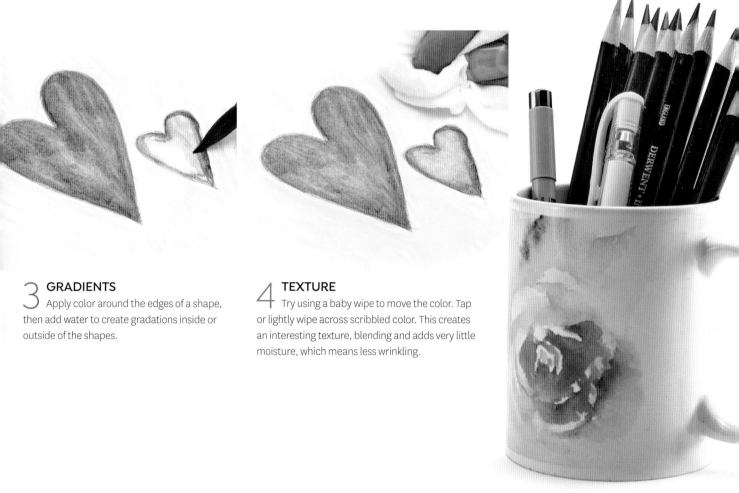

3 **GRADIENTS**
Apply color around the edges of a shape, then add water to create gradations inside or outside of the shapes.

4 **TEXTURE**
Try using a baby wipe to move the color. Tap or lightly wipe across scribbled color. This creates an interesting texture, blending and adds very little moisture, which means less wrinkling.

Watercolor *Paints*

In Bible journaling, watercolor paints pose a few challenges, but the solutions aren't difficult.

Paints come in pans (paint cakes dried in plastic trays), tubes (thick liquid paint) and specialty types. Different brands vary by price and quality, but for Bible journaling, most are fine. Just be aware that a few of the cheapest brands bleed through the paper entirely, so test whatever you purchase.

Watercolor pans are ready to go; just wet a brush and touch it to the pigment to liquefy it. Tube paints need to be squeezed out to be used; you can do this on a plastic plate, ceramic tile or store-bought palette with wells. The nice thing about watercolor is that, as long as your palette is durable, you can save and re-wet the paints to use again later.

Watercolor Tips

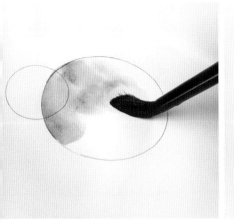

1 **LAYER INTENSITY**
It's often best to mix light paints—less pigment, more water—and add more layers later. Let the page air dry completely or iron it (see Flattening Bible Pages on page 41) to flatten the page before continuing.

2 **BLEND**
Blending the pigment with clean water creates a gradation that provides the illusion of depth.

3 **LAYER COLORS**
The transparency of watercolor allows the layering of hues. Here, yellow on top of pink creates an orange shape where they meet.

Mixing With the Color Wheel

Daniel Smith tube watercolor paints are used throughout this book. They are high-quality paints, beautifully transparent and have high lightfast ratings, which means they won't fade over time.

It's amazing how many colors can be created with just three hues:

yellow + red = orange
red + blue = purple
blue + yellow = green

On the wheel, note that more yellow or more blue changes the shade of the green. The same applies for each of the other color groups.

To make brown or gray, use a combination of all three colors in a variety of amounts.

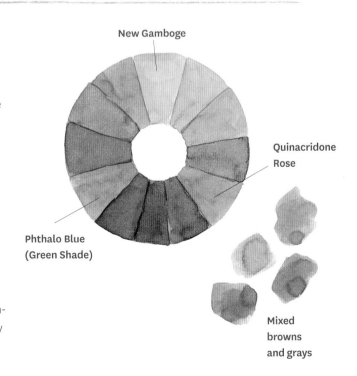

New Gamboge

Quinacridone Rose

Phthalo Blue (Green Shade)

Mixed browns and grays

Brushes

For both watercolor pencil and watercolor paints, brushes can be used to move the pigment. For painting on Bible paper, the quality of the brush isn't nearly as important as it might be for other types of painting.

Some watercolor sets come with a brush, but those brushes are often low quality, so you may want to purchase a separate brush. Brushes come in a variety of shapes, most commonly round and flat (squared-off). Some techniques may work better with one or the other shape, but if you're only buying one nice brush, buy a no. 8 round.

A note on aqua brushes, sometimes called water brushes: The barrel of the brush can be filled with water that is released out of the brush nib when it's squeezed or turned upright. These are fine to use, but the amount of water can be challenging to control.

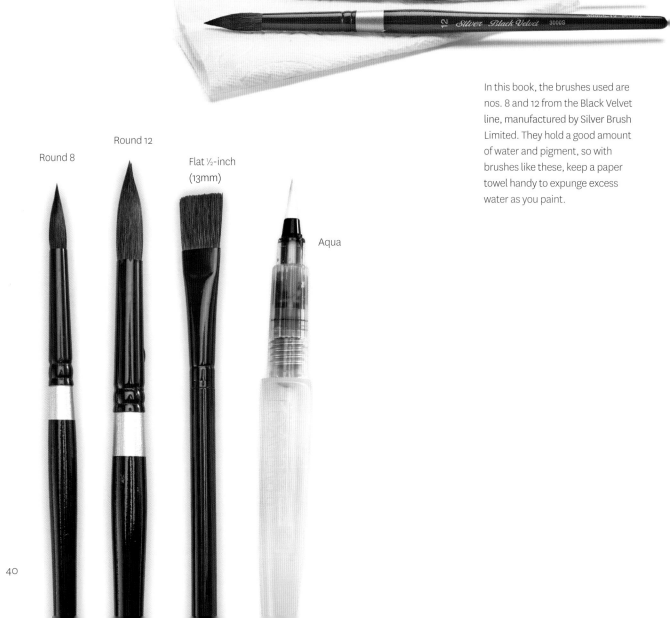

In this book, the brushes used are nos. 8 and 12 from the Black Velvet line, manufactured by Silver Brush Limited. They hold a good amount of water and pigment, so with brushes like these, keep a paper towel handy to expunge excess water as you paint.

Round 8

Round 12

Flat ½-inch (13mm)

Aqua

Minitutorial: Flattening Bible Pages

When water is added to paper, it buckles, and with thin Bible paper tends to buckle even more. There's a simple fix: an iron.

Let the wet pigment air dry first; don't use a heat gun, as this could damage the book. Place a sheet of copier paper on top of the art and one or more sheets underneath, then iron on high for about 10 seconds.

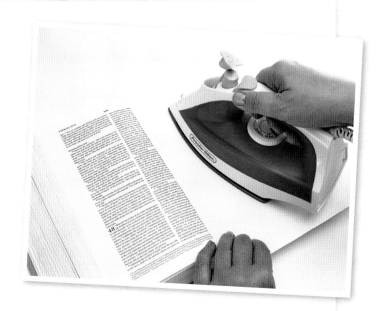

This can be done periodically during the creation process to make the page easier to work with.

Even ironing won't restore the paper to 100 percent prepainted state because Bible paper is thin and the fibers are altered slightly by the water. The page will flatten, but there still may be minor creases.

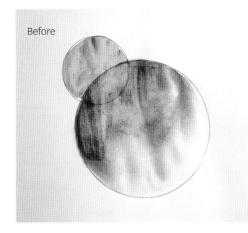

Before

After

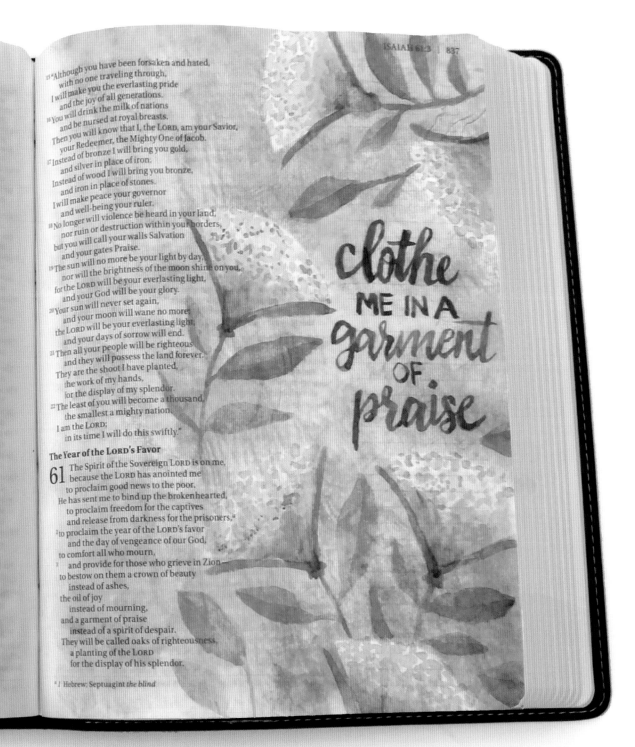

When you see ✱ *Web content available,* visit the book website biblejournalingmadesimple.com for more information, video tutorials, free downloadable sketches and links to Bibles and supplies.

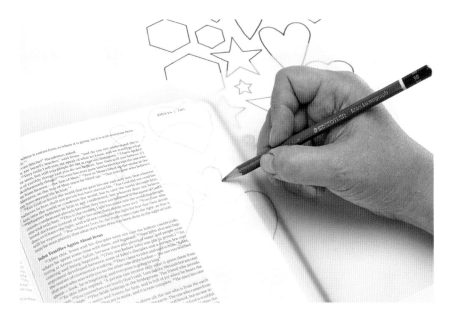

Downloadable Sketches

More sketches are added regularly to the site and are free for personal use. See Tips for Creating and Transferring Images on page 78 for a tutorial on transferring images to your Bible.

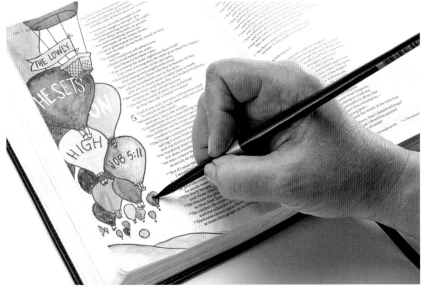

Video Tutorials

Videos showing more techniques related to those in this book can be found on the website, and more are added regularly. There is also a video demonstrating the watercolor flowers on the cover of this book.

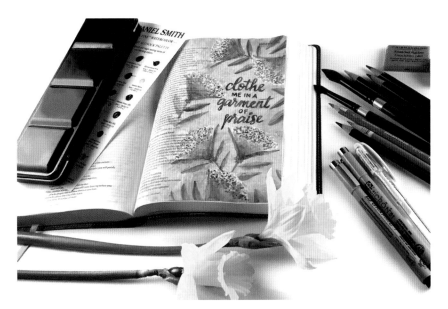

More About Supplies

Further discussion about supplies and Bibles can be found on the website, especially as others are discovered after the printing of this book.

Jesus Christ, [22]who has gone into heaven and is at God's right hand — with angels, authorities and powers in submission to him.

Living for God

4 Therefore, since Christ suffered in his body, arm yourselves also with the same attitude, because whoever suffers in the body is done with sin. [2]As a result, they do not live the rest of their earthly lives for evil human desires, but rather for the will of God. [3]For you have spent enough time in the past doing what pagans choose to do — living in debauchery, lust, drunkenness, orgies, carousing and detestable idolatry. [4]They are surprised that you do not join them in their reckless, wild living, and they heap abuse on you. [5]But they will have to give account to him who is ready to judge the living and the dead. [6]For this is the reason the gospel was preached even to those who are now dead, so that they might be judged according to human standards in regard to the body, but live according to God in regard to the spirit.

[7]The end of all things is near. Therefore be alert and of sober mind so that you may pray. [8]Above all, love each other deeply, because love covers over a multitude of sins. [9]Offer hospitality to one another without grumbling. [10]Each of you should use whatever gift you have received to serve others, as faithful stewards of God's grace in its various forms. [11]If anyone speaks, they should do so as one who speaks the very words of God. If anyone serves, they should do so with the strength God provides, so that in all things God may be praised through Jesus Christ. To him be the glory and the power for ever and ever. Amen.

Suffering for Being a Christian

[12]Dear friends, do not be surprised at the fiery ordeal that has come on you to test you, as though something strange were happening to you. [13]But rejoice inasmuch as you participate in the sufferings of Christ, so that you may be overjoyed when his glory is revealed. [14]If you are insulted because of the name of Christ, you are blessed, for the Spirit of glory and of God rests on you. [15]If you suffer, it should not be as a murderer or thief or any other kind of criminal, or even as a meddler. [16]However, if you suffer as a Christian, do not be ashamed, but praise God that you bear that name. [17]For it is time for judgment to begin with God's household; and if it begins with us, what will the outcome be for those who do not obey the gospel of God? [18]And,

"If it is hard for the righteous to be saved,
 what will become of the ungodly and the sinner?"[a]

[19]So then, those who suffer according to God's will should commit themselves to their faithful Creator and continue to do good.

To the Elders and the Flock

5 To the elders among you, I appeal as a fellow elder and a witness of Christ's sufferings who also will share in the glory to be revealed: [2]Be shepherds of God's flock that is under your care, watching over them — not because you must, but because you are willing, as God wants you to be; not pursuing dishonest gain, but eager to serve; [3]not lording it over those entrusted to you, but being examples to the flock. [4]And when the Chief Shepherd appears, you will receive the crown of glory that will never fade away.

[5]In the same way, you who are younger, submit yourselves to your elders. All of you, clothe yourselves with humility toward one another, because,

"God opposes the proud
 but shows favor to the humble."[b]

[6]Humble yourselves, therefore, under God's mighty hand, that he may lift you up in due time. [7]Cast all your anxiety on him because he cares for you.

[a] 18 Prov. 11:31 (see Septuagint) [b] 5 Prov. 3:34

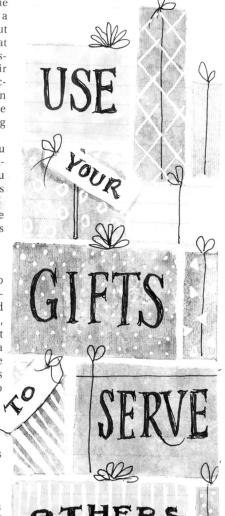

USE YOUR GIFTS TO SERVE OTHERS

In this season in the wilderness... help me to remember to keep on reaching out! Jesus, my own heart needs a nudge to serve... open my eyes to see needs + my ♡ to take action.

3 | *Patterns of Kindness*
Background Patterns

BE KIND TO THE NEEDY

Volunteering has been a staple in my life. From a young age, I instinctively knew that it felt good to be kind to someone else. From staying late to paint sets for school plays to becoming a volunteer sailing instructor, I was true to the meaning of my name, Sandy: helper of humankind.

Throughout the Bible, God commands us to be kind, to care for the poor and to bear each other's burdens. I've always been amazed that I'm a vital part of His plan for the world; He actually counts on *me* to be His hands and feet to love people. What a gift!

As with all of God's instruction, the command to be kind is not only for the good of others—it's also good for me. I've learned that truth as a woman with a lifelong struggle with depression. On days when I feel low, one sure-fire way to lift the cloud is to focus my attention on meeting the needs of others. I look for someone whom I can assist: carrying groceries, writing an encouraging letter or taking an action in one of my ministries.

God's prescription for what ails me is also His plan for healing the world. He relies on each of us to be His gift to others and bring His kingdom to Earth, one person at a time.

1 Peter 4:10
Watercolor paints

A simple stack of painted rectangles—either masked off with washi tape or drawn freehand—is perfect for verses about the many gifts we receive from the Lord. Decorating them is as simple as doodling!

✱ *Web content available*

What's Your Story?

- How does receiving an unexpected kindness feel?
- How does being kind affect you?
- Is there an area where God has asked you to serve?
- Have you taken steps toward doing so?
- What is holding you back?
- Journal about your fears and hopes, and watch for Jesus to come through with answers.

Highlighting *Focal Verses*

When God shows us a verse, it's important to focus our attention on it. In the midst of a field of beautiful color, be sure His words stand out. There are both simple and complicated ways to do this, so when you start thinking about your creation, make this your first question: Do I need to mask off or call out my verse before applying color?

and they will possess the land forever.
They are the shoot I have planted,
the work of my hands,
for the display of my splendor.
²²The least of you will become a thousand,
the smallest a mighty nation.
I am the LORD;
in its time I will do this swiftly."

The Year of the LORD's Favor

61 The Spirit of the Sovereign LORD is on me,
because the LORD has anointed me
to proclaim good news to the poor.
He has sent me to bind up the brokenhearted,
to proclaim freedom for the captives
and release from darkness for the prisoners,ᵃ
²to proclaim the year of the LORD's favor
and the day of vengeance of our God,
to comfort all who mourn,
³ and provide for those who grieve in Zion —
to bestow on them a crown of beauty
instead of ashes,
the oil of joy
instead of mourning,
and a garment of praise
instead of a spirit of despair.
They will be called oaks of righteousness,
a planting of the LORD
for the display of his splendor.

ᵃ1 Hebrew; Septuagint *the blind*

Use a simple pen or colors matching the artwork to highlight the verse, underscore important words or create a box around several verses.

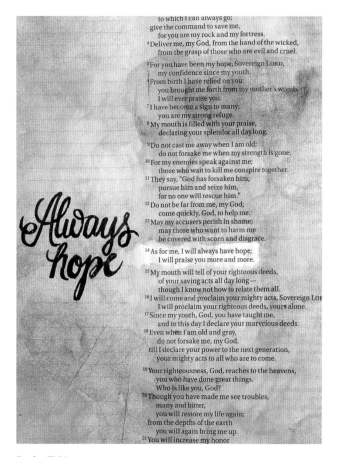

Psalm 71:14
Watercolor paints

Surround a featured verse with a field of simple color—one verse or a whole section. It will be clear what the focus is.

Isaiah 52:7
Watercolor pencil

Use an element in the art, such as a cloud, to surround the verse and call attention to it. (See more on drawing mountains on pages 96 and 97.)

52 Awake, awake, Zion,
clothe yourself with strength!
Put on your garments of splendor,
Jerusalem, the holy city.
The uncircumcised and defiled
will not enter you again.
[2] Shake off your dust;
rise up, sit enthroned, Jerusalem.
Free yourself from the chains on your neck,
Daughter Zion, now a captive.

[3] For this is what the LORD says:

"You were sold for nothing,
and without money you will be redeemed."

[4] For this is what the Sovereign LORD says:

"At first my people went down to Egypt to live;
lately, Assyria has oppressed them.

[5] "And now what do I have here?" declares the LORD.

"For my people have been taken away for nothing,
and those who rule them mock,[a]"

declares the LORD.

"And all day long
my name is constantly blasphemed.
[6] Therefore my people will know my name;
therefore in that day they will know
that it is I who foretold it.
Yes, it is I."

[7] How beautiful on the mountains
are the feet of those who bring good news,
who proclaim peace,
who bring good tidings,
who proclaim salvation,
who say to Zion,
"Your God reigns!"
[8] Listen! Your watchmen lift up their voices;
together they shout for joy.
When the LORD returns to Zion,
they will see it with their own eyes.
[9] Burst into songs of joy together,
you ruins of Jerusalem,
for the LORD has comforted his people,
he has redeemed Jerusalem.
[10] The LORD will lay bare his holy arm
in the sight of all the nations,
and all the ends of the earth will see
the salvation of our God.

[11] Depart, depart, go out from there!
Touch no unclean thing!
Come out from it and be pure,
you who carry the articles of the LORD's house.
[12] But you will not leave in haste
or go in flight;
for the LORD will go before you,
the God of Israel will be your rear guard.

[a] 5 Dead Sea Scrolls and Vulgate; Masoretic Text *wail*

how beautifully... ...He reigns!

The Sufferi

[13] See, my se
he will
[14] Just as the
his app
hu
and his
[15] so he will s
and kin
For what th
and wh

53 Who h
and to
[2] He grew u
and like
He had no
nothing
[3] He was des
a man o
Like one fr
he was d

[4] Surely he t
and bor
yet we cons
stricken
[5] But he was
he was c
the punish
and by h
[6] We all, like
each of u
and the LO
the iniqu

[7] He was opp
yet he di
he was led t
and as a
so he did
[8] By oppressi
Yet who
For he was
for the tr
[9] He was assi
and with
though he h
nor was a
[10] Yet it was th
suf
and thou
he will see
and the

[a] 13 Or will pros
(see also Septuag
off from the land
[f] 10 Hebrew thou

MATERIALS LIST

colored pencils, light shades

copier paper

pen, black bleedproof

ruler

A simple background is sometimes enough—fancy drawings with clever images and deep meanings aren't necessary. Color draws our eye to the page, so when we flip through our Bible, we'll stop and remember why we created and what God spoke.

Tips for Other Mediums

Carefully place washi tape on either side of a line, and use a brush or baby wipe to lightly move watercolor or watercolor pencil pigment. See page 12 for an example of the plaid pattern created in watercolor using this technique, and see Wash Tape Tips on page 53 for suggestions on using washi.

Select any verse you wish for this exercise. Backgrounds can work with any Scripture.

706 | PROVERBS 14:1

14 The wise woman builds her house,
but with her own hands the foolish one tears hers do

[2] Whoever fears the LORD walks uprightly,
but those who despise him are devious in their ways.

[3] A fool's mouth lashes out with pride,
but the lips of the wise protect them.

[4] Where there are no oxen, the manger is empty,
but from the strength of an ox come abundant harve

[5] An honest witness does not deceive,
but a false witness pours out lies.

[6] The mocker seeks wisdom and finds none,
but knowledge comes easily to the discerning.

[7] Stay away from a fool,
for you will not find knowledge on their lips.

[8] The wisdom of the prudent is to give thought to their w
but the folly of fools is deception.

[9] Fools mock at making amends for sin,
but goodwill is found among the upright.

[10] Each heart knows its own bitterness,
and no one else can share its joy.

[11] The house of the wicked will be destroyed,
but the tent of the upright will flourish.

[12] There is a way that appears to be right,
but in the end it leads to death.

[13] Even in laughter the heart may ache,
and rejoicing may end in grief.

[14] The faithless will be fully repaid for their ways,
and the good rewarded for theirs.

[15] The simple believe anything,
but the prudent give thought to their steps.

[16] The wise fear the LORD and shun evil,
but a fool is hotheaded and yet feels secure.

[17] A quick-tempered person does foolish things,
and the one who devises evil schemes is hated.

[18] The simple inherit folly,
but the prudent are crowned with knowledge.

[19] Evildoers will bow down in the presence of the good,
and the wicked at the gates of the righteous.

[20] The poor are shunned even by their neighbors,
but the rich have many friends.

[21] It is a sin to despise one's neighbor,
but blessed is the one who is kind to the needy.

[22] Do not those who plot evil go astray?
But those who plan what is good find[a] love and fait

[23] All hard work brings a profit,
but mere talk leads only to poverty.

[a] 22 Or *show*

BE KIND to the NEEDY.

1 **DRAW THE LINES**
With one pencil color, use a ruler to draw a few wide, unevenly-spaced lines.

2 **THICKEN THE LINES**
Place copier paper under the Bible page to prevent the pencil lines from traveling down the side of the book. Widen some of your original lines.

3 **ADD ANOTHER COLOR**
With a second color, make lines to fill in some of the spaces left blank by the first color.

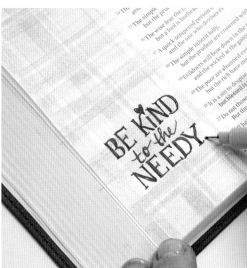

4 **WIDEN THE NEW LINES**
Widen some of the new lines. Where they cross, a new color is formed.

5 **ADD A THIRD COLOR**
Fill in more spaces with lines of a third color.

6 **ADD TEXT**
Finish by journaling words on top of the background with a bleedproof black pen.

A Word About Journaling

Leave space for journaling a prayer, thought or story. Why did God draw your attention here? What do you want to remember? Imagine someone you love reading this after you're long gone. What would you want them to learn from what you have created?

| *Block Pattern*

MATERIALS LIST

baby wipes

copier paper

iron (optional)

pen, black bleedproof

no. 2 pencil

sticky notes

watercolor pencils

Another type of background is a grid pattern that can highlight a verse by leaving it as the only uncolored space. Grids can fill an entire page or just a column. It can also serve as a background behind imagery. Best of all, the blocks are easy to mask off with sticky notes. See a looser version of this pattern on page 134.

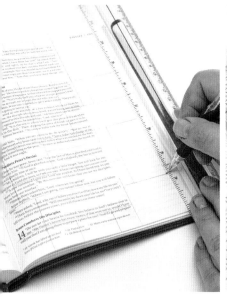

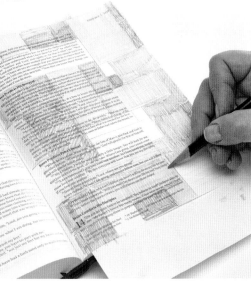

1 **MAKE THE GRID**
Draw a grid in pencil. It can be an evenly spaced pattern or random as shown here.

2 **ADD COLOR**
Place copier paper under the Bible page. Scribble watercolor pencil into each shape.

3 **FRAME THE BLOCK**
Place sticky notes around four sides of the block.

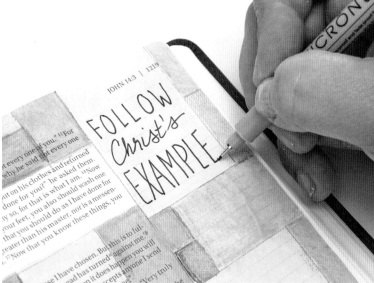

4 **BLEND THE COLOR**
Wipe gently across the pencil with a baby wipe. Repeat for each rectangle, each time a block is complete.

5 **ADD TEXT**
When all shapes have been completed, let dry and iron to flatten the page. Add journaling in one or more of the rectangles.

Tips for Other Mediums

This is a relaxing design for colored pencil, and it needs no masking. If using watercolor, dip a baby wipe into paint to apply it. Sticky notes don't like a lot of moisture.

Watercolor Stone

MATERIALS LIST

baby wipes

copier paper

iron (optional)

palette or plate

pen, black bleedproof

no. 2 pencil

washi tape

watercolor paints

This lovely stone texture is easy to create in a column, as a background or as a splash to highlight a special verse in your favorite colors. Mask the verse with washi tape or just have fun with color.

See the technique demonstrated in the video tutorials on the website. The background for the Bible page shown on the cover uses this technique.

them a powerful delusion so that they will believe the lie [12]and so that all will be condemned who have not believed the truth but have delighted in wickedness.

Stand Firm

[13]But we ought always to thank God for you, brothers and sisters loved by the Lord, because God chose you as firstfruits[a] to be saved through the sanctifying work of the Spirit and through belief in the truth. [14]He called you to this through our gospel, that you might share in the glory of our Lord Jesus Christ.

[15]So then, brothers and sisters, stand firm and hold fast to the teachings[b] we passed on to you, whether by word of mouth or by letter.

[16]May our Lord Jesus Christ himself and God our Father, who loved us and by his grace gave us eternal encouragement and good hope, [17]encourage your hearts and strengthen you in every good deed and word.

Request for Prayer

3 As for other matters, brothers and sisters, pray for us that the message of the Lord may spread rapidly and be honored, just as it was with you. [2]And pray that we may be delivered from wicked and evil people, for not everyone has faith. [3]But the Lord is faithful, and he will strengthen you and protect you from the evil one. [4]We have confidence in the Lord that you are doing and will continue to do the things we command. [5]May the Lord direct your hearts into God's love and Christ's perseverance.

Warning Against Idleness

[6]In the name of the Lord Jesus Christ, we command you, brothers and sisters, to keep away from every believer who is idle and disruptive and does not live according to the teaching[c] you received from us. [7]For you yourselves know how you ought to follow our example. We were not idle when we were with you, [8]nor did we eat anyone's food without paying for it. On the contrary, we worked night and day, laboring and toiling so that we would not be a burden to any of you. [9]We did this, not because we do not have the right to such help, but in order to offer ourselves as a model for you to imitate. [10]For even when we were with you, we gave you this rule: "The one who is unwilling to work shall not eat."

[11]We hear that some among you are idle and disruptive. They are not busy; they are busybodies. [12]Such people we command and urge in the Lord Jesus Christ to settle down and earn the food they eat. [13]And as for you, brothers and sisters, never tire of doing what is good.

[14]Take special note of anyone who does not obey our instruction in this letter. Do not associate with them, in order that they may feel ashamed. [15]Yet do not regard them as an enemy, but warn them as you would a fellow believer.

Final Greetings

[16]Now may the Lord of peace himself give you peace at all times and in every way. The Lord be with all of you.

[17]I, Paul, write this greeting in my own hand, which is the distinguishing mark in all my letters. This is how I write.

[18]The grace of our Lord Jesus Christ be with you all.

never TIRE of DOING what is GOOD!

[a] 13 Some manuscripts *because from the beginning God chose you* [b] 15 Or *traditions*
[c] 6 Or *tradition*

Washi Tape Tips

Inexpensive *washi* or decorative tapes can be used in Bible journaling for embellishing, but they also can be used to mask off areas from color. Here are a few tips for using washi tape:

- Lessen the stickiness of the tape by sticking it to fabric or skin first.
- Some tapes can rip the paper when pulled off, so remove it slowly, gently and at an angle.
- To make a skinny strip of tape to use as a mask, cut the tape in half lengthwise.

Tips for Other Mediums

It's possible to get a similar marbled look, but softer, with watercolor pencil by scribbling color, then tapping the baby wipe around the page to create texture.

1 MIX YOUR COLORS
Mix two or three colors in a palette or on a plate.

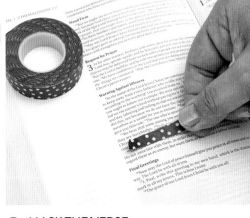

2 MASK THE VERSE
Apply washi tape to any areas or words that will remain uncolored.

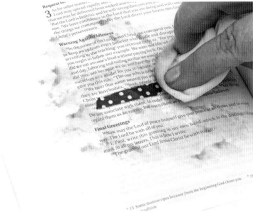

3 ADD COLOR
Place copier paper under the Bible page. Pick up paint with a baby wipe. Dab it on the surface of the paper, tapping and moving it around as desired.

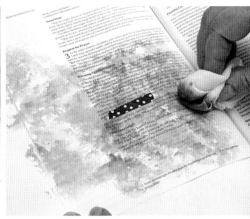

4 ADD THE NEXT COLOR
Add a second color in the same way you applied the first. Experiment with different amounts of pigment and tapping techniques.

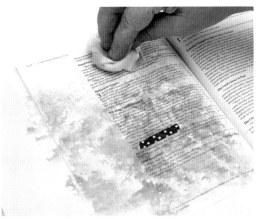

5 CONTINUE ADDING COLOR
Add more colors as desired. If too much pigment is applied, lighten by removing some color with a clean baby wipe.

After the paint is dry, gently remove the washi tape.

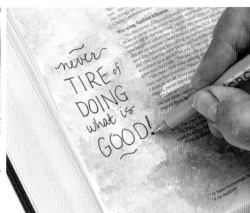

6 ADD FINISHING TOUCHES
Iron to flatten the page, then add text and journaling. Write the journaling lightly in pencil before tracing it with a pen.

Minitutorial: Decorative Word Text

Large text is a great place to add a doodled pattern as well. Consider one word—a short one—and print it from your computer at dimensions that fit the journaling space. Place the printout under the Bible page and trace the outlines, either in no. 2 pencil or pen, then have fun adding patterned detail.

The Be Kind graphic used here is on the next page to copy. Slide the book page underneath your Bible page or photocopy it for easier tracing.

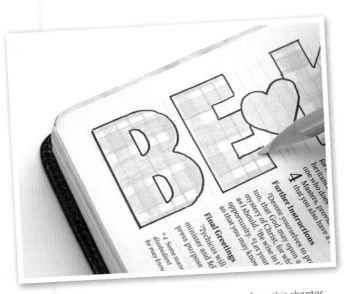

Use a background pattern from this chapter, or come up with your own, and fill the letters with color. Meditate on God's call for use to be kind while coloring, and pray for opportunities to show the Lord's kindness to someone who needs it.

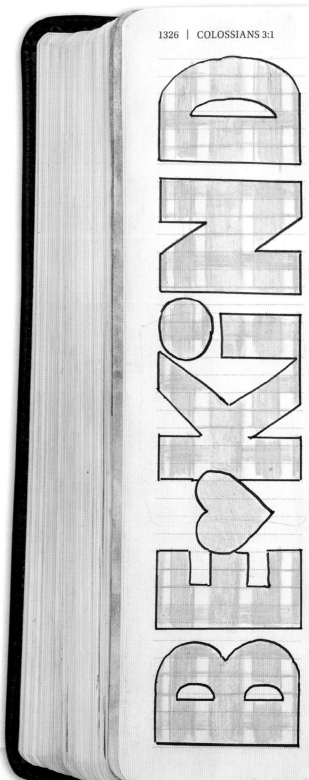

Suggestions for *Study*

When determining imagery for a page, sometimes the words of Scripture just don't inspire any visuals. These are great times to have some beautiful patterns in your toolbox. Add color to the page, and let your journaling speak for itself.

As a new Bible journaler, consider verses that have meant a lot to you throughout your life. Write down a few, and choose one to journal using a technique in this chapter.

While writing this chapter, I was studying the Fruit of the Spirit, which began with kindness. Do a word study in an online searchable Bible and see what God has to say.

4 | The Colors of Love

Choosing and Using Color in Bible Journaling

THE LOVE OF CHRIST

I thought I knew what the love of God felt like. That is, until a Saturday night in 1998 at a retreat; I remember it like it was yesterday. We'd had a lovely time of deep fellowship all weekend, and the final evening's worship service was to begin.

After dark, we were led in silence to the sanctuary door. It was dark inside, lit only by candles held by dozens of people—men and women I did not know. They sang quietly of Christ's love as we paused in front of each stranger and in every face I saw reflected back to me the eyes of Jesus Himself, full of His love and grace. These weren't people I knew, just showing me their own love for me; this was the family of God, bearing Jesus' message for me: "I love you. Yes, you."

Until that moment, I had only understood God's love for me as part of His grace for all mankind. I had not truly grasped how personally He cares for me. But decades later, I still recall the warmth of His presence that night. That recollection alone is enough to make me ask, "Who can I show that kind of love to today?"

What's Your Story?

- Have you understood God's personal affection for you?
- Do you have a moment that's seared into your memory?
- Can you capture even a small part of that experience in a Bible journal page?
- How does God's love motivate you?
- How can you share that love with others?

Galatians 2:19
Watercolor paints and watercolor pencil

A candle lights up the darkness—and orange lights up its complementary color: blue. (See complementary colors on page 59.) Watercolor pencil was used to trace hexagon stencils, then the color was spread with a baby wipe to give it a soft look.

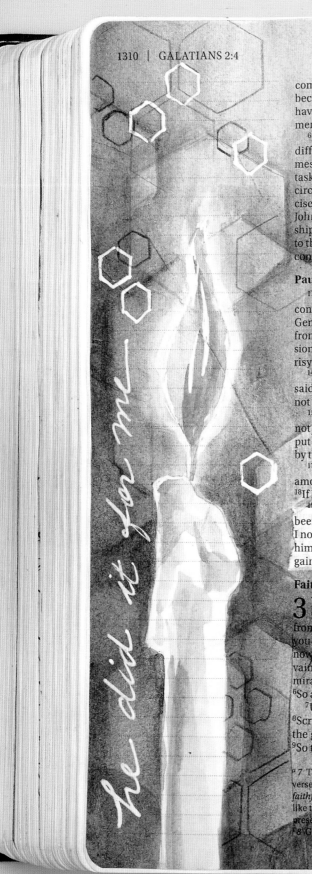

he did it for me

compelled to be circumcised, even though he was a Greek. [4]This matter arose because some false believers had infiltrated our ranks to spy on the freedom we have in Christ Jesus and to make us slaves. [5]We did not give in to them for a moment, so that the truth of the gospel might be preserved for you.

[6]As for those who were held in high esteem—whatever they were makes no difference to me; God does not show favoritism—they added nothing to my message. [7]On the contrary, they recognized that I had been entrusted with the task of preaching the gospel to the uncircumcised,[a] just as Peter had been to the circumcised.[b] [8]For God, who was at work in Peter as an apostle to the circumcised, was also at work in me as an apostle to the Gentiles. [9]James, Cephas[c] and John, those esteemed as pillars, gave me and Barnabas the right hand of fellowship when they recognized the grace given to me. They agreed that we should go to the Gentiles, and they to the circumcised. [10]All they asked was that we should continue to remember the poor, the very thing I had been eager to do all along.

Paul Opposes Cephas

[11]When Cephas came to Antioch, I opposed him to his face, because he stood condemned. [12]For before certain men came from James, he used to eat with the Gentiles. But when they arrived, he began to draw back and separate himself from the Gentiles because he was afraid of those who belonged to the circumcision group. [13]The other Jews joined him in his hypocrisy, so that by their hypocrisy even Barnabas was led astray.

[14]When I saw that they were not acting in line with the truth of the gospel, I said to Cephas in front of them all, "You are a Jew, yet you live like a Gentile and not like a Jew. How is it, then, that you force Gentiles to follow Jewish customs?

[15]"We who are Jews by birth and not sinful Gentiles [16]know that a person is not justified by the works of the law, but by faith in Jesus Christ. So we, too, have put our faith in Christ Jesus that we may be justified by faith in[d] Christ and not by the works of the law, because by the works of the law no one will be justified.

[17]"But if, in seeking to be justified in Christ, we Jews find ourselves also among the sinners, doesn't that mean that Christ promotes sin? Absolutely not! [18]If I rebuild what I destroyed, then I really would be a lawbreaker.

[19]"For through the law I died to the law so that I might live for God. [20]I have been crucified with Christ and I no longer live, but Christ lives in me. The life I now live in the body, I live by faith in the Son of God, who loved me and gave himself for me. [21]I do not set aside the grace of God, for if righteousness could be gained through the law, Christ died for nothing!"[e]

Faith or Works of the Law

3 You foolish Galatians! Who has bewitched you? Before your very eyes Jesus Christ was clearly portrayed as crucified. [2]I would like to learn just one thing from you: Did you receive the Spirit by the works of the law, or by believing what you heard? [3]Are you so foolish? After beginning by means of the Spirit, are you now trying to finish by means of the flesh?[f] [4]Have you experienced[g] so much in vain—if it really was in vain? [5]So again I ask, does God give you his Spirit and work miracles among you by the works of the law, or by your believing what you heard? [6]So also Abraham "believed God, and it was credited to him as righteousness."[h]

[7]Understand, then, that those who have faith are children of Abraham. [8]Scripture foresaw that God would justify the Gentiles by faith, and announced the gospel in advance to Abraham: "All nations will be blessed through you."[i] [9]So those who rely on faith are blessed along with Abraham, the man of faith.

[a] 7 That is, Gentiles [b] 7 That is, Jews; also in verses 8 and 9 [c] 9 That is, Peter; also in verses 11 and 14 [d] 16 Or *but through the faithfulness of . . . justified on the basis of the faithfulness of* [e] 21 Some interpreters end the quotation after verse 14. [f] 3 In contexts like this, the Greek word for *flesh* (*sarx*) refers to the sinful state of human beings, often presented as a power in opposition to the Spirit. [g] 4 Or *suffered* [h] 6 Gen. 15:6 [i] 8 Gen. 12:3; 18:18; 22:18

[10]"Cur[s] of the cause contr redec ten: " the b so tha

The I

[15]B one c it is in ture o mean 430 y and th then i ham t

[19] s sions en thr more t

[21]Is a law h have c trol of might

Child

[23]Be locked our gu this fai

[26]So who w neither you are seed, a

4 Wh a sl and tru we wer the set law, [5]to [6]Becau who ca since ye

Paul's

[8]For ture are

[a] 10 Deu 24:7 f basic prin full legal

Choosing *Colors* and *Combinations*

Any colors selected are, of course, perfectly okay. But colorways (groups of colors) can create an emotion or vibrancy in your art to enhance the message you're trying to convey.

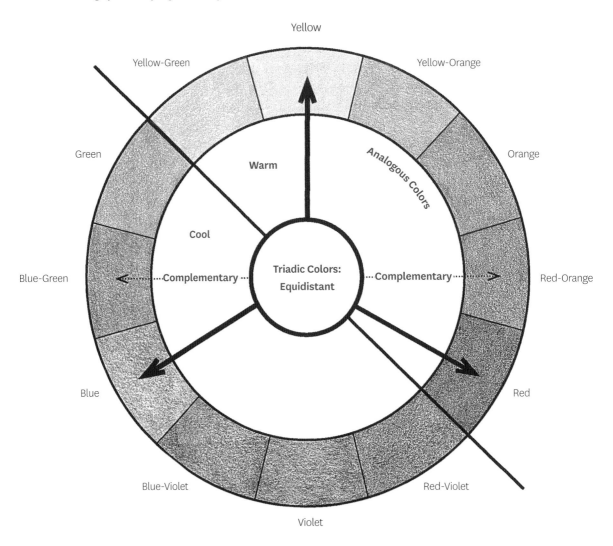

Colors convey meaning, both alone and in combination. Here are a few emotions or concepts that can be expressed by hues:

 Black: hidden, mystery, sin, affliction, death, mourning

 Blue: authority, healing, trust, peace, loyalty, integrity

 Brown: down-to-earth, security, protection, comfort

 Gold: glory, divinity, holiness, majesty, righteousness

 Green: praise, growth, restoration, resurrection

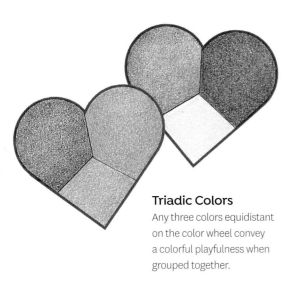

Triadic Colors

Any three colors equidistant on the color wheel convey a colorful playfulness when grouped together.

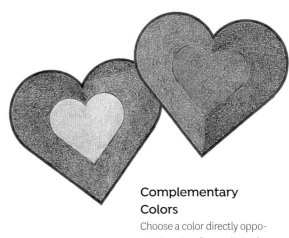

Complementary Colors

Choose a color directly opposite the other for a splash of vibrant color.

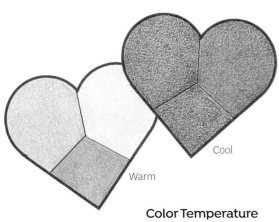

Cool

Warm

Color Temperature

Warm colors are more energetic and pop forward, while cool colors recede and create a relaxed appearance.

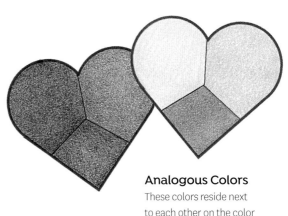

Analogous Colors

These colors reside next to each other on the color wheel and create a pleasing, coordinated feeling.

 Gray: compromise, nonemotional, detached

 Orange: passion, praise, optimism

 Pink: unconditional love, nurturing

 Purple: priesthood, royalty, mediator, imagination

 Red: love, atonement, salvation, passion, action

 Silver: scripture, truth, atonement, redemption

 Turquoise: sanctification, clarity of mind

 White: purity, innocence, wholeness, surrender, peace

 Yellow: faith, joy, cheerful, purification, optimistic

Vibrant Circles

MATERIALS LIST

colored pencils

iron

pen, black bleedproof

pencil, no. 2

round objects to trace

Simple shapes don't require elaborate drawing skills. Just trace the shapes and add color. Circles are all around you to trace in the form of drinking glasses, candles or rolls of washi tape. Choose light colors to use with a black pen for journaling or dark colors to use with a white pen.

Tips for Other Mediums

Watercolor and watercolor pencil require a brush to move the color within the shapes. As a result, some of the pigment can bleed beyond the edge of the shape. This can be a beautiful effect, as shown in th example of hearts on page 20.

Embrace Imperfection

Let pencil lines and textures show, and use your own handwriting. Things that are sometimes considered "imperfect" are actually desirable in Bible journaling. Remember, God made your handwriting too!

588 | PSALM 32:1

YOUR UNFAILING
love ♡
surrounds me !

Psalm 32

Of David. A maskil.[a]

1 Blessed is the one
 whose transgressions are forgiven,
 whose sins are covered.
2 Blessed is the one
 whose sin the LORD does not count against them
 and in whose spirit is no deceit.

3 When I kept silent,
 my bones wasted away
 through my groaning all day long.
4 For day and night
 your hand was heavy on me;
my strength was sapped
 as in the heat of summer.[b]

5 Then I acknowledged my sin to you
 and did not cover up my iniquity.
I said, "I will confess
 my transgressions to the LORD."
And you forgave
 the guilt of my sin.

6 Therefore let all the faithful pray to you
 while you may be found;
surely the rising of the mighty waters
 will not reach them.
7 You are my hiding place;
 you will protect me from trouble
 and surround me with songs of deliverance.

8 I will instruct you and teach you in the way you sho
 I will counsel you with my loving eye on you.
9 Do not be like the horse or the mule,
 which have no understanding
but must be controlled by bit and bridle
 or they will not come to you.
10 Many are the woes of the wicked,
 but the LORD's unfailing love
 surrounds the one who trusts in him.

11 Rejoice in the LORD and be glad, you righteous;
 sing, all you who are upright in heart!

Psalm 33

1 Sing joyfully to the LORD, you righteous;
 it is fitting for the upright to praise him.
2 Praise the LORD with the harp;
 make music to him on the ten-stringed lyre.
3 Sing to him a new song;
 play skillfully, and shout for joy.

4 For the word of the LORD is right and true;
 he is faithful in all he does.
5 The LORD loves righteousness and justice;
 the earth is full of his unfailing love.

[a] Title: Probably a literary or musical term [b] 4 The Hebrew
meaning) here and at the end of verses 5 and 7.

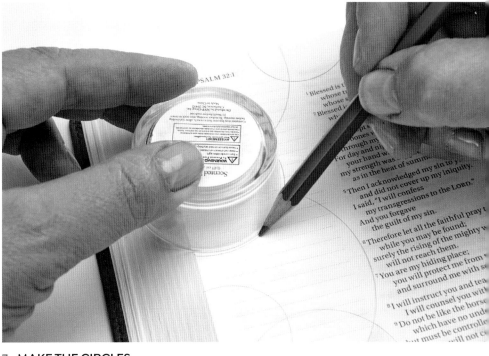

To work out colorways, try a miniature doodle on a scrap of paper to see what colors work best and in what order.

1 MAKE THE CIRCLES
Trace circles, overlapping them on your Bible page.

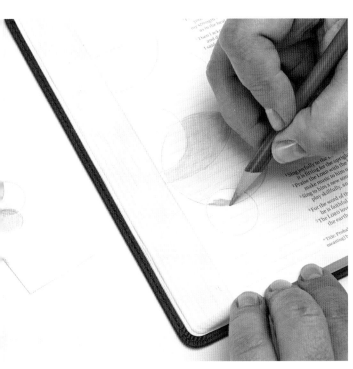

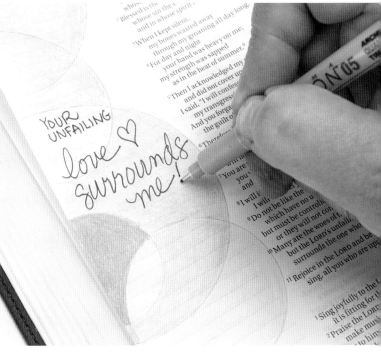

2 COLOR THE CIRCLES
Begin adding colors. Use a light touch when adding pencil to avoid a waxy buildup.

3 ADD FINISHING TOUCHES
Iron to flatten the page, if needed, then add text and journaling.

MATERIALS LIST

baby wipes

copier paper

pen, black bleedproof

pencil, no. 2

tracing paper

watercolor pencils

Many shapes can create beautiful art to surround a featured Scripture verse. Coloring inside the shapes is an obvious option, but try coloring *outside* the shapes, as well. See Shape Templates on page 66 for alternate shapes to trace.

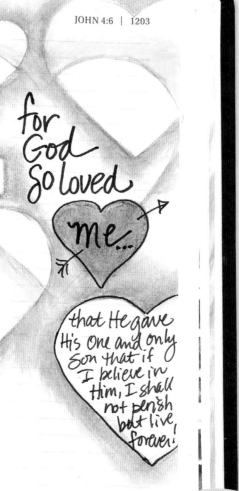

JOHN 4:6 | 1203

cannot tell where it comes from or where it is going. So it is with everyone born of the Spirit."[a]

[9]"How can this be?" Nicodemus asked.

[10]"You are Israel's teacher," said Jesus, "and do you not understand these things? [11]Very truly I tell you, we speak of what we know, and we testify to what we have seen, but still you people do not accept our testimony. [12]I have spoken to you of earthly things and you do not believe; how then will you believe if I speak of heavenly things? [13]No one has ever gone into heaven except the one who came from heaven—the Son of Man.[b] [14]Just as Moses lifted up the snake in the wilderness, so the Son of Man must be lifted up,[c] [15]that everyone who believes may have eternal life in him."[d]

[16]For God so loved the world that he gave his one and only Son, that whoever believes in him shall not perish but have eternal life. [17]For God did not send his Son into the world to condemn the world, but to save the world through him. [18]Whoever believes in him is not condemned, but whoever does not believe stands condemned already because they have not believed in the name of God's one and only Son. [19]This is the verdict: Light has come into the world, but people loved darkness instead of light because their deeds were evil. [20]Everyone who does evil hates the light, and will not come into the light for fear that their deeds will be exposed. [21]But whoever lives by the truth comes into the light, so that it may be seen plainly that what they have done has been done in the sight of God.

John Testifies Again About Jesus

[22]After this, Jesus and his disciples went out into the Judean countryside, where he spent some time with them, and baptized. [23]Now John also was baptizing at Aenon near Salim, because there was plenty of water, and people were coming and being baptized. [24](This was before John was put in prison.) [25]An argument developed between some of John's disciples and a certain Jew over the matter of ceremonial washing. [26]They came to John and said to him, "Rabbi, that man who was with you on the other side of the Jordan—the one you testified about—look, he is baptizing, and everyone is going to him."

[27]To this John replied, "A person can receive only what is given them from heaven. [28]You yourselves can testify that I said, 'I am not the Messiah but am sent ahead of him.' [29]The bride belongs to the bridegroom. The friend who attends the bridegroom waits and listens for him, and is full of joy when he hears the bridegroom's voice. That joy is mine, and it is now complete. [30]He must become greater; I must become less."[e]

[31]The one who comes from above is above all; the one who is from the earth belongs to the earth, and speaks as one from the earth. The one who comes from heaven is above all. [32]He testifies to what he has seen and heard, but no one accepts his testimony. [33]Whoever has accepted it has certified that God is truthful. [34]For the one whom God has sent speaks the words of God, for God[f] gives the Spirit without limit. [35]The Father loves the Son and has placed everything in his hands. [36]Whoever believes in the Son has eternal life, but whoever rejects the Son will not see life, for God's wrath remains on them.

Jesus Talks With a Samaritan Woman

4 Now Jesus learned that the Pharisees had heard that he was gaining and baptizing more disciples than John— [2]although in fact it was not Jesus who baptized, but his disciples. [3]So he left Judea and went back once more to Galilee. [4]Now he had to go through Samaria. [5]So he came to a town in Samaria called Sychar, near the plot of ground Jacob had given to his son Joseph. [6]Jacob's well

[a]8 The Greek for *Spirit* is the same as that for *wind*. [b]13 Some manuscripts *Man, who is in heaven* [c]14 The Greek for *lifted up* also means *exalted*. [d]15 Some interpreters end the quotation with verse 21. [e]30 Some interpreters end the quotation with verse 36. [f]34 Greek *he*

When choosing words to journal, consider personalizing them—"For God so loved *me*" brings the message more directly into my own heart.

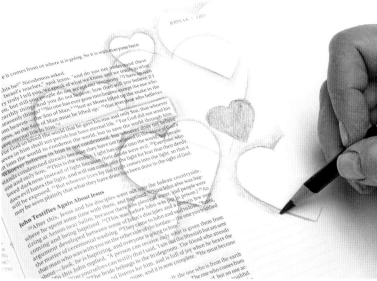

1 DRAW THE DESIGN

Sketch the shapes you like on tracing paper, creating an overlapping design. Place the finished design under the Bible page and trace. Mask off the verse, if desired, or be careful to color only outside the verse area.

2 ADD THE COLOR

Trace around the shapes with watercolor pencil, placing heavier color at the edge and allowing the color to lighten as you get further from the edge.

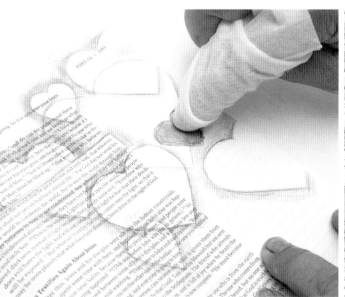

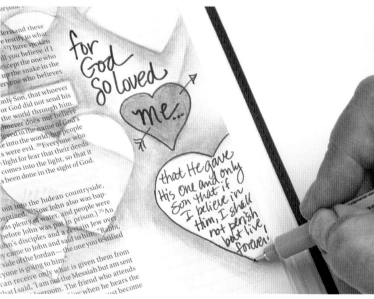

3 BLEND THE COLORS

Wrap a baby wipe around one finger. Dab, wipe and tap to soften color and edges.

4 ADD FINISHING TOUCHES

Iron to flatten the page, and use a black pen to add journaling.

Tips for Other Mediums

Create a soft look using graduated coloring with colored pencils. Start off with heavier pencil lines at the edge of an image and get progressively lighter as you move the color away from the edge.

Create a loose look with watercolor. Let color flow over the edges of the black pen lines. See page 20 for a lovely sample page with a differently shaped heart.

Watercolor Rainbow

Rainbows are beautiful, colorful signs of God's love and promise to His children. They're easy to draw and lend themselves to decorating many verses. Consider doing a study on hope, promises or joy to decorate with rainbows.

MATERIALS LIST

brush, no. 8 round

copier paper

iron

pen, black bleedproof

pencil

round template

template word, page 66

watercolor paints, rainbow colors

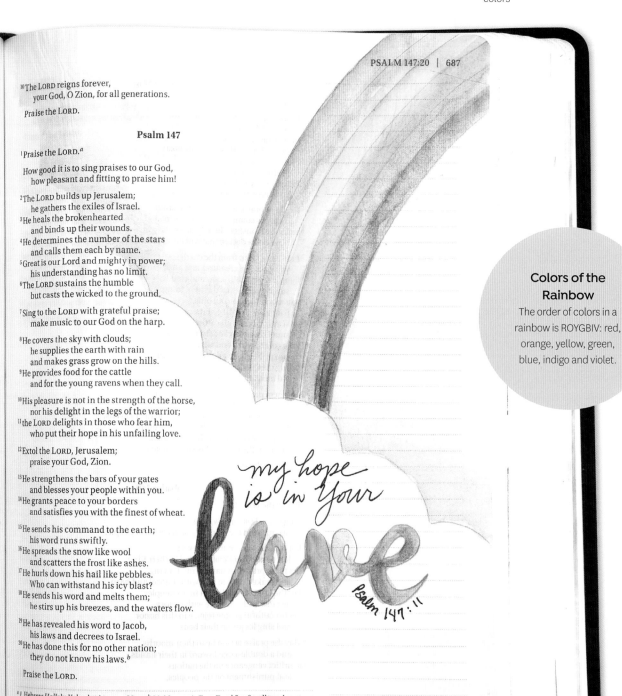

[10]The LORD reigns forever,
 your God, O Zion, for all generations.

Praise the LORD.

Psalm 147

[1]Praise the LORD.[a]

How good it is to sing praises to our God,
 how pleasant and fitting to praise him!

[2]The LORD builds up Jerusalem;
 he gathers the exiles of Israel.
[3]He heals the brokenhearted
 and binds up their wounds.
[4]He determines the number of the stars
 and calls them each by name.
[5]Great is our Lord and mighty in power;
 his understanding has no limit.
[6]The LORD sustains the humble
 but casts the wicked to the ground.

[7]Sing to the LORD with grateful praise;
 make music to our God on the harp.

[8]He covers the sky with clouds;
 he supplies the earth with rain
 and makes grass grow on the hills.
[9]He provides food for the cattle
 and for the young ravens when they call.

[10]His pleasure is not in the strength of the horse,
 nor his delight in the legs of the warrior;
[11]the LORD delights in those who fear him,
 who put their hope in his unfailing love.

[12]Extol the LORD, Jerusalem;
 praise your God, Zion.

[13]He strengthens the bars of your gates
 and blesses your people within you.
[14]He grants peace to your borders
 and satisfies you with the finest of wheat.

[15]He sends his command to the earth;
 his word runs swiftly.
[16]He spreads the snow like wool
 and scatters the frost like ashes.
[17]He hurls down his hail like pebbles.
 Who can withstand his icy blast?
[18]He sends his word and melts them;
 he stirs up his breezes, and the waters flow.

[19]He has revealed his word to Jacob,
 his laws and decrees to Israel.
[20]He has done this for no other nation;
 they do not know his laws.[b]

Praise the LORD.

[a]1 Hebrew *Hallelu Yah*; also in verse 20 [b]20 Masoretic Text; Dead Sea Scrolls and Septuagint *nation; / he has not made his laws known to them*

my hope is in Your love Psalm 147:11

Colors of the Rainbow

The order of colors in a rainbow is ROYGBIV: red, orange, yellow, green, blue, indigo and violet.

1 DRAW THE RAINBOW
Use a large plate or bowl as a rainbow template. Test the size of the arc on a piece of scrap or tracing paper.

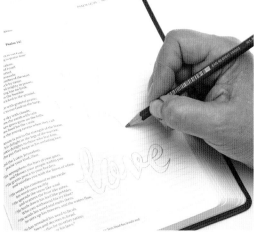

2 ADD CLOUDS
Draw simple scallops along the end of the rainbow. A few curves convey the shape of a cloud very well. At this time, add any open lettering that will be part of the painting to decorate. (See Shape Templates on page 66 for a template of the word *love* shown here.)

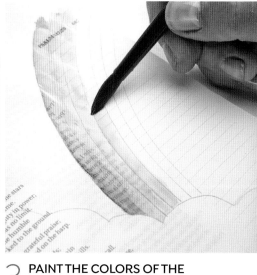

3 PAINT THE COLORS OF THE RAINBOW
Place copier paper under the Bible page. When painting the bands, allow the watercolors to remain wet so they blend together softly.

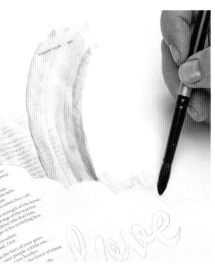

4 PAINT THE SKY
Paint the sky, not the clouds. Make a line of blue above the scallops, then use clean water to blend the color into the white of the page.

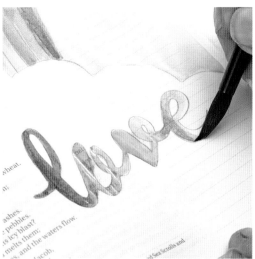

5 COLOR THE LETTERING
Paint the word *love* with wet color to make a rainbow gradation.

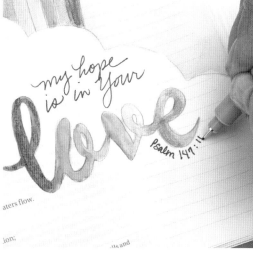

6 ADD FINISHING TOUCHES
Iron to flatten the page and add journaling with a black pen.

Tips for Other Mediums

The control of colored pencil may give comfort to those nervous about this soft-blended look. See the rainbow example on page 31 for an idea of how it would look in this medium.

Watercolor pencils may be easier than the loose application of watercolor. They will limit the blending of colors and allow the previous color to dry before applying the next.

Shape Templates

Photocopy and cut out the shapes to trace them, or use tracing paper to copy the shapes.

Suggestions for *Study*

Shapes and colors are, as seen in this chapter, flexible and can be used as general backgrounds. Below are just a few suggestions for your own studies, and a handful of results from a quick online search at the website biblegateway .com. Consider journaling some of these with your own adaptations of techniques taught in this book.

CIRCLES (SURROUND, ENCIRCLE)

2 Corinthians 10:13, Isaiah 40:22, Psalm 5:12, Psalm 32:7, Psalm 32:10, Psalm 89:7, Psalm 89:8, Psalm 125:2

HEARTS

Deuteronomy 4:29, Deuteronomy 10:12, 1 Samuel 12:24, 1 Kings 8:61, 1 Chronicles 16:10, Psalm 13:5, Psalm 26:2, Psalm 51:17, Proverbs 4:23, Jeremiah 29:13, Ezekiel 11:19, Matthew 5:8, Mark 12:30, Luke 2:19, John 14:27, 2 Corinthians 4:16

STARS

Genesis 26:4, Nehemiah 9:6, Psalm 33:6, Daniel 12:3, Revelation 1:20. Stars also can be used for patriotic verses like Psalm 33:12.

Consider stars for Bible journaling during a season of prayer for nation, armed services and leaders.

HEXAGONS (HONEY, SWEET, TASTE)

Psalm 19:10, Psalm 34:8, Psalm 119:103, Proverbs 16:24, Leviticus 20:24, 1 Peter 2:2–4 (See sample on page 56.)

RAINBOWS AND ARCS

Genesis 9:13–16, Ezekiel 1:28, Revelation 4:3, Revelation 10:1

Rainbows are excellent images to use for topics about promises, hope and love.

COLOR STUDIES

See Choosing Colors and Combinations on page 58, and use those word lists for studies as well. Focus on using chosen colors with the techniques taught in this chapter.

During this chapter, love was the Fruit of the Spirit in my studies. God's love for us, our love for Him and how He wants us to love others.

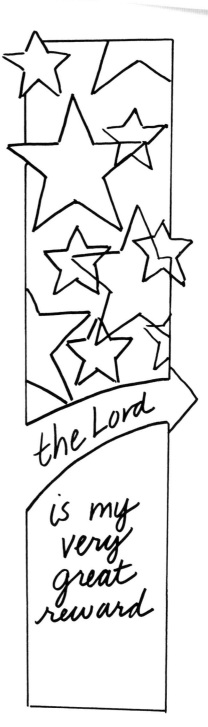

This starry sketch may be copied for use in your Bible. See the finished piece on page 5.

³The God of Israel spoke,
 the Rock of Israel said to me:
'When one rules over people in righteousness,
 when he rules in the fear of God,
⁴he is like the light of morning at sunrise
 on a cloudless morning,
like the brightness after rain
 that brings grass from the earth.'

⁵"If my house were not right with God,
 surely he would not have made with me an everlasting covenant,
 arranged and secured in every part;
surely he would not bring to fruition my salvation
 and grant me my every desire.
⁶But evil men are all to be cast aside like thorns,
 which are not gathered with the hand.
⁷Whoever touches thorns
 uses a tool of iron or the shaft of a spear;
 they are burned up where they lie."

David's Mighty Warriors

⁸These are the names of David's mighty warriors:

Josheb-Basshebeth,ᵃ a Tahkemonite,ᵇ was chief of the Three; he raised his spear against eight hundred men, whom he killedᶜ in one encounter. ⁹Next to him was Eleazar son of Dodai the Ahohite. As one of the three mighty warriors, he was with David when they taunted the Philistines gathered at Pas Dammimᵈ for battle. Then the Israelites retreated, ¹⁰but Eleazar stood his ground and struck down the Philistines till his hand grew tired and froze to the sword. The LORD brought about a great victory that day. The troops returned to Eleazar, but only to strip the dead.

¹¹Next to him was Shammah son of Agee the Hararite. When the Philistines banded together at a place where there was a field full of lentils, Israel's troops fled from them. ¹²But Shammah took his stand in the middle of the field. He defended it and struck the Philistines down, and the LORD brought about a great victory.

¹³During harvest time, three of the thirty chief warriors came down to David at the cave of Adullam, while a band of Philistines was encamped in the Valley of Rephaim. ¹⁴At that time David was in the stronghold, and the Philistine garrison was at Bethlehem. ¹⁵David longed for water and said, "Oh, that someone would get me a drink of water from the well near the gate of Bethlehem!" ¹⁶So the three mighty warriors broke through the Philistine lines, drew water from the well near the gate of Bethlehem and carried it back to David. But he refused to drink it; instead, he poured it out before the LORD. ¹⁷"Far be it from me, LORD, to do this!" he said. "Is it not the blood of men who went at the risk of their lives?" And David would not drink it.

Such were the exploits of the three mighty warriors.

¹⁸Abishai the brother of Joab son of Zeruiah was chief of the Three.ᵉ He raised his spear against three hundred men, whom he killed, and so he became as famous as the Three. ¹⁹Was he not held in greater honor than the Three? He became their commander, even though he was not included among them.

²⁰Benaiah son of Jehoiada, a valiant fighter from Kabzeel, performed great exploits. He struck down Moab's two mightiest warriors. He also went down into

ᵃ8 Hebrew; some Septuagint manuscripts suggest *Ish-Bosheth*, that is, *Esh-Baal* (see also 1 Chron. 11:11 *Jashobeam*). ᵇ8 Probably a variant of *Hakmonite* (see 1 Chron. 11:11) ᶜ8 Some Septuagint manuscripts (see also 1 Chron. 11:11); Hebrew and other Septuagint manuscripts *Three; it was Adino the Eznite who killed eight hundred men* ᵈ9 See 1 Chron. 11:13; Hebrew *gathered there.* ᵉ18 Most Hebrew manuscripts (see also 1 Chron. 11:20); two Hebrew manuscripts and Syriac *Thirty*

The Same Sunrise Jesus saw
Sea of Galilee July 2007

5 | *God of Heaven & Earth*

Drawing Land, Sky and Sea

PEACE ON THE GALILEE

I arose early, before the sun had even considered getting up, and took a walk. I sat on the shore of the lake, facing the soft glow that was forming to the east, and began to pray. "Jesus, tell me something I didn't know about You today."

In that cloudless sky, the first rays of the sun splashed over the hills on the opposite shore. I was surprised at just how fast the bright sun blazed its way into full view, its light dancing across the surface of the lake.

While I sat on the shore of the Galilee that day, Jesus instantly answered my prayer. "See that sunrise? It's still the same one."

I wanted to walk in the footsteps of Jesus—that's why I traveled to Israel. I wanted to be where He was, stand where He stood and know the place my Lord physically lived to deepen my faith. In modern-day Israel, it's a challenge to picture what Jesus really saw; ruins are all that's left of many sites, while others are covered with souvenir shops.

But in that small, quiet moment, I found myself doing just what Jesus had done: arising before the same dawn, walking along the same banks of Galilee, talking with my Father and gathering my own strength for the day—just as He did.

2 Samuel 23:4

Watercolor paints

There is no verse more appropriate to recall a morning on the seashore. "He is like the light of morning at sunrise on a cloudless morning."

What's Your Story?

- Where do you gather your strength for the day?
- Does nature arouse a worshipful attitude in your heart?
- What questions do you ask in your prayer time, and how does God answer?
- Capture the answer in your Bible for days when they seem far away.

Placing *Imagery*

In this chapter, which is all about creating heavens and earth, it's time to consider where on a page to create the art. Sometimes it's dictated entirely by the location of the verse on the page: left-side or right-side, top or bottom. Images and backgrounds can be very small, next to a specific verse, or the idea might be so big that it takes up two pages.

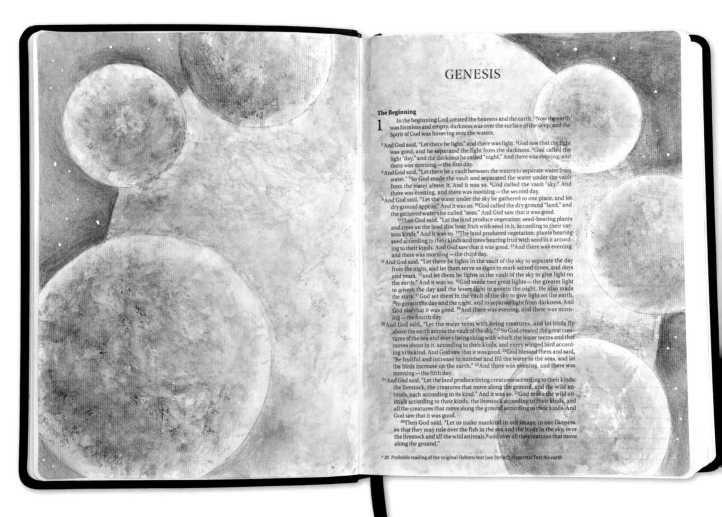

Genesis 1:4

Watercolor paints and watercolor pencil

This intergalactic scene needed two pages to truly convey just how big God made the universe. Create this spread using baby wipes to tap watercolor in the various circles. Then add small amount of watercolor pencil to sharpen a few areas. Use light colors to keep the text readable. See the step-by-step creation of this art on the website biblejournalingmadesimple.com.

✳ *Web content available*

Then all the people shall say, "Amen!"

d is anyone who has sexual relations with any animal."

Then all the people shall say, "Amen!"

d is anyone who sleeps with his sister, the daughter of his father
hter of his mother."

Then all the people shall say, "Amen!"

d is anyone who sleeps with his mother-in-law."

Then all the people shall say, "Amen!"

d is anyone who kills their neighbor secretly."

Then all the people shall say, "Amen!"

d is anyone who accepts a bribe to kill an innocent person."

Then all the people shall say, "Amen!"

d is anyone who does not uphold the words of this law by car-
out."

Then all the people shall say, "Amen!"

Obedience

fully obey the LORD your God and carefully follow all his com-
l give you today, the LORD your God will set you high above all the
rth. ²All these blessings will come on you and accompany you if
ORD your God:

l be blessed in the city and blessed in the country.

it of your womb will be blessed, and the crops of your land and
f your livestock—the calves of your herds and the lambs of your

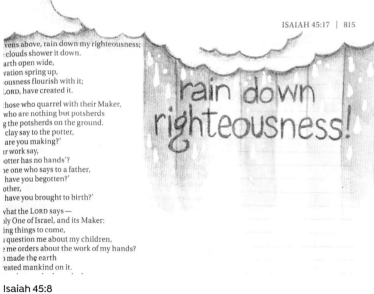

Deuteronomy 28:3
Watercolor pencil

Here, the Scripture referenced is located at the bottom of the page. Placing
the art on the bottom edge of the page directs the eye to the passage.

vens above, rain down my righteousness;
clouds shower it down.
arth open wide,
vation spring up,
ousness flourish with it;
LORD, have created it.

hose who quarrel with their Maker,
who are nothing but potsherds
g the potsherds on the ground.
clay say to the potter,
are you making?'
r work say,
otter has no hands'?
ne one who says to a father,
have you begotten?'
other,
have you brought to birth?'

vhat the LORD says—
ly One of Israel, and its Maker:
ing things to come,
question me about my children,
me orders about the work of my hands?
made the earth
eated mankind on it.

Isaiah 45:8
Colored pencil

Don't neglect the top edge of the page, especially for items that are up in
the air, such as clouds, the sun, the moon and kites.

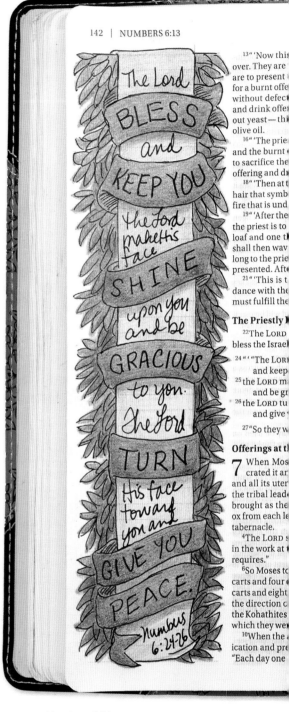

Numbers 6:26
Colored pencil

Art can also remain within the side border,
leaving all of the Scripture text easily visible.

DEMONSTRATION | *Sunrise, Sunset*

MATERIALS LIST

colored pencils

gel pen, white

pen, black bleedproof

pencil, no. 2

round object to trace

Many verses in the Bible can be illustrated with sunrises or sunsets. Choose any verse that mentions subjects like evening thanks, creation or the new mercies God gives us every day. Let's take a look at what makes a sun look like a rising sun versus a setting sun, and how to create a simple hilly scene with colored pencils.

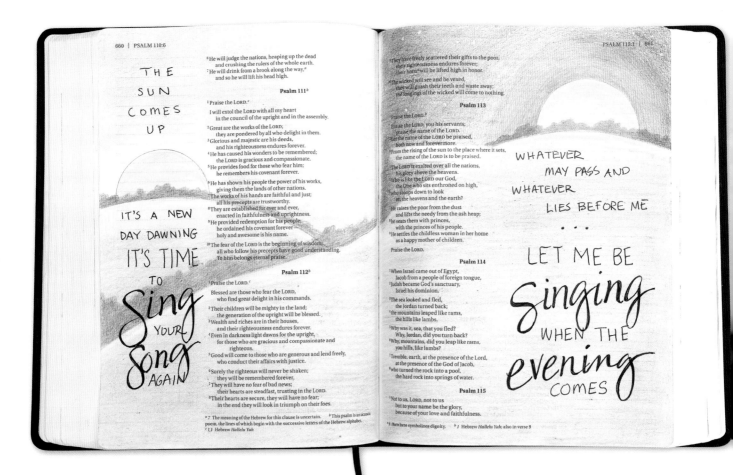

Tips for Other Mediums

A large background blends beautifully with both watercolor and watercolor pencil. Note that when drawing many hills, the hillsides closest to the foreground appear larger. The trees and houses in the foreground will also be bigger than those in the distance.

For additional finishing touches, draw simple triangle trees, rounded puffy trees, or houses or cities, as desired. See page 71 for an example of a city.

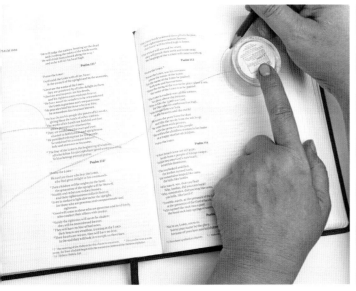

1 SKETCH THE SCENE

For this two-page spread, first sketch rounded hillsides with a circle for a sun on each page.

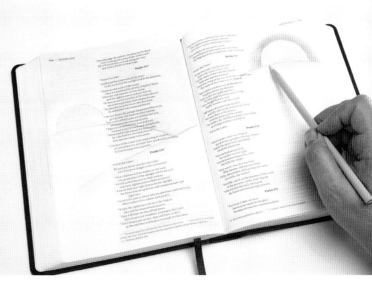

2 COLOR THE SUN AND SKY

Suns are yellow, but they change the sky around them depending on the time of day and weather. For dawn, create a light halo around the sun and a light blue sky. Dusk can be more dramatic with oranges, pinks and purples.

3 CONTINUE ADDING COLOR

The ground may also reflect the time of day. Use brighter greens for morning and deeper greens to show the sun dipping behind the hillside in the evening.

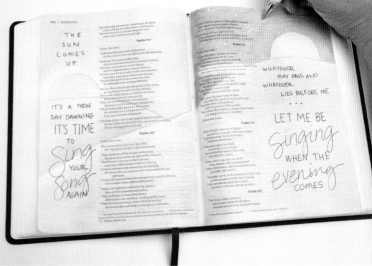

4 ADD FINISHING TOUCHES

Color the night sky dark blue and use a white gel pen to add stars to complete the evening sun. Add journaling, like the song lyric shown here, with a black pen.

| # Earth and Sky

MATERIALS LIST

baby wipes

copier paper

gel pen, white

watercolor pencils

Praise the Lord from one end of the earth to the other! God created an amazing planet for us to enjoy, and drawing one in your Bible will help capture the awe He deserves. Create a simple, loose globe, add a starry sky and journal away about your love for God.

Tips for Other Mediums

To create soft, fuzzy land masses (and avoid geography!), make the edges of the green and blue blend together softly. Or, search the internet for a globe showing an area to more closely replicate on the surface of the earth.

With watercolor, create the large earth shape and apply color. Create the sky using baby wipes.

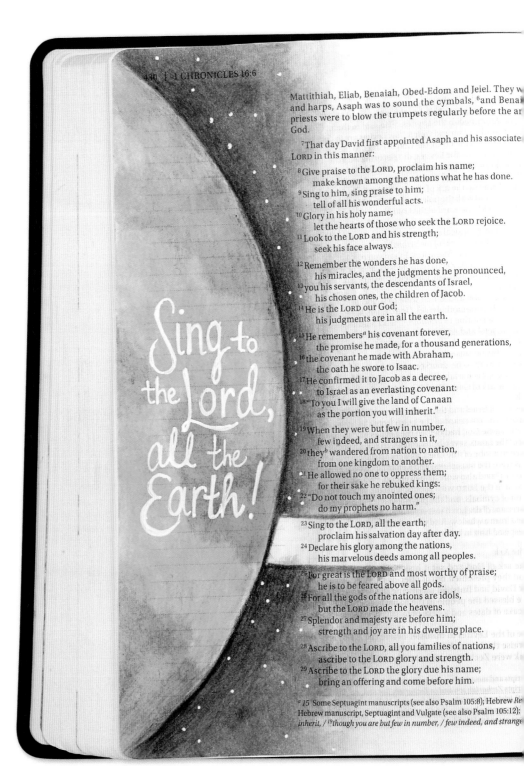

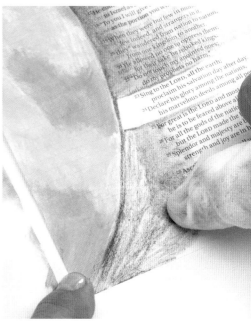

1 **CREATE THE PLANET**
Place copier paper under the Bible page. Draw an arc down the side of the page, and scribble the land, sea and dark sky colors with watercolor pencils. Don't worry about mapping accuracy.

2 **BLEND THE PLANET COLORS**
Use a baby wipe to blend pigments, first the green color then the blue. Let edges softly overlap.

3 **BLEND THE SKY**
Blend the sky with baby wipes, or be daring and try a full-page sky, as shown on page 5.

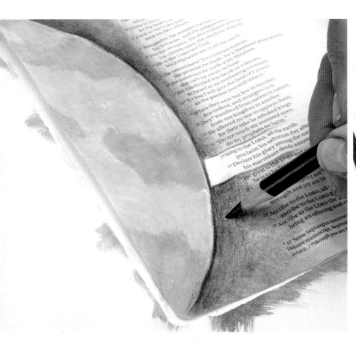

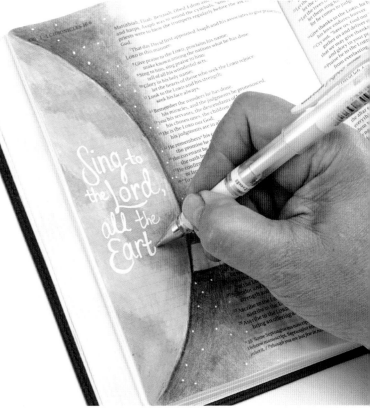

4 **CLEAN UP AND INTENSIFY**
Tidy up and intensify the edges around the globe with another layer of color.

5 **ADD FINISHING TOUCHES**
Add stars and journaling with a white gel pen.

DEMONSTRATION | *Rain Clouds*

MATERIALS LIST

baby wipes

brush

copier paper

iron

gel pen, white

palette

pen, black bleedproof

watercolor paints

Let the Holy Spirit rain down! A rainy rainbow cloud will serve as a reminder of the constant renewing of the heart provided by the Lord. Many verse selections on abundance, blessings and showers of love could be captured with an image like this.

1 CREATE THE CLOUD
Make a cloud mask, either by drawing your own or using the template below, and trace it onto the corner of the page.

2 ADD PAINT
Place copier paper under the Bible page. Hold the cutout cloud as a mask to prevent the paint from getting into the cloud area. Paint a rainbow of colors along the edge.

3 PULL THE PAINT
While the paint is wet, drag the color down the page at an angle with a baby wipe. Add more paint as needed by dipping the baby wipe into paints mixed on the palette. A light touch makes a streaky line; a wetter, heavier touch will fill the area more completely.

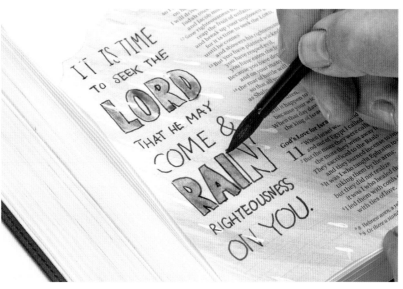

4 ADD RAIN DROPS
Iron to flatten the page, then add raindrops with a white gel pen. To create the drops, make a line that gets thicker and rounded on the lower end.

5 ADD FINISHING TOUCHES
Add journaling with a black pen. If desired, make some raindrops pass through (i.e., on top of) the journaling text.

Tips for Other Mediums

With watercolor pencils, draw thick stripes, but keep the first coat light. Use a baby wipe to blend. If richer color is desired, add more layers.

With colored pencil, try creating a small section of rainbow rain as seen in the example on page 71.

Trace this cloud and cut it out to create a mask for this project.

Minitutorial: Tips for Creating and Transferring Images

For some, it may feel daunting to try to create an image that requires a little bit of drawing. But have no fear, there are a few ways to copy an image into your Bible.

PLAN THEN TRACE

Start by sketching the design on tracing paper, include your journaling area so it isn't forgotten. Resketch it a few times as needed to move items around and work out the details.

On the final copy, go over the lines with a pen so it can be seen through the Bible paper; most is thin enough that the image can be seen through it. Sketch the main outlines in light pencil and proceed with coloring.

TRANSFER PAPER

At times, an image needs to be transferred after a background is painted, which may make it difficult to see through the page to trace. Use transfer paper (also called graphite paper) which has graphite (lead) on one side. When pressed with your pencil, the graphite will transfer the lines you make to the page.

You can make your own transfer paper by scribbling on the back side of your sketch page with a pencil. Scribble dark enough that the graphite transfers when tracing the image.

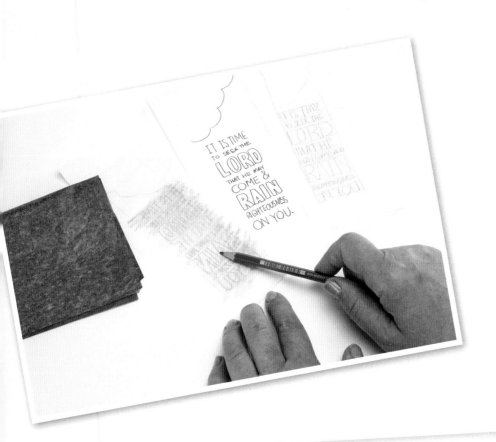

Suggestions for *Study*

The Scriptures are full of references to the natural world around us—heaven, earth, rain and sky. Below are just a few suggestions for your own studies. Choose one or more to try the techniques found in this chapter. Also, try changing up the mediums and styles you use.

Thematically, many verses about the glory of God and His majesty are appropriate to explore with scenes of heaven and earth.

SUNRISE, SUNSET (DAWN, MORNING, EVENING, DAYS)
Genesis 1:5, 1 Chronicles 23:30, Psalm 59:16, Psalm 65:8, Psalm 93:5, Psalm 119:147, Psalm 143:8, Lamentations 3:23, Isaiah 58:8, Isaiah 60:20, 2 Samuel 23:4, Habakkuk 3:4, Matthew 4:16, 2 Peter 1:19.

Also consider new beginnings and fresh starts.

EARTH
Genesis 1:1, Numbers 14:21, Deuteronomy 10:14, 1 Chronicles 16:23, Psalm 8:9, Psalm 57:5, Psalm 68:32, Psalm 98:3, Psalm 119:64, Isaiah 6:3, Isaiah 40:22, Habakkuk 2:14, Matthew 5:5, Matthew 28:18, Mark 13:31, Luke 2:14, Acts 13:47, Hebrews 1:10.

Also create the sky from the earth tutorial and seek out verses about the heavens and stars to journal: Exodus 20:11, Job 9:8, Psalm 8:3, Psalm 36:5, Psalm 89:11, Proverbs 3:19, Ecclesiastes 3:1, Isaiah 55:9, Jeremiah 10:12

RAIN (SHOWERS)
Genesis 7:12, Leviticus 26:4, Job 36:28, Psalm 72:6, Psalm 68:9, Psalm 147:8, Ecclesiastes 11:3, Isaiah 30:23, Isaiah 45:8, Zechariah 10:1, Acts 2:17, Romans 5:5. Hebrews 6:7

As I wrote this chapter, peace was the Fruit of the Spirit I was studying. Consider a word study of your own. The natural world can bring peace, in our journaling and in our hearts.

This sketch can be copied to replicate the finished piece on page 76.

IT IS TIME TO SEEK THE LORD THAT HE MAY COME & RAIN RIGHTEOUSNESS ON YOU.

Closing Appeal for Steadfastness and Unity

4 Therefore, my brothers and sisters, you whom I love and long for, my joy and crown, stand firm in the Lord in this way, dear friends! ²I plead with Euodia and I plead with Syntyche to be of the same mind in the Lord. ³Yes, and I ask you, my true companion, help these women since they have contended at my side in the cause of the gospel, along with Clement and the rest of my co-workers, whose names are in the book of life.

Final Exhortations

⁴Rejoice in the Lord always. I will say it again: Rejoice! ⁵Let your gentleness be evident to all. The Lord is near. ⁶Do not be anxious about anything, but in every situation, by prayer and petition, with thanksgiving, present your requests to God. ⁷And the peace of God, which transcends all understanding, will guard your hearts and your minds in Christ Jesus.

⁸Finally, brothers and sisters, whatever is true, whatever is noble, whatever is right, whatever is pure, whatever is lovely, whatever is admirable—if anything is excellent or praiseworthy—think about such things. ⁹Whatever you have learned or received or heard from me, or seen in me—put it into practice. And the God of peace will be with you.

Thanks for Their Gifts

¹⁰I rejoiced greatly in the Lord that at last you renewed your concern for me. Indeed, you were concerned, but you had no opportunity to show it. ¹¹I am not saying this because I am in need, for I have learned to be content whatever the circumstances. ¹²I know what it is to be in need, and I know what it is to have plenty. I have learned the secret of being content in any and every situation, whether well fed or hungry, whether living in plenty or in want. ¹³I can do all this through him who gives me strength.

¹⁴Yet it was good of you to share in my troubles. ¹⁵Moreover, as you Philippians know, in the early days of your acquaintance with the gospel, when I set out from Macedonia, not one church shared with me in the matter of giving and receiving, except you only; ¹⁶for even when I was in Thessalonica, you sent me aid more than once when I was in need. ¹⁷Not that I desire your gifts; what I desire is that more be credited to your account. ¹⁸I have received full payment and have more than enough. I am amply supplied, now that I have received from Epaphroditus the gifts you sent. They are a fragrant offering, an acceptable sacrifice, pleasing to God. ¹⁹And my God will meet all your needs according to the riches of his glory in Christ Jesus.

²⁰To our God and Father be glory for ever and ever. Amen.

Final Greetings

²¹Greet all God's people in Christ Jesus. The brothers and sisters who are with me send greetings. ²²All God's people here send you greetings, especially those who belong to Caesar's household.

²³The grace of the Lord Jesus Christ be with your spirit. Amen.ᵃ

ᵃ 23 Some manuscripts do not have *Amen*.

joy joy joy joy DOWN IN MY ♡

6 | *Growing in Christ*

Simple Trees, Flowers and Plants

JOY DOWN IN MY HEART

Joy can be the most powerful witness of Christ's presence. But it's easy (and human) to get lost in whatever happenstance in which I find myself. I get grumbly, bemoan that my joy was stolen and beg God to remove me from the hard places.

Joy is independent of what's going on around me. As a Fruit of the Spirit, it stems from my experience of God, my trust in Him to walk through fire with me and the promises I know to be 100 percent true. How do I find joy when in my dark days?

I sing. Music transports me away from wherever I am, and it lets me speak truth to my circumstance. If my bucket is especially low on joy, I sing the children's song "Joy, joy, joy, joy, down in my heart!" That little chorus wakes up my inner child, and I make up new verses.

"I've got the strength to make the presentation down in my heart. Where!?"

"I've got the answer to my frust-er-ation down in my heart. Where!?"

"And if the dentist doesn't like it, he can. . . ."

I bet you're smiling right now.

Joy is available at the drop of a hat—or the hum of a chorus!

Philippians 4:4
Colored pencil

A favorite song is a wonderful theme for a Bible journal page. Music resonates in the mind, and the truth in the lyrics will keep faith alive and growing.

✱ *Web content available*

What's Your Story?

- What brings you joy that's deeper than happiness?
- Where do you find joy in your darkest times?
- Who is the most joyful person you know—have you asked them how they live in joy?
- Journal about these things, and turn your Bible into a reservoir of joy.

Choosing Words *Creatively*

A simple image or background to highlight a verse is perfectly fine for Bible journaling. Text isn't necessary, but it usually helps to jog the memory about what God spoke. Try some of the options here to add impact to your pages.

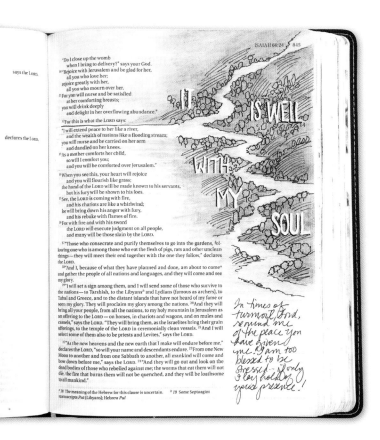

Isaiah 66:12
Watercolor pencil

Sing a Song

Lyrics from hymns or contemporary songs may have phrases that pack a punch. Research the story behind the writing of a favorite song and journal that verse.

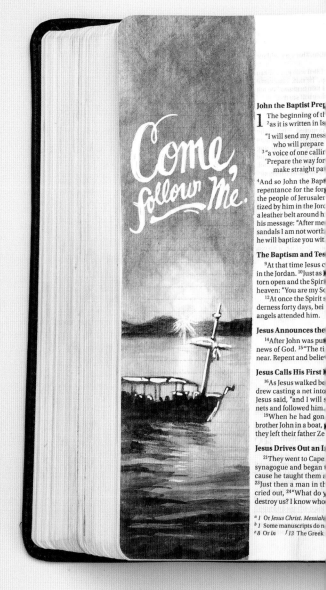

Mark 1:17
Watercolor pencil

Simplify, Simplify, Simplify

Fewer words often carry more power. Choose a few words from the focal verse and edit, edit, edit. Instead of "Come, follow me, and I will make you fishers of men," try "Come!" or "Come, follow me."

Handwriting vs. Hand Lettering

Admiring the work of fancy hand letterers should never result in dismissing our own God-given, Spirit-breathed hand. Over time, a style may emerge that suits you best. In the meantime, try different scripts and printing styles on tracing paper to see what will work best on the page.

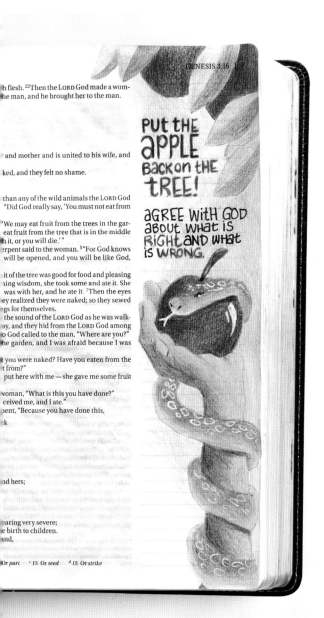

Genesis 3:13
Watercolor pencil

Capture a Sermon

A pastor's powerful preaching may contain a phrase, a new thought or a word from God straight to your heart. Turn sermon notes into art that you'll remember and put into action.

✽ *Web content available*

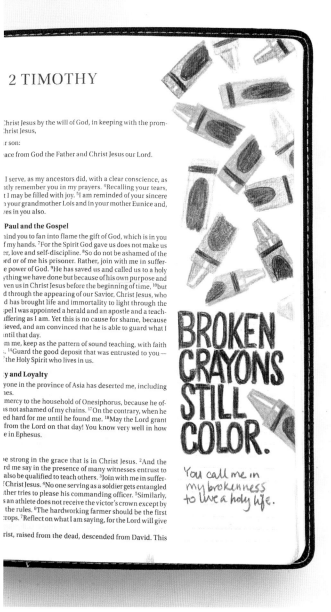

2 Timothy 1:9
Colored pencil

Non-Scripture Text

Words of a song, a poem or even a phrase seen on social media can capture the essence of a verse, drawing your attention back to reread the focal verse again and again.

✽ *Web content available*

Simple *Trees*

Throughout this chapter we'll explore some drawings that can be embellished or kept simplified while communicating the joy of growing in Christ. The trees of the field will clap their hands—as will a person delighted with how easy it is to draw a tree! In art, the suggestion of an object can be enough, and the tree shapes shown here are simple.

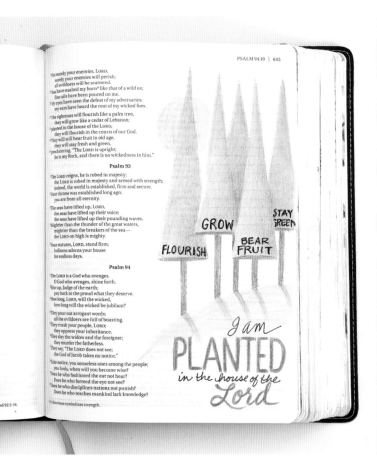

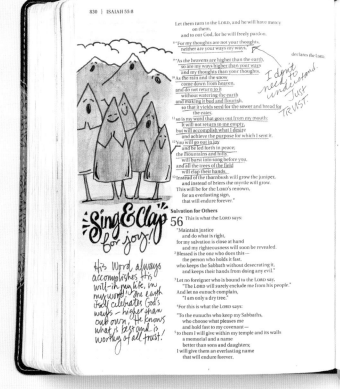

Psalm 92:12–13
Colored pencil

A forest of colored-pencil triangle trees wear skirts with penned words from the focal verse. A sun, a hint of a hillside and simple shadows from the trunks add extra detail.

✱ *Web content available*

Isaiah 55:12
Watercolor paints

For a playful forest, draw the trees with rounded bellies. Add faces and stick arms—they'll clap for joy in God's presence and remind you to keep smiling.

Colored pencil pine trees are easily drawn with triangle shapes, either with or without tree trunks.

Trees can be outlined and painted in watercolor in a variety of green shades.

Create a popsicle forest with watercolor pencil circles.

Draw tree trunks with a pen onto simple blobs of paint.

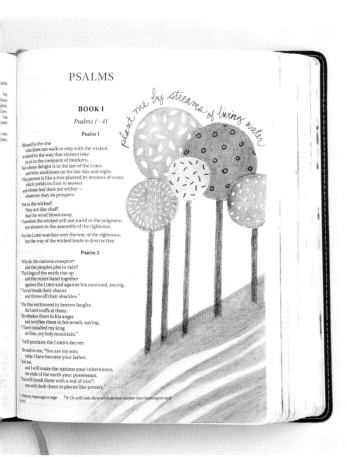

Psalm 1:3
Watercolor pencil

Bright circles with doodled patterns in black-and-white pen turn popsicle trees into a cheerful scene. Add pen details only when the paper is dry to prevent bleeding.

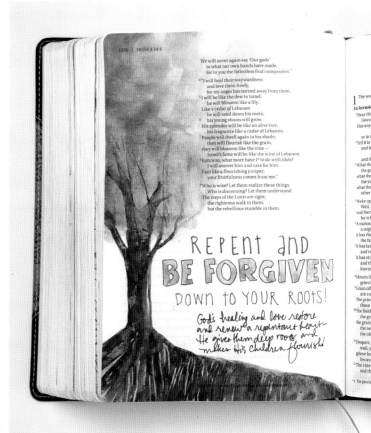

Hosea 14:6
Watercolor paints

A cloudy watercolor treetop drawn with deep roots marks the depth of forgiveness available when we repent. It's a perfect reminder for the heart.

The Simplest of *Flowers*

Florals are a favorite visual for many Bible journalers, whether it's because they're easy and pretty or because they convey happiness and joy. Flowers come in a variety of shapes, so try grouping different types together or drawing a cluster of one type to add life to a page.

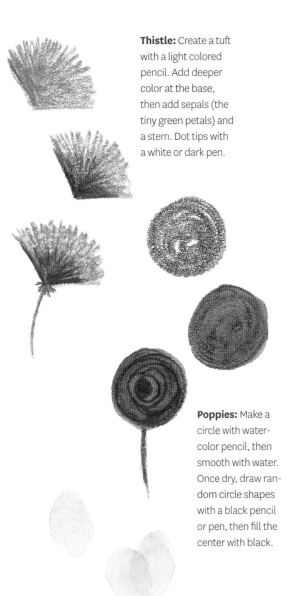

Thistle: Create a tuft with a light colored pencil. Add deeper color at the base, then add sepals (the tiny green petals) and a stem. Dot tips with a white or dark pen.

Poppies: Make a circle with water-color pencil, then smooth with water. Once dry, draw random circle shapes with a black pencil or pen, then fill the center with black.

Tulips: Watercolor a single petal shape, and let it dry completely. Add an overlapping petal on both the left and right, then add a stem once it's dry.

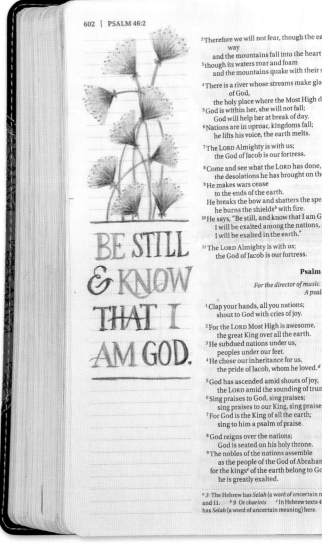

Psalm 46:10
Colored pencil

Grow a thistle garden with flowers facing different directions and long elegant stems tracing down to a baseline above the sentiment. Make dots on these flowers in a dark blue pencil to add extra detail. Reflect the same colors used in the image in the text as well.

✱ *Web content available*

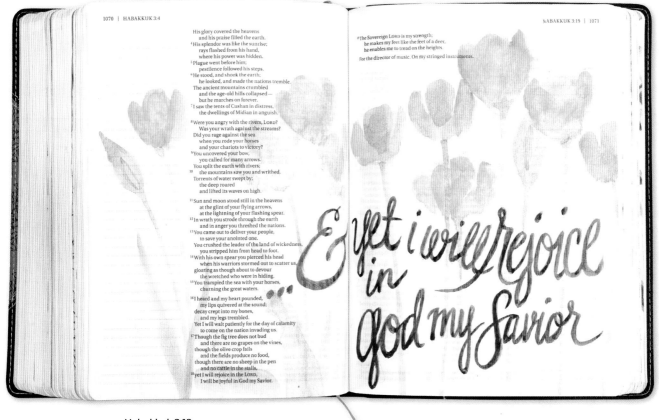

Luke 12:27
Watercolor pencil

Fill a garden with watercolor pencil poppies. Make soft edges that blend into a background of blues and greens using a baby wipe. Once everything is dry, add sketchy lines with a black watercolor pencil. Add text with a white gel pen.

Habakkuk 3:18
Watercolor

Take advantage of the extra space on the last page of a chapter with a splashy garden of tulips. Paint the flowers in light colors (using more water than pigment), and add text on top with a richer color by writing with watercolor pencil and going over it with a wet brush.

Seeds, Roots and *Shoots*

Marking moments of growth is probably one of the best reasons for Bible journaling. Every seed of new life deserves celebration! Seeds and their resulting shoots are incredibly simple to doodle in any medium.

Seeds can be tiny and round, long and thin, or oval and fat.

Roots are drawn as spidery lines below the surface of the dirt. The spiritual meanings of being rooted in Christ run deep.

Seedlings and shoots can have a few leaves or many, in a wide variety of shapes.

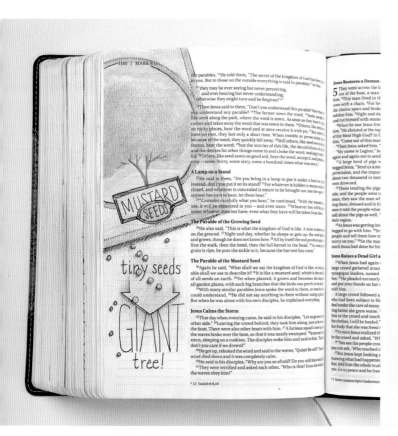

Mark 4:30
Colored pencil

Mustard seeds are teensy and round, and they can pour across a simple Bible page. Sketch the words on the page in pencil first, then spill the seeds across the page. Those feeling adventurous can add a seed packet.

Jeremiah 17:8
Watercolor pencil

Secure roots anchor our souls; fear dissipates in the face of trust. In this example, draw a large light area of roots. On top of that, add more layers in darker colors, leaving space for the text.

Luke 8:15

Watercolor paints

Sketch a triangular pile of dirt, and paint a sky above it (in this example, color was dabbed with a baby wipe). Draw or paint the seedling on top of the light blue background. Once everything is dry, outline the seedling with a pen, sketch in the roots and add text.

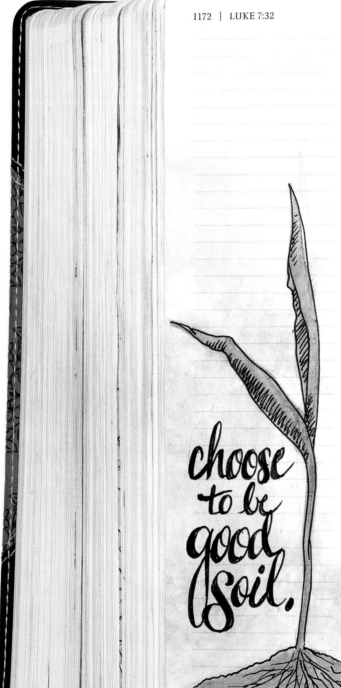

1172 | LUKE 7:32

generation? What are they like? [32]They are like ch
place and calling out to each other:

> "'We played the pipe for you,
> and you did not dance;
> we sang a dirge,
> and you did not cry.'

[33]For John the Baptist came neither eating bread
say, 'He has a demon.' [34]The Son of Man came eati
'Here is a glutton and a drunkard, a friend of tax
wisdom is proved right by all her children."

Jesus Anointed by a Sinful Woman

[36]When one of the Pharisees invited Jesus to ha
to the Pharisee's house and reclined at the table.
lived a sinful life learned that Jesus was eating at
came there with an alabaster jar of perfume. [38]As
feet weeping, she began to wet his feet with her tea
her hair, kissed them and poured perfume on them
[39]When the Pharisee who had invited him saw t
man were a prophet, he would know who is touchin
an she is — that she is a sinner."

[40]Jesus answered him, "Simon, I have somethin
"Tell me, teacher," he said.

[41]"Two people owed money to a certain moneyle
dred denarii," and the other fifty. [42]Neither of the
back, so he forgave the debts of both. Now which o

[43]Simon replied, "I suppose the one who had the
"You have judged correctly," Jesus said.

[44]Then he turned toward the woman and said
woman? I came into your house. You did not give
she wet my feet with her tears and wiped them wi
me a kiss, but this woman, from the time I entered
feet. [46]You did not put oil on my head, but she has
[47]Therefore, I tell you, her many sins have been fo
shown. But whoever has been forgiven little loves
[48]Then Jesus said to her, "Your sins are forgiven.
[49]The other guests began to say among themse
forgives sins?"
[50]Jesus said to the woman, "Your faith has saved

The Parable of the Sower

8 After this, Jesus traveled about from one town
claiming the good news of the kingdom of Goc
[2]and also some women who had been cured of ev
(called Magdalene) from whom seven demons ha
of Chuza, the manager of Herod's household; Susa
women were helping to support them out of their o
[4]While a large crowd was gathering and people
town after town, he told this parable: [5]"A farmer
he was scattering the seed, some fell along the pa
the birds ate it up. [6]Some fell on rocky ground, and
withered because they had no moisture. [7]Other se
grew up with it and choked the plants. [8]Still other s
up and yielded a crop, a hundred times more than

[41] A denarius was the usual daily wage of a day laborer (se

Minitutorial: Simple Shading for Grapes

Bible journaling doesn't require realistic rendering of objects, but a simple study of light and shadow may be helpful in some drawings.

Choose a direction for the light; perhaps, always choose the same light source so it becomes natural for you. The highlights on an object are always on the side facing the light source, while the shadows are on the side furthest away.

On rounded objects, color the main color first, then add a C shape for the dark shadow. Blend it with a middle tone.

Grapes, while oblong, still have a C-shaped shadow—it just stretches along the shape. Turning the grape in a different direction moves the C shape to the side furthest from the light.

Leaves and flower petals can be thought of in similar ways. Darker shadows appear away from the light source, and lighter color appears facing the light source.

JOHN 15:25 | 1221

...ve spoken to you. [4]Remain in me, as I also remain in you. No... fruit by itself; it must remain in the vine. Neither can you bear ...remain in me.

...e; you are the branches. If you remain in me and I in you, you ...fruit; apart from me you can do nothing. [6]If you do not remain ...ke a branch that is thrown away and withers; such branches are ...wn into the fire and burned. [7]If you remain in me and my words ...ask whatever you wish, and it will be done for you. [8]This is to my ...hat you bear much fruit, showing yourselves to be my disciples. ...er has loved me, so have I loved you. Now remain in my love. ...y commands, you will remain in my love, just as I have kept my ...ands and remain in his love. [11]I have told you this so that my joy ...and that your joy may be complete. [12]My command is this: Love ...have loved you. [13]Greater love has no one than this: to lay down ...e's friends. [14]You are my friends if you do what I command. [15]I no ...servants, because a servant does not know his master's business. ...called you friends, for everything that I learned from my Father I ...own to you. [16]You did not choose me, but I chose you and appoint-...t you might go and bear fruit—fruit that will last—and so that ...ask in my name the Father will give you. [17]This is my command: ...er.

...ates the Disciples

...orld hates you, keep in mind that it hated me first. [19]If you belonged ...t would love you as its own. As it is, you do not belong to the world, ...osen you out of the world. That is why the world hates you. [20]Re-...t I told you: 'A servant is not greater than his master.'[a] If they per-...they will persecute you also. If they obeyed my teaching, they will ...lso. [21]They will treat you this way because of my name, for they do ...e one who sent me. [22]If I had not come and spoken to them, they ...e guilty of sin; but now they have no excuse for their sin. [23]Whoever ...es my Father as well. [24]If I had not done among them the works no ...they would not be guilty of sin. As it is, they have seen, and yet they ...oth me and my Father. [25]But this is to fulfill what is written in their ...ated me without reason.'[b]

...of the Holy Spirit

...the Advocate comes, whom I will send to you from the Father—the ...th who goes out from the Father—he will testify about me. [27]And you ...stify, for you have been with me from the beginning.

Remain in Me and bear much fruit!

John 15:5

Watercolor pencil

A few oval grapes quickly become a bunch—a reminder to bear much fruit. Add a little highlight to the grapes in the front with a white gel pen to make them look shiny.

✱ *Web content available*

Suggestions for *Study*

The elements in this chapter can work together to create scenes in your Bible journaling. Think out of the box and consider combining techniques as you get more comfortable. Below are a few suggestions for your own study.

TREES (CEDAR, OLIVE, FOREST)

Genesis 1:11, 1 Chronicles 16:33, Ecclesiastes 2:5, Psalm 1:3, Psalm 52:8, Psalm 50:9–10, Psalm 80:10, Psalm 92:12, Psalm 96:12, Proverbs 3:18, Proverbs 13:12, Isaiah 44:23, Jeremiah 17:8, Ezekiel 31:8, Matthew 7:18

Any outdoor scene can also be enhanced with trees.

FLOWERS (GARDEN, BLOSSOM)

Song of Songs 2:12, Isaiah 40:8, Isaiah 27:6, Isaiah 58:11, Matthew 6:28, Luke 12:27

While there are very few verses mentioning flowers specifically, they can be used for many other subjects: joy, peace, love, happiness and many more.

SEEDS, SHOOTS, ROOTS

Genesis 1:11, Isaiah 61:11, Psalm 80:11, Psalm 128:3, Ezekiel 17:5, Ezekiel 31:7, Hosea 14:6 , Matthew 13:32, Mark 4:31, Mark 4:27, Luke 8:8, John 12:24, Romans 11:16, Romans 15:12, Ephesians 3:17, Colossians 2:7, 1 Corinthians 3:6, 1 Corinthians 15:37

Bible journaling spiritual growth need not always be connected with verses mentioning plants. Also consider Scriptures about God's instruction, discipline, encouragement or calling.

Joy was part of my Fruit of the Spirit study for this chapter, and it's a wonderful concept to bring into your Bible journaling. There are so many lovely verses to lift our spirits!

This sketch can be copied to use in your Bible. See the finished piece on page 84.

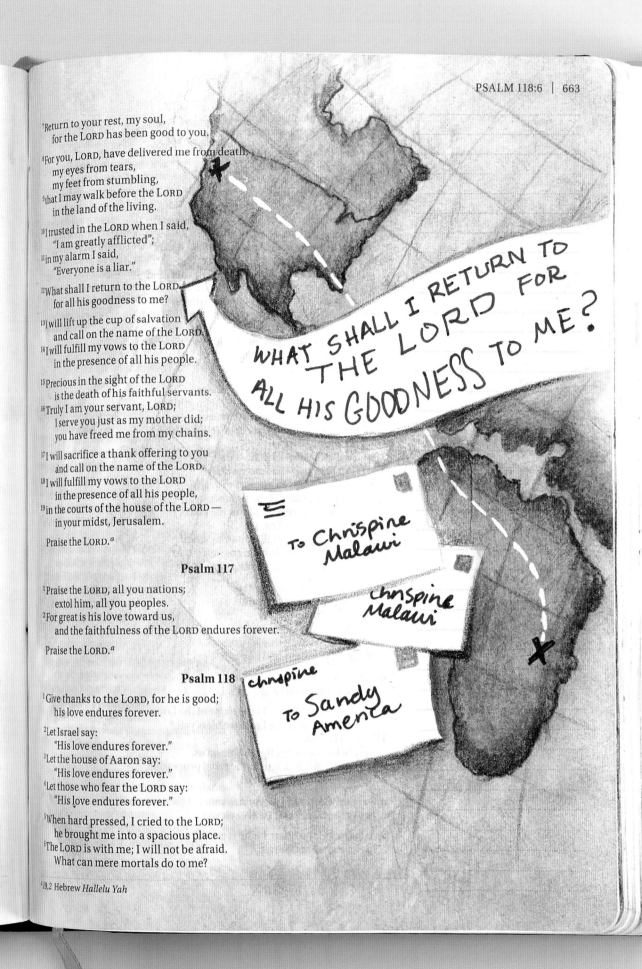

7Return to your rest, my soul,
 for the LORD has been good to you.

8For you, LORD, have delivered me from death,
 my eyes from tears,
 my feet from stumbling,
9that I may walk before the LORD
 in the land of the living.

10I trusted in the LORD when I said,
 "I am greatly afflicted";
11in my alarm I said,
 "Everyone is a liar."

12What shall I return to the LORD
 for all his goodness to me?

13I will lift up the cup of salvation
 and call on the name of the LORD.
14I will fulfill my vows to the LORD
 in the presence of all his people.

15Precious in the sight of the LORD
 is the death of his faithful servants.
16Truly I am your servant, LORD;
 I serve you just as my mother did;
 you have freed me from my chains.

17I will sacrifice a thank offering to you
 and call on the name of the LORD.
18I will fulfill my vows to the LORD
 in the presence of all his people,
19in the courts of the house of the LORD—
 in your midst, Jerusalem.

Praise the LORD.*a*

Psalm 117

1Praise the LORD, all you nations;
 extol him, all you peoples.
2For great is his love toward us,
 and the faithfulness of the LORD endures forever.

Praise the LORD.*a*

Psalm 118

1Give thanks to the LORD, for he is good;
 his love endures forever.

2Let Israel say:
 "His love endures forever."
3Let the house of Aaron say:
 "His love endures forever."
4Let those who fear the LORD say:
 "His love endures forever."

5When hard pressed, I cried to the LORD;
 he brought me into a spacious place.
6The LORD is with me; I will not be afraid.
 What can mere mortals do to me?

a 19,2 Hebrew *Hallelu Yah*

7 | Walking with God
Mountains, Maps and Trails

GOODNESS AND GENEROSITY

An envelope from Malawi in my mailbox made my day.

I broke the seal right away. It was a little thicker than usual because it contained a whole stack of photos of my sponsored child, Chrispine, in his new school uniform and shoes. He had his new backpack, box of pencils and three new notebooks. Best of all, Chrispine stood grinning beside his goat. His letter was full of gratitude for the Christmas gift that had provided the extra blessings.

Joyous emotions washed over me. Not about what I had done, but about what I knew was now possible for Chrispine on the other side of the world. I smiled thinking how tall this boy would stand in his new uniform. He'd write so carefully in that new notebook, not wasting one page. I could hear his caregiver uncle sigh with relief now that his burden was eased.

I suddenly wondered if what I was experiencing is what God feels every time he meets one of my needs with His goodness. When he stretches my bank account, does He giggle with delight? When he makes my jaw drop at the majesty of nature, does He feel warm and fuzzy? When He showers grace and mercy upon me, does He tear up a little, knowing what is ahead for me?

I'm certain God delights in taking our breath away with His generosity, and He wants us to do the same for others as we walk in His footsteps.

Psalm 116:12

Watercolor pencil

God has been so good, and it's a joy to document all the ways. A vintage-colored map helped mark the location of a sponsored child's home as a constant reminder to keep him in prayer.

✱ *Web content available*

What's Your Story?

- What gifts has God given you recently?
- How has He protected you and provided for you at major moments in your life?
- How does being generous make you feel?
- Are there people God loves who you can bless with your time, talent or treasure?
- What steps will you take toward serving them?

A Secret About *Outlining Images*

Many beginning artists joke that they flunked coloring in kindergarten. This is more likely an excuse because they've ceased trying. Fortunately for you, this book is in your hands, and you know the truth: God made you with an ability to grow and learn.

A little secret that helps with coloring in images and staying within the lines: Add the lines after the coloring! This allows you to refine the shapes—to make them a little larger or move them a little to the left—and add the final hard lines it at the end.

Deuteronomy 6:18
Watercolor paints

These mountains and trees were painted loosely, along with the sky. A few pen strokes add a tiny bit of detail to the mountains in the column but not under the Scriptures.

✳ *Web content available*

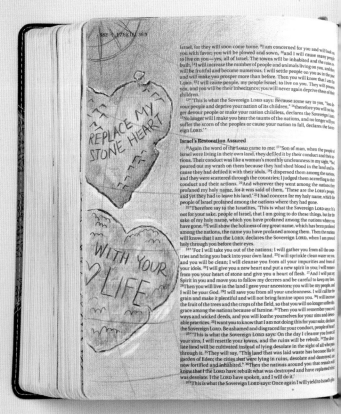

Ezekiel 36:26
Colored pencil

These islands (one dead and rocky, one filled with life) were drawn whimsically, and at the end were outlined with navy blue pencil to clean up the edges and add the cartoonish line.

A loosely painted group of trees may be just the desired look, but outlines added afterward with a pencil or pen can clean up edges. The strong contrast draws attention away from paint outside the lines.

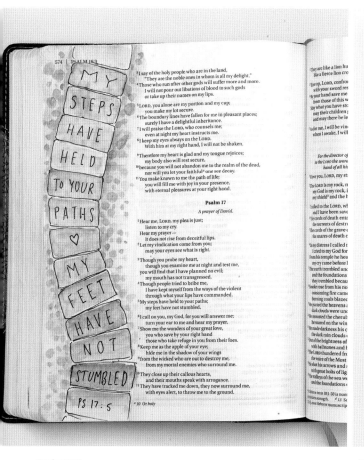

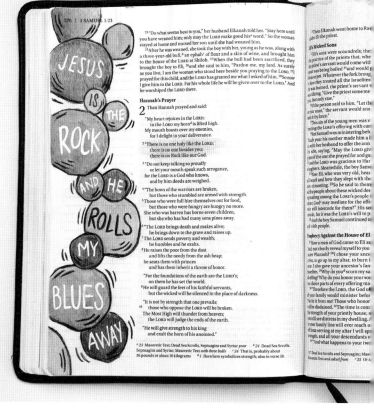

Psalm 17:5
Watercolor paints

For this prophetic path, the curved lines were sketched in first, then the bricks were painted. Text was added at the end, as were outlines around each of the paving stones.

1 Samuel 2:2
Watercolor pencil

A soft, thick pencil outline was added to these fun tumbling boulders after the color was applied. The little movement lines around the outside edges make them look like they're rolling.

Mountains

MATERIALS LIST

colored pencils

gel pen, white

pencil, no. 2

On Mount Sinai, God gave Moses the Ten Commandments; on the Mount of Olives, God gave Jesus the strength for His trials to come; and on mountains of our own, God speaks to us as well. Mountain peaks are an epic image to use in Bible journaling, commemorating the things the Lord says to us while with Him in private, and when representing His strength in our lives.

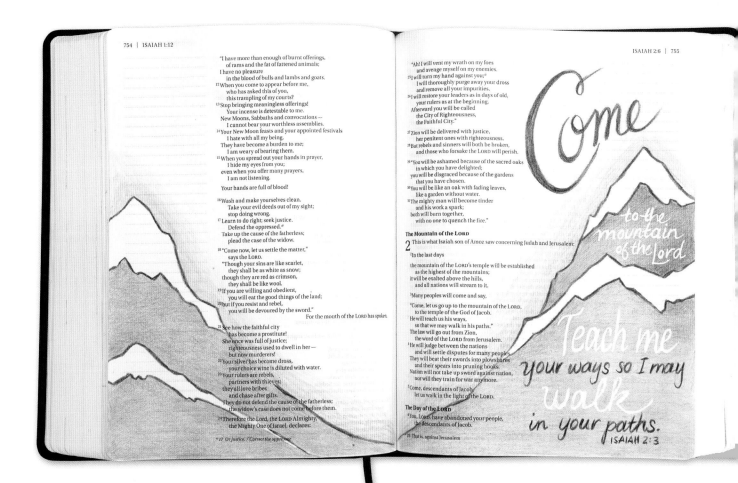

Tips for Other Mediums

Watercolor pencil mountains may need a mask to keep the snow white while using a baby wipe. (See the Rain Clouds demonstration on page 76 for how to make a mask.)

A watercolor mountain range can be loose and soft or sharp with detail. Add a few trees from the last chapter, too. (See more examples of mountains on pages 47 and 94.)

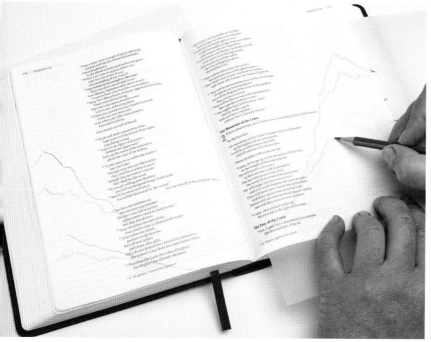

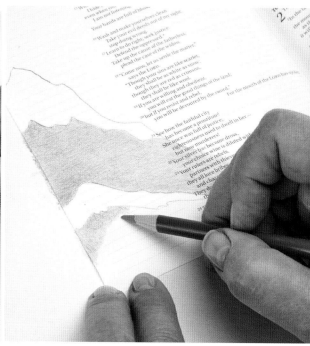

1 SKETCH THE SCENE

In pencil, lightly sketch general peak shapes. Mountains are basically lumpy triangles, so there are no rules about their appearance. (See Suggestions for Study on page 103 for the mountain sketch.)

2 ADD COLOR

With colored pencil, fill in the shapes with one color, or with graduated layers of color blended together.

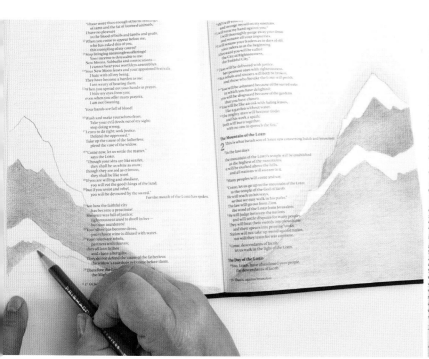

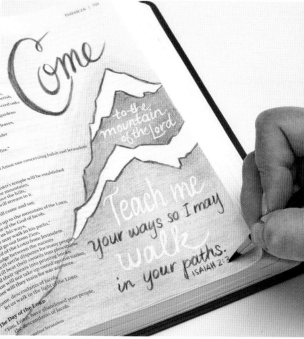

3 REFINE THE COLOR AND SHAPES

Refine the shapes as needed, leaving the snowcapped peaks uncolored. Note that the snow starts to look white as the colors fill in next to it.

4 ADD FINISHING TOUCHES

Add outlines on top with black or a coordinating dark color like a blue or purple. Text can be in white if mountain colors are dark enough, or in dark pencil if the hues are very light.

Walking with the Lord is a day-by-day process, and one worth documenting. Journal the trip and remember all God has done. Maps are a versatile concept to play with; islands can be made of any shape and in any color, labeled with life events and gifts received from the Lord along the way.

MATERIALS LIST

baby wipes

copier paper

gel pen, white

iron

pen, black bleedproof

pencil, no. 2

watercolor pencils

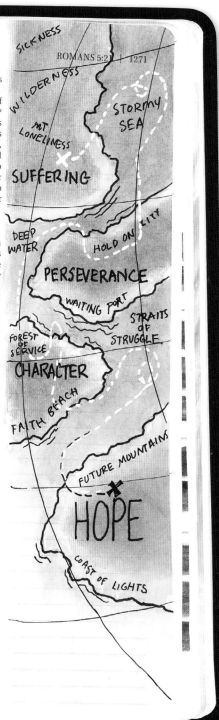

ht of God, in whom he believed — the God who gives life to the dead and calls o being things that were not.
[18]Against all hope, Abraham in hope believed and so became the father of ny nations, just as it had been said to him, "So shall your offspring be."[a] Without weakening in his faith, he faced the fact that his body was as good as d — since he was about a hundred years old — and that Sarah's womb was o dead. [20]Yet he did not waver through unbelief regarding the promise of God, t was strengthened in his faith and gave glory to God, [21]being fully persuaded t God had power to do what he had promised. [22]This is why "it was credited to n as righteousness." [23]The words "it was credited to him" were written not for n alone, [24]but also for us, to whom God will credit righteousness — for us who ieve in him who raised Jesus our Lord from the dead. [25]He was delivered over eath for our sins and was raised to life for our justification.

ace and Hope

Therefore, since we have been justified through faith, we[b] have peace with God through our Lord Jesus Christ, [2]through whom we have gained access aith into this grace in which we now stand. And we[c] boast in the hope of the y of God. [3]Not only so, but we[c] also glory in our sufferings, because we know suffering produces perseverance; [4]perseverance, character; and character, e. [5]And hope does not put us to shame, because God's love has been poured into our hearts through the Holy Spirit, who has been given to us.
You see, at just the right time, when we were still powerless, Christ died for ungodly. [7]Very rarely will anyone die for a righteous person, though for a d person someone might possibly dare to die. [8]But God demonstrates his love for us in this: While we were still sinners, Christ died for us.
Since we have now been justified by his blood, how much more shall we be ed from God's wrath through him! [10]For if, while we were God's enemies, we e reconciled to him through the death of his Son, how much more, having n reconciled, shall we be saved through his life! [11]Not only is this so, but we boast in God through our Lord Jesus Christ, through whom we have now ived reconciliation.

th Through Adam, Life Through Christ

Therefore, just as sin entered the world through one man, and death through and in this way death came to all people, because all sinned —
To be sure, sin was in the world before the law was given, but sin is not ged against anyone's account where there is no law. [14]Nevertheless, death ed from the time of Adam to the time of Moses, even over those who did not y breaking a command, as did Adam, who is a pattern of the one to come.
But the gift is not like the trespass. For if the many died by the trespass of one man, how much more did God's grace and the gift that came by the e of the one man, Jesus Christ, overflow to the many! [16]Nor can the gift od be compared with the result of one man's sin: The judgment followed sin and brought condemnation, but the gift followed many trespasses and ght justification. [17]For if, by the trespass of the one man, death reigned ugh that one man, how much more will those who receive God's abundant ision of grace and of the gift of righteousness reign in life through the one , Jesus Christ!
Consequently, just as one trespass resulted in condemnation for all people, so one righteous act resulted in justification and life for all people. [19]For s through the disobedience of the one man the many were made sinners, so through the obedience of the one man the many will be made righteous. The law was brought in so that the trespass might increase. But where sin ased, grace increased all the more, [21]so that, just as sin reigned in death, so

en. 15:5 [b]1 Many manuscripts *let us* [c]2,3 Or *let us*

Tips for Other Mediums

In colored pencil, be careful not to let the pigment get too waxy or shiny, which will keep a pen from writing well on top. Watercolor maps aren't hard since shapes for land masses are so forgiving. Combine with pencils and pens to add details.

1 SKETCH THE MAP

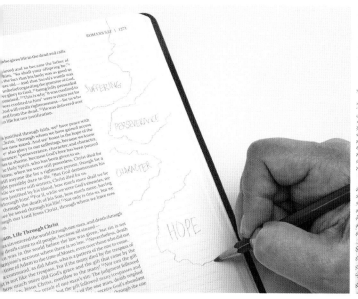

Sketch the island names in pencil along with some random shapes around them.

2 ADD COLOR

Color the islands with single or multiple hues of watercolor pencil. Use deeper colors for the difficult concepts and brighter ones for the journey highlights.

3 BLEND THE COLOR

Place copier paper under the Bible page. Smooth the color with a baby wipe or a brush, then iron to flatten the page. Want stronger color? Add another layer after the first layer is dry.

4 ADD FINISHING TOUCHES

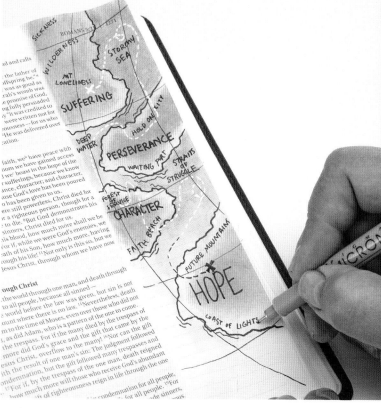

Draw outlines and island names in a thick pen, then switch to a thinner pen to add features to the island—name some mountains, valleys and beaches to correspond with your life experiences. Complete the image with large, arced latitude and longitude lines, then add a dotted line to follow your path along the adventure.

| *Rocky Path*

MATERIALS LIST

brush, no. 8 round

iron

pen, black bleedproof

pencil, no. 2

watercolor paints

Walking the path that God sets before us is a necessary part of growing in Christ's likeness. Reminding ourselves of the steps to take, the commands He's given and the journeys we've walked will build faith for the next step He asks of us.

Tips for Other Mediums

Rocks created with colored pencil may not need any outlines if the colors are different enough from each other.

With watercolor pencil, outlines can be drawn in a darker shade rather than with a black pen, softening the overall look.

Rocky paths can be regular and even, with large smooth rocks, or filled with pebbles and weeds at times. Draw a path that suits the verse God leads you to.

THIS IS LOVE: THAT WE WALK IN OBEDIENCE TO HIS COMMANDS. WALK IN LOVE

2 JOHN 1:6

2 JOHN

[1]The elder,

To the lady chosen by God and to her children not I only, but also all who know the truth — [2]be us and will be with us forever:

[3]Grace, mercy and peace from God the Fath ther's Son, will be with us in truth and love.

[4]It has given me great joy to find some of yo just as the Father commanded us. [5]And now, new command but one we have had from the another. [6]And this is love: that we walk in obe have heard from the beginning, his command

[7]I say this because many deceivers, who do coming in the flesh, have gone out into the w ceiver and the antichrist. [8]Watch out that you for, but that you may be rewarded fully. [9]Anyo continue in the teaching of Christ does not hav teaching has both the Father and the Son. [10]If a bring this teaching, do not take them into you one who welcomes them shares in their wicke

[12]I have much to write to you, but I do not w I hope to visit you and talk with you face to face

[13]The children of your sister, who is chosen

a 8 Some manuscripts you

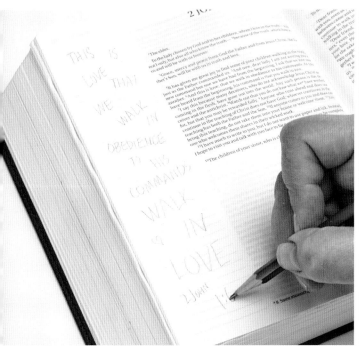

1 SKETCH THE TEXT

Write the words in pencil. They can be at any angle or size.

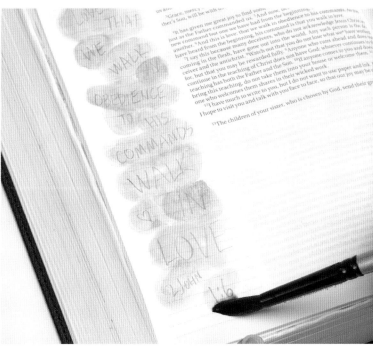

2 ADD WATERCOLOR

Use natural or other hues to create watercolor blobs over each word. When dry, iron the page to flatten.

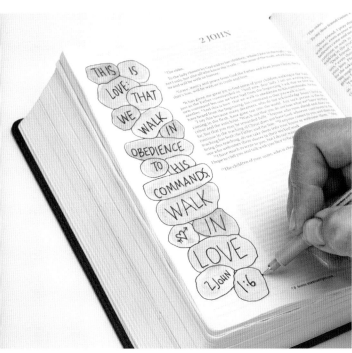

3 ADD INK

Write over the words in pen, and outline the rocks of the path.

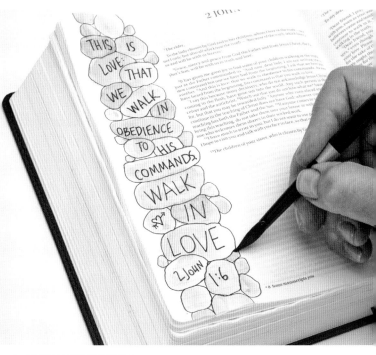

4 CLEAN UP DETAILS

If needed, fill in any open spaces with smaller rocks and paint them in.

Minitutorial: Vanishing Point Perspective

When making roads or paths, sometimes it's helpful to illustrate distance in the picture, and that's done with a vanishing point. All objects point to this one spot in the drawing. With a road, the closer it is, the wider it is, and the further away, the smaller it appears. (Note we are only discussing a single vanishing point, also known as one-point perspective, for the sake of simplicity.)

Vanishing Point

Vanishing Point

Vanishing Point

Vanishing Point

Lines of a road recede and come together as they end at one point.

A path's paving stones get smaller brick by brick and row by row.

Faraway stones on a path shrink in size.

A winding river recedes, and the trees are smaller in the distance.

Isaiah 40:3

Watercolor paints and watercolor pencil

The road clearly points to the vanishing point just beneath the sun. This page was first loosely painted, then pencil was added to create outlines and cactus spikes, and text was written with black and white pens.

Suggestions for *Study*

You might have realized that the techniques in this chapter are starting to work alongside previous chapters—add trees to your mountains and flowers to your trails. Below is a sampling of suggestions for your own Scripture study to create more pages of creative worship.

MOUNTAINS (MOUNT, PEAK)

1 Kings 19:11, Psalm 3:4, Psalm 24:3, Psalm 95:4, Psalm 104:13, Isaiah 40:4, Isaiah 44:23, Isaiah 52:7, Amos 4:13, Nahum 1:15, Matthew 17:20, Matthew 21:21, Mark 6:46, Mark 9:2, Luke 6:12

 Mountains signify strength and journeys into the presence of God.

MAPS (JOURNEY, TRAVEL)

Judges 18:6, Psalm 91:11, Isaiah 35:8

 You can replicate maps of actual places, but the journey of the heart is more interesting. Draw maps of where your life has been transformed.

TRAILS (PATHS)

2 Samuel 22:37, Psalm 16:11, Psalm 23:3, Psalm 25:4, Psalm 119:35, Proverbs 3:6, Proverbs 4:18, Proverbs 11:5, Isaiah 26:7, Micah 4:2, Mark 1:3, 2 Corinthians 6:3, John 14:6

 Consider searching for verses about following God's lead and being called by Him.

Think about the areas of your life in which God has changed you. Where did you begin and how far have you come? These points can all be marked on a map, plotted as trailheads on a mountain, or as stepping stones on an illustrated journey.

A study on goodness inspired me as I prepared this chapter. Understanding it more deeply as generosity opened my eyes to even more Fruit of the Spirit.

This mountain sketch provides several shapes for mountains (they're *not* intended to be used on top of each other as shown). Trace dotted lines for one end of a mountain range and solid lines for the other.

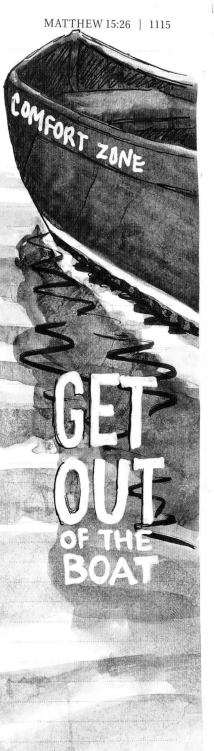

COMFORT ZONE

GET OUT OF THE BOAT

[left margin fragments]

m there. ⁵⁴Con-
gogue, and they
iraculous pow-
er's name Mary,
n't all his sisters
hey took offense

in his own town

k of faith.

us, ²and he said
from the dead.

n prison because
to him: "It is not
was afraid of the

r the guests and
her whatever she
platter the head
his oaths and his
d John beheaded
to the girl, who
dy and buried it.

oat privately to a
from the towns.
on on them and

id, "This is a re-
so they can go to

m something to

answered.
eople to sit down
ng up to heaven.
isciples, and the
ed, and the disci-
over. ²¹The num-
en and children.

d go on ahead of
e had dismissed
hat night, he was
e from land, but

he lake. ²⁶When
It's a ghost," they

Don't be afraid.

[main column]

²⁸"Lord, if it's you," Peter replied, "tell me to come to you on the water."

²⁹"Come," he said.

Then Peter got down out of the boat, walked on the water and came toward Jesus. ³⁰But when he saw the wind, he was afraid and, beginning to sink, cried out, "Lord, save me!"

³¹Immediately Jesus reached out his hand and caught him. "You of little faith," he said, "why did you doubt?"

³²And when they climbed into the boat, the wind died down. ³³Then those who were in the boat worshiped him, saying, "Truly you are the Son of God."

³⁴When they had crossed over, they landed at Gennesaret. ³⁵And when the men of that place recognized Jesus, they sent word to all the surrounding country. People brought all their sick to him ³⁶and begged him to let the sick just touch the edge of his cloak, and all who touched it were healed.

That Which Defiles

15 Then some Pharisees and teachers of the law came to Jesus from Jerusalem and asked, ²"Why do your disciples break the tradition of the elders? They don't wash their hands before they eat!"

³Jesus replied, "And why do you break the command of God for the sake of your tradition? ⁴For God said, 'Honor your father and mother'ᵃ and 'Anyone who curses their father or mother is to be put to death.'ᵇ ⁵But you say that if anyone declares that what might have been used to help their father or mother is 'devoted to God,' ⁶they are not to 'honor their father or mother' with it. Thus you nullify the word of God for the sake of your tradition. ⁷You hypocrites! Isaiah was right when he prophesied about you:

⁸ " 'These people honor me with their lips,
 but their hearts are far from me.
⁹ They worship me in vain;
 their teachings are merely human rules.'ᶜ "

¹⁰Jesus called the crowd to him and said, "Listen and understand. ¹¹What goes into someone's mouth does not defile them, but what comes out of their mouth, that is what defiles them."

¹²Then the disciples came to him and asked, "Do you know that the Pharisees were offended when they heard this?"

¹³He replied, "Every plant that my heavenly Father has not planted will be pulled up by the roots. ¹⁴Leave them; they are blind guides.ᵈ If the blind lead the blind, both will fall into a pit."

¹⁵Peter said, "Explain the parable to us."

¹⁶"Are you still so dull?" Jesus asked them. ¹⁷"Don't you see that whatever enters the mouth goes into the stomach and then out of the body? ¹⁸But the things that come out of a person's mouth come from the heart, and these defile them. ¹⁹For out of the heart come evil thoughts—murder, adultery, sexual immorality, theft, false testimony, slander. ²⁰These are what defile a person; but eating with unwashed hands does not defile them."

The Faith of a Canaanite Woman

²¹Leaving that place, Jesus withdrew to the region of Tyre and Sidon. ²²A Canaanite woman from that vicinity came to him, crying out, "Lord, Son of David, have mercy on me! My daughter is demon-possessed and suffering terribly."

²³Jesus did not answer a word. So his disciples came to him and urged him, "Send her away, for she keeps crying out after us."

²⁴He answered, "I was sent only to the lost sheep of Israel."

²⁵The woman came and knelt before him. "Lord, help me!" she said.

²⁶He replied, "It is not right to take the children's bread and toss it to the dogs."

ᵃ 4 Exodus 20:12; Deut. 5:16 ᵇ 4 Exodus 21:17; Lev. 20:9 ᶜ 9 Isaiah 29:13 ᵈ 14 Some manuscripts *blind guides of the blind*

8 | *Engulfed in Christ*

Drawing Water

GOODNESS AND GENEROSITY

"Get out of the boat!" Each time Matthew 14 comes up in my life, I know God's at work.

That Scripture was the subject of a sermon when I was praying about a job transfer to a new city. Another time, as I was debating a medical decision, a radio preacher said Jesus calls us to get out of the boat so He can prove He's able to hold us in the midst of a storm. When fretting about my ineffectiveness in ministry, I opened a hymnal to find a bookmark proclaiming, "If you want to walk on water, you have to get out of the boat!"

The Lord's gentle instructions to exit my comfort zone may sound like harsh orders, but it no longer causes me fear. He's the ultimate persuader: God speaks when I am actively listening for answers. He reminds me He'll stay with me no matter what. Correction and guidance are given with the gentleness of a Father who loves me.

As I learn from His example, God's persuasive tactics teach me how to lead others gently as well. When I ask "What would Jesus do?" I think of the ways Christ has treated me—and learn to treat others with that same love.

Matthew 14:29

Watercolor paints

Consider ongoing themes and recurring Scripture verses in your life. If the same verse pops up regularly, that's a great place to start a Bible journaling page!

✱ *Web content available*

What's Your Story?

- Are there Scripture verses that are repeated anchors in your life?
- Does God's direction bring you comfort?
- What questions are you praying about right now?
- Are you listening for Him to answer through His Word?

Just for fun, choose a simple image like a heart or a star and see how many ways you can think of to doodle it in a sketchbook. Which was most fun? Which one sparked an idea? Which style might make it into your Bible journaling?

Exploring Your *Style*

An email I received from an online Bible store opened with this:

"You were deliberately planned, specifically gifted and lovingly positioned on this earth by the Master Craftsman."

Every bit of that statement is true! God created you, planned the steps of your life, gifted you to meet every one of them and placed you right where you are today. But knowing this and walking in it are sometimes two different things.

Before we move on to more tutorials, let's take some advice and stand creatively in our own shoes.

BE PATIENT WHILE DEVELOPING A STYLE
Even a seasoned artist takes a long time to develop a recognizable style. It could take months, or even years, before discovering your own, but it's absolutely okay to proceed without a signature look to your work.

BE BRAVE
Attempt a variety of styles and mediums, and see what suits you. Remember, if you're like many artists, there could be styles you love to look at that just aren't going to be in your repertoire, and that's normal.

BE YOUR OWN BEST FRIEND
Look through your art, and imagine a friend gave it to you to comment on. What would you tell them? In what ways would you say your friend was skilled? Hear those compliments in your own heart.

TRY SOMETHING OUTLANDISH
Shake things up and attempt a technique you think you never would if you were in your right mind. Try it in a sketchbook first or in a journal. Reduce the pressure to be perfect, and broaden your horizons to consider new ideas.

BE PATIENT
Rather than saying "I just can't do that," add one word to that sentence: "yet." Give yourself the freedom to try a technique again or to attempt it next week or next month after a break. God is patient with you—you should be, too.

DEMONSTRATION | *Bubbling Water*

Bubbles springing up from water, as well as in the air, are like new life welling up thanks to the presence of the Holy Spirit. A group of bubbles is technically called a froth, by the way (useless trivia!), and can be drawn with backgrounds or without and in any combination of sizes and colors.

MATERIALS LIST

circle template (or round objects to trace)

colored pencils

gel pen, white

pen, black bleedproof

pencil, no. 2

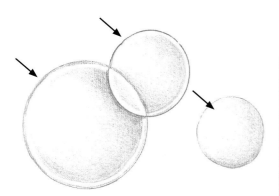

Bubbles are round shapes, like the grapes on page 90, with the same C-shaped shadow. The shadow can reach the edge, as shown, or leave a white line around the inside of the bubble, which makes it look clear. As bubbles cross in front of each other, darken the area around those edges, and add a very light haze of color to the seed-shaped area where they cross.

Bubbles lend themselves well to watercolor—loose and splashy! Remember to leave white highlights to allow the bubbles to look airy and clear. Sharpen up just a few areas with watercolor pencil on top.

160 | NUMBERS 21:3

deliver these people into our hands, we will tota
LORD listened to Israel's plea and gave the Canaa
pletely destroyed them and their towns; so the pla

The Bronze Snake

[4]They traveled from Mount Hor along the route
Edom. But the people grew impatient on the way
against Moses, and said, "Why have you brought u
wilderness? There is no bread! There is no water!
food!"

[6]Then the LORD sent venomous snakes among
many Israelites died. [7]The people came to Moses
spoke against the LORD and against you. Pray that
away from us." So Moses prayed for the people.

[8]The LORD said to Moses, "Make a snake and p
is bitten can look at it and live." [9]So Moses made a
a pole. Then when anyone was bitten by a snake a
they lived.

The Journey to Moab

[10]The Israelites moved on and camped at Ob
Oboth and camped in Iye Abarim, in the wildern
sunrise. [12]From there they moved on and camped
out from there and camped alongside the Arnon,
tending into Amorite territory. The Arnon is the b
and the Amorites. [14]That is why the Book of the W

"... Zahab[d] in Suphah and the ravines,
the Arnon [15]and[e] the slopes of the ravines
that lead to the settlement of Ar
and lie along the border of Moab."

[16]From there they continued on to Beer, the well
"Gather the people together and I will give them
[17]Then Israel sang this song:

"Spring up, O well!
Sing about it,
[18]about the well that the princes dug,
that the nobles of the people sank—
the nobles with scepters and staffs."

Then they went from the wilderness to Mattanah
from Nahaliel to Bamoth, [20]and from Bamoth to
top of Pisgah overlooks the wasteland.

Defeat of Sihon and Og

[21]Israel sent messengers to say to Sihon king of

[22]"Let us pass through your country. We wil
or vineyard, or drink water from any well. We
Highway until we have passed through your te

[23]But Sihon would not let Israel pass through hi
tire army and marched out into the wilderness a
Jahaz, he fought with Israel. [24]Israel, however, p

[a]2 The Hebrew term refers to the irrevocable giving over
often by totally destroying them; also in verse 3. [b]3 He
[c]4 Or *the Sea of Reeds* [d]14 Septuagint; Hebrew *Wahel
from Suphah and the ravines / of the Arnon* [15]*to*

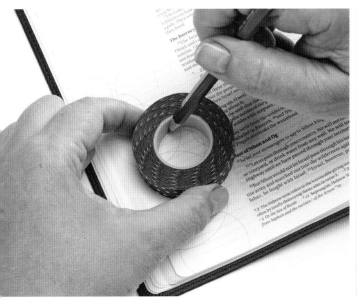

1 SKETCH THE BUBBLES

Draw circles in overlapping patterns. Use round objects of a few sizes to trace the outlines lightly in pencil. Leave gaps where the text will be written.

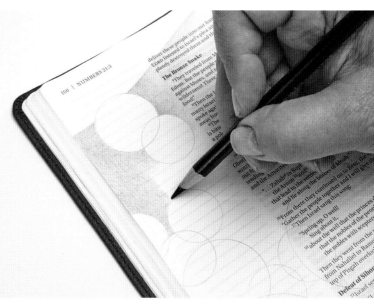

2 ADD COLOR

Color the background using colored pencils.

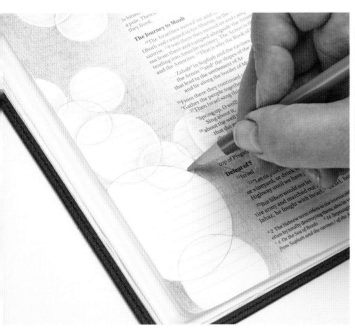

3 ADD SHADING

Add light blue shading inside each bubble.

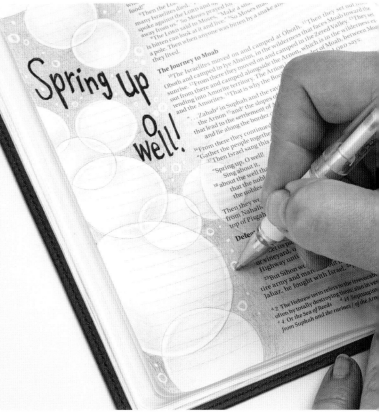

4 ADD TEXT

Add text in white or black pen—whichever shows up best—and add a few extra bubbles with a white pen, if needed. Journaling can be done within a large bubble or two in the design.

Ocean Waves

MATERIALS LIST

baby wipes

copier paper

iron

gel pen, white

pencil, no. 2

watercolor pencils

The crashing of waves can represent the Lord's power and might, or the welling up of the Holy Spirit. At other times, it stands for the worldly challenges that feel like waves overtaking us. In either case, don't tell God how big your storm is; tell the storm how big your God is. Whatever the medium, waves and water are a forgiving shape to curve and blend.

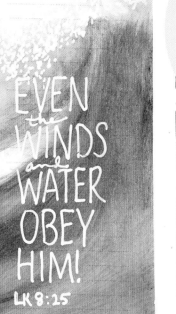

When he said this, he called out, "Whoever has ears to hear, let them hear." [9]His disciples asked him what this parable meant. [10]He said, "The knowledge of the secrets of the kingdom of God has been given to you, but to others I speak in parables, so that,

" 'though seeing, they may not see;
though hearing, they may not understand.'[a]

[11]"This is the meaning of the parable: The seed is the word of God. [12]Those along the path are the ones who hear, and then the devil comes and takes away the word from their hearts, so that they may not believe and be saved. [13]Those on the rocky ground are the ones who receive the word with joy when they hear it, but they have no root. They believe for a while, but in the time of testing they fall away. [14]The seed that fell among thorns stands for those who hear, but as they go on their way they are choked by life's worries, riches and pleasures, and they do not mature. [15]But the seed on good soil stands for those with a noble and good heart, who hear the word, retain it, and by persevering produce a crop.

A Lamp on a Stand

[16]"No one lights a lamp and hides it in a clay jar or puts it under a bed. Instead, they put it on a stand, so that those who come in can see the light. [17]For there is nothing hidden that will not be disclosed, and nothing concealed that will not be known or brought out into the open. [18]Therefore consider carefully how you listen. Whoever has will be given more; whoever does not have, even what they think they have will be taken from them."

Jesus' Mother and Brothers

[19]Now Jesus' mother and brothers came to see him, but they were not able to get near him because of the crowd. [20]Someone told him, "Your mother and brothers are standing outside, wanting to see you."

[21]He replied, "My mother and brothers are those who hear God's word and put it into practice."

Jesus Calms the Storm

[22]One day Jesus said to his disciples, "Let us go over to the other side of the lake." So they got into a boat and set out. [23]As they sailed, he fell asleep. A squall came down on the lake, so that the boat was being swamped, and they were in great danger.

[24]The disciples went and woke him, saying, "Master, Master, we're going to drown!"

He got up and rebuked the wind and the raging waters; the storm subsided, and all was calm. [25]"Where is your faith?" he asked his disciples.

In fear and amazement they asked one another, "Who is this? He commands even the winds and the water, and they obey him."

Jesus Restores a Demon-Possessed Man

[26]They sailed to the region of the Gerasenes,[b] which is across the lake from Galilee. [27]When Jesus stepped ashore, he was met by a demon-possessed man from the town. For a long time this man had not worn clothes or lived in a house, but had lived in the tombs. [28]When he saw Jesus, he cried out and fell at his feet, shouting at the top of his voice, "What do you want with me, Jesus, Son of the Most High God? I beg you, don't torture me!" [29]For Jesus had commanded the impure spirit to come out of the man. Many times it had seized him, and though he was chained hand and foot and kept under guard, he had broken his chains and had been driven by the demon into solitary places.

[a] 10 Isaiah 6:9 [b] 26 Some manuscripts *Gadarenes*; other manuscripts *Gergesenes*; also in verse 37

LUKE 8:29 | 1173

EVEN the WINDS and WATER OBEY HIM!
LK 8:25

A single wave is a series of curved lines, some thinner, some thicker, all joining and curling up beneath the crest of the wave (see the simple sketch below). The foamy crest is shaped by drawing a cap of scallops.

1 **SKETCH THE WAVE**
Draw a series of curving lines that meet beneath a scalloped cap of waves.

2 **ADD COLOR**
Place copier paper under the Bible page. Use a variety of blues in any order to color the wave and sky. Use light blue watercolor pencil to add a little color to the crest of the wave. When adding white foam later, this will create some color for contrast.

3 **BLEND THE COLOR**
Move and blend the color with a baby wipe, tapping the color around the crest to create soft edges, but leave some of the paper uncolored. To make waves, use long strokes with a baby wipe to blend colors.

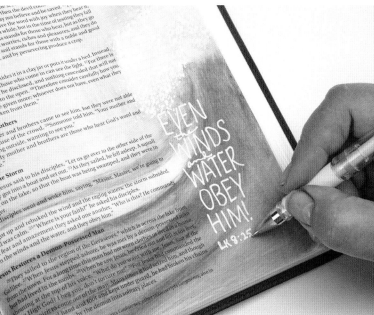

4 **ADD THE FOAM**
Iron to flatten, as needed; do this before adding white gel pen, as that melts most gel pen ink. Then scribble around the edges of the scallops with a white gel pen to create delicate foam and drips as desired.

5 **ADD THE TEXT**
Text can be added above or below the wave (or both), using either a color or a white gel pen. If white is preferred, be sure the wave has enough pigment to create contrast behind the words.

Gentle Lake

MATERIALS LIST

brush, no. 8 round

copier paper

pen, black bleedproof

pencil, no. 2

watercolors

Paint a peaceful lake to journal remembrances of times with the Lord spent in quiet. He waits to take our burdens, if only we would spend the time with Him. Water is a series of horizontal broken lines. The next time you visit a lake, take the time to watch the surface of the water and to study how the light shines on it.

Watercolor is a loose and forgiving medium with its splashes of color. For those desiring more control or detail, create a lake in watercolor pencil, or even further detail work with colored pencil. Whichever you choose, here's some advice I received from an art teacher: "Paint the dog, not the fleas." In other words, keep the main thing in mind, and don't get sidetracked by detail.

1 PAINT THE LAND

Sketch a horizon line, adding low hills and a line of your favorite trees. If preferred, make mountains or any other scene your wish. Place copier paper under the Bible page and begin adding a light wash of color to the trees and land.

2 PAINT THE SKY

Begin painting the sky with a light yellow, then orange and red. Add these layers lightly and darken them as you reach the distant sky. Apply each color while the last is still wet and allow them to blend.

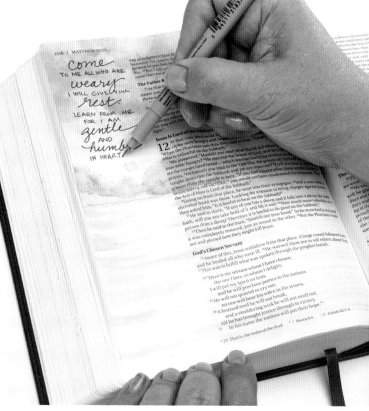

3 PAINT THE WATER

To paint water, create a series of light, broken lines and washes, allowing the paper to show through in an irregular strip below the sun. These uncolored strips act as reflections.

4 ADD THE TEXT

Once the page is dry, sketch the text in pencil. When pencil is on *top* of watercolor, it can be erased once the text is inked. Redraw the text with a black pen.

Minitutorial: Ripples

Beautiful ripples spread out from a drop in a puddle or a lake, creating movement across the surface of the water. There are many types of ripples and currents, but let's look at just a few.

For a river, realistic currents appear horizontal, with thin tips on each wave. They can also be drawn in fun stylized curves. As shown in the Vanishing Point lesson on page 102, textures become smaller and the colors become lighter the further away the water is.

Water in the forefront of a picture can have shaped ripples ending in points, becoming larger the closer they are, and lighter and smaller the further away they are.

Matthew 28:19

Watercolor

A concentric ripple may be perfectly round when viewed directly from overhead, but it is more forgiving to draw it as an oval shape, seen at an angle with rings occasionally touching. The color and line thickness can vary, looking artistic without the need to be perfect. Journal along the ripples, or let the droplet stand by itself.

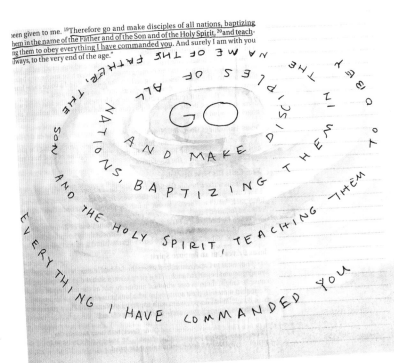

Suggestions for *Study*

Water conveys many meanings: baptism, the washing away of sin and the power of God to still our fears. Positive meanings of water in all three techniques (bubbling water, ocean wave and lake) can be expressed with brighter, purer colors. Below is a sampling of suggestions for your own Scripture study.

SALVATION
Isaiah 12:3, Isaiah 55:1, John 4:10–15, John 7:38, Revelation 7:17, Revelation 21:6, Revelation 22:1–2

SPIRITUAL CLEANSING
Ezekiel 36:25, Ephesians 5:26, Hebrews 10:22

THIRST
Psalm 42:2, Psalm 63:1, Psalm 107:9, Isaiah 48:21, Matthew 5:6, Matthew 25:35

HOLY SPIRIT
Genesis 1:2, Isaiah 44:3, Mark 1:10, 1 John 5:6–8

LIVING WATER
Jeremiah 2:13, Jeremiah 17:13, John 7:37

BAPTISM
Matthew 3:6–17, Mark 1:8, Mark 16:16, John 3:5, Luke 3:16, Acts 1:5, Acts 2:38, 1 Peter 3:21

TROUBLES
Psalm 32:6, Psalm 69, Job 11:16, Isaiah 43:2, Lamentations 3:54

Journaling troubled waters as a prayer to God for rescue from circumstances can be drawn as the same image but with darker, murkier colors.

The Fruit of the Spirit—God's gentleness in the cleansing of our sin—inspires us to do as He has done: to forgive readily and to be gentle with ourselves and others.

EVEN *the* WINDS *and* WATER OBEY HIM.

This wave sketch will help you guide your drawn curves. Enlarge or reduce it, as needed, for your Bible journaling page.

[25]Large crowds from Galilee, the Decapolis,[a] Jerusalem, Judea and the region across the Jordan followed him.

Introduction to the Sermon on the Mount

5 Now when Jesus saw the crowds, he went up on a mountainside and sat down. His disciples came to him, [2]and he began to teach them.

The Beatitudes

He said:

[3]"Blessed are the poor in spirit,
for theirs is the kingdom of heaven.
[4]Blessed are those who mourn,
for they will be comforted.
[5]Blessed are the meek,
for they will inherit the earth.
[6]Blessed are those who hunger and thirst for righteousness,
for they will be filled.
[7]Blessed are the merciful,
for they will be shown mercy.
[8]Blessed are the pure in heart,
for they will see God.
[9]Blessed are the peacemakers,
for they will be called children of God.
[10]Blessed are those who are persecuted because of righteousness,
for theirs is the kingdom of heaven.

[11]"Blessed are you when people insult you, persecute you and falsely say all kinds of evil against you because of me. [12]Rejoice and be glad, because great is your reward in heaven, for in the same way they persecuted the prophets who were before you.

Salt and Light

[13]"You are the salt of the earth. But if the salt loses its saltiness, how can it be made salty again? It is no longer good for anything, except to be thrown out and trampled underfoot.

[14]"You are the light of the world. A town built on a hill cannot be hidden. [15]Neither do people light a lamp and put it under a bowl. Instead they put it on its stand, and it gives light to everyone in the house. [16]In the same way, let your light shine before others, that they may see your good deeds and glorify your Father in heaven.

The Fulfillment of the Law

[17]"Do not think that I have come to abolish the Law or the Prophets; I have not come to abolish them but to fulfill them. [18]For truly I tell you, until heaven and earth disappear, not the smallest letter, not the least stroke of a pen, will by any means disappear from the Law until everything is accomplished. [19]Therefore anyone who sets aside one of the least of these commands and teaches others accordingly will be called least in the kingdom of heaven, but whoever practices and teaches these commands will be called great in the kingdom of heaven. [20]For I tell you that unless your righteousness surpasses that of the Pharisees and the teachers of the law, you will certainly not enter the kingdom of heaven.

Murder

[21]"You have heard that it was said to the people long ago, 'You shall not murder,[b] and anyone who murders will be subject to judgment.' [22]But I tell you that

[a] 25 That is, the Ten Cities [b] 21 Exodus 20:13

9 | Burning Bright

Light and Fire

A FAITHFUL CITY ON A HILL

Within a few months of moving to a new community, I was scheduled for surgery that would keep me off my feet and riding a scooter for weeks. My family lived far away, and I was facing a daunting recovery with few local friends to rely on for help. I cried out to God urgently as the hospital date grew nearer.

One Saturday my phone rang. "You don't know me, but God told me about you."

What? At the time, I was new to the concept that God actually spoke to anyone. He had told someone I had never met to call me? Susan attended the church I had joined. She said the Lord had told her a new member named Sandy needed help. She had asked the church secretary if anyone fit that description, and they passed on my number.

Through teary eyes, I explained my situation and was in awe at Susan's response. She rallied church members and scheduled weeks of visits, meals, cleaning and errands. I watched the church act as the hands and feet of Christ to serve a stranger in their midst, proving God's faithful and tangible care.

Jesus wants us to shine like that. He wants us to be a community that loves like that. He wants our light to burn bright for the world to know that He is real.

Matthew 5:14
Colored pencil

This church is the light shining on a hill—inside a light bulb (see the mini-tutorial on page 126). It's a reminder that we are to be the church and the shining light for each other. I recall my own times of need, and I serve others in theirs.

✱ *Web content available*

What's Your Story?

- How are you a part of your church family's life?
- Do you seek out the stranger in your midst?
- Has your own experience of being welcomed (or the opposite) colored how you participate in church life?
- How has God called you to serve?
- Journal about those who need your help, and see your own struggles fade by changing your focus outward.

Bible Journaling as *Evangelism*

Once you've caught the Bible journaling bug, the instinct to draw others into the grace you find may be irresistible. You might have already been thinking of family, friends and others in your church who might be intrigued with the idea.

How do you help someone else get started when you're still learning yourself? Martin Luther once said, "We are all mere beggars showing other beggars where to find bread." Share the bread you've discovered, and invite someone else to learn alongside you.

ROMANS

a servant of Christ Jesus, called to be an apostle and set apart for the l of God— [2] the gospel he promised beforehand through his prophets ly Scriptures [3] regarding his Son, who as to his earthly life[a] was a de- of David, [4] and who through the Spirit of holiness was appointed the d in power[b] by his resurrection from the dead: Jesus Christ our Lord. him we received grace and apostleship to call all the Gentiles to the e that comes from[c] faith for his name's sake. [6] And you also are among ntiles who are called to belong to Jesus Christ.

in Rome who are loved by God and called to be his holy people:

and peace to you from God our Father and from the Lord Jesus Christ.

nging to Visit Rome

I thank my God through Jesus Christ for all of you, because your faith eported all over the world. [9] God, whom I serve in my spirit in preach- ospel of his Son, is my witness how constantly I remember you [10] in my t all times; and I pray that now at last by God's will the way may be or me to come to you.

g to see you so that I may impart to you some spiritual gift to make you [12] that is, that you and I may be mutually encouraged by each other's do not want you to be unaware, brothers and sisters,[d] that I planned nes to come to you (but have been prevented from doing so until now) hat I might have a harvest among you, just as I have had among the ntiles.

obligated both to Greeks and non-Greeks, both to the wise and the fool- at is why I am so eager to preach the gospel also to you who are in Rome.

am not ashamed of the gospel, because it is the power of God that lvation to everyone who believes: first to the Jew, then to the Gentile. ne gospel the righteousness of God is revealed—a righteousness that is rom first to last,[e] just as it is written: "The righteous will live by faith."[f]

rath Against Sinful Humanity

wrath of God is being revealed from heaven against all the godlessness edness of people, who suppress the truth by their wickedness, [19] since be known about God is plain to them, because God has made it plain [20] For since the creation of the world God's invisible qualities—his eter- r and divine nature—have been clearly seen, being understood from been made, so that people are without excuse.

lthough they knew God, they neither glorified him as God nor gave him, but their thinking became futile and their foolish hearts were l. [22] Although they claimed to be wise, they became fools [23] and ex- the glory of the immortal God for images made to look like a mortal eing and birds and animals and reptiles.

efore God gave them over in the sinful desires of their hearts to sexual for the degrading of their bodies with one another. [25] They exchanged about God for a lie, and worshiped and served created things rather Creator—who is forever praised. Amen.

according to the flesh [b] 4 Or *was declared with power to be the Son of God* s [d] 13 The Greek word for *brothers and sisters (adelphoi)* refers here to oth men and women, as part of God's family; also in 7:1, 4; 8:12, 29; 10:1; 11:25; 12:1

Romans 1:16
Colored pencil

The easiest way to begin reaching out and sharing your art is online. On blogs or social media, a quick snapshot of a beautiful verse will garner attention. You'll discover friends who have an interest in Bible journaling who you never expected to. You may also have to explain your perspective on marking in your Bible to some who don't understand.

The Power of Art

Unbelievers may even be drawn into a relationship with God through your art. Most people become fascinated with looking at art—even art they don't understand—and Bible journaling can open discussions that regular conversations may not permit. Never underestimate the power of art to win people for Christ.

The Insight of Children
Children are naturals at creating. Put a pack of pencils in front of a young one, and they'll be thrilled to have permission to color in a Bible given to them for this purpose. Discuss the Scriptures with them to help them think about what image best captures what God says. You may be surprised at their depth of insight.

Group Study
A ministry group is a wonderful place to share your love of Bible journaling. In a group of like-minded friends, show them your work, explain what God was teaching you and let them know that you can help them get started. Retreats are an especially good time to help others hear from God. Begin with a simple technique to add color to His Word from Chapter 3.

MATERIALS LIST

colored pencils

pen, black bleedproof

pencil, no. 2

A simple flame lights a path, inspires a heart or awaits the coming of the Lord. Candles are also a beautiful symbol for journaling during the church seasons of Advent and Lent.

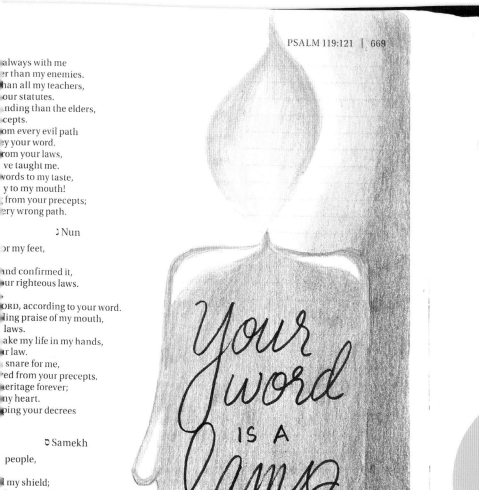

Tips for Other Mediums

Watercolor blends flame colors together softly, and watercolor pencil gives the shapes more definition. Try multiple candles as well, and give them rich, dark backgrounds to let the light shine bright.

A full page can be colored, but the candle's effect is still stunning with just the edge of the page colored in deep blue. See another candle example on page 57.

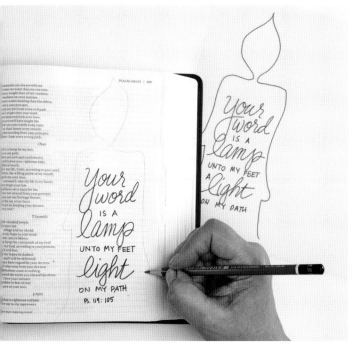

1 SKETCH THE CANDLE

Draw the candle shape and add text in pencil to make sure it's where you want it. Afterward, go over the text with a black pen.

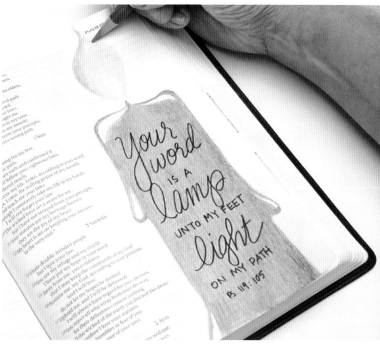

2 COLOR THE CANDLE

Color the candle, leaving a few white highlights on any drips by not coloring in that space. Color the flame using a light color in the center and a darker color at the edges or vice versa.

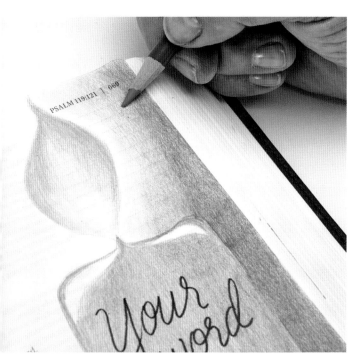

3 COLOR THE BACKGROUND

Color the background, leaving a little bit of a white glow around the flames, blending into light blue and deepening to dark blue.

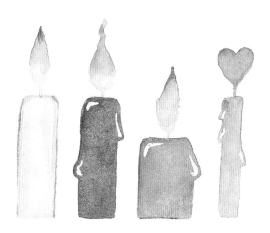

Candles are rectangles of various sizes, generally with rounded edges. Create wax drips on one or two sides by letting some color blobs cascade down the side. A whimsical flame can be shaped like another object—perhaps a heart!

Since the story of Moses and the burning bush, God's holy flame has fascinated generations. And for Bible journalers, lighting objects on fire is easy—flames are another forgiving shape to draw, and the colors can be quite striking.

MATERIALS LIST

baby wipes or brush

copier paper

gel pen, white

pen, black bleedproof

watercolor pencils

2 TIMOTHY

...aul, an apostle of Christ Jesus by the will of God, in keeping with the prom-
...e of life that is in Christ Jesus,

...o Timothy, my dear son:

...ace, mercy and peace from God the Father and Christ Jesus our Lord.

...ksgiving

...hank God, whom I serve, as my ancestors did, with a clear conscience, as
...and day I constantly remember you in my prayers. ⁴Recalling your tears,
...to see you, so that I may be filled with joy. ⁵I am reminded of your sincere
...which first lived in your grandmother Lois and in your mother Eunice and,
...ersuaded, now lives in you also.

...al for Loyalty to Paul and the Gospel

...or this reason I remind you to fan into flame the gift of God, which is in you
...gh the laying on of my hands. ⁷For the Spirit God gave us does not make us
..., but gives us power, love and self-discipline. ⁸So do not be ashamed of the
...mony about our Lord or of me his prisoner. Rather, join with me in suffer-
...r the gospel, by the power of God. ⁹He has saved us and called us to a holy
...not because of anything we have done but because of his own purpose and
.... This grace was given us in Christ Jesus before the beginning of time, ¹⁰but
...now been revealed through the appearing of our Savior, Christ Jesus, who
...estroyed death and has brought life and immortality to light through the
...l. ¹¹And of this gospel I was appointed a herald and an apostle and a teach-
...That is why I am suffering as I am. Yet this is no cause for shame, because
...w whom I have believed, and am convinced that he is able to guard what I
...entrusted to him until that day.
...What you heard from me, keep as the pattern of sound teaching, with faith
...ove in Christ Jesus. ¹⁴Guard the good deposit that was entrusted to you—
...d it with the help of the Holy Spirit who lives in us.

...ples of Disloyalty and Loyalty

...You know that everyone in the province of Asia has deserted me, including
...elus and Hermogenes.
...May the Lord show mercy to the household of Onesiphorus, because he of-
...efreshed me and was not ashamed of my chains. ¹⁷On the contrary, when he
...n Rome, he searched hard for me until he found me. ¹⁸May the Lord grant
...e will find mercy from the Lord on that day! You know very well in how
...y ways he helped me in Ephesus.

...Appeal Renewed

...ou then, my son, be strong in the grace that is in Christ Jesus. ²And the
...ings you have heard me say in the presence of many witnesses entrust to
...le people who will also be qualified to teach others. ³Join with me in suffer-
...ke a good soldier of Christ Jesus. ⁴No one serving as a soldier gets entangled
...ilian affairs, but rather tries to please his commanding officer. ⁵Similarly,
...e who competes as an athlete does not receive the victor's crown except by
...eting according to the rules. ⁶The hardworking farmer should be the first
...ceive a share of the crops. ⁷Reflect on what I am saying, for the Lord will give
...nsight into all this.
...emember Jesus Christ, raised from the dead, descended from David. This

Tips for Other Mediums

Colored pencil is an easy way to create detailed decorated gift boxes in the center of the images or other items that are being set ablaze. Watercolor can then add splashy flames to the background, staying away from the colored pencil areas.

A finished page can be fully colored, or the flames can blend softly into white.

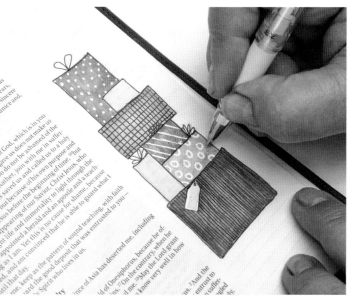

1 SKETCH AND DECORATE

Sketch the gift boxes, or other object to be burned, with watercolor pencils. Decorate as desired. Add white decorations on the boxes with a white gel pen, and outline and texture some of the boxes with black pen. This sketch is available on the website.

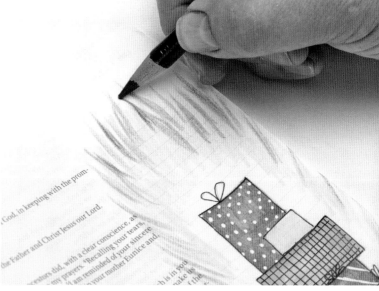

2 ADD THE FLAMES

Place copier paper under the Bible page. Draw flame shapes that are widest at the base and flick out to a pointed tip. Use lighter colors at the base and darker colors at the tips, or vice versa.

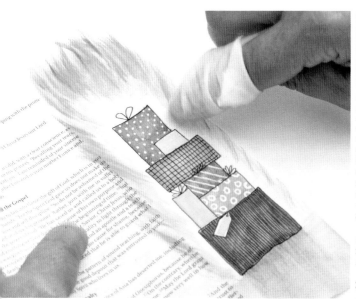

3 BLEND THE FLAMES

Blend pigment with a brush or baby wipes. Use light strokes to follow the shapes of the flames.

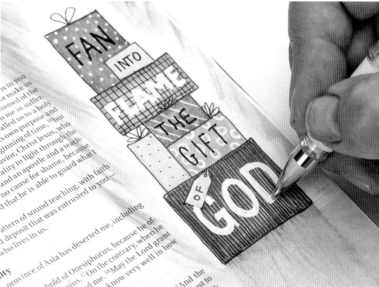

4 ADD TEXT

Add text with a black or white pen, depending on the colors you're writing on and the contrast you desire.

Other objects can also be set ablaze. Here is Moses's burning bush, and your heart on fire for the Lord!

MATERIALS LIST

baby wipes

copier paper

gel pen, white

pen, black bleedproof

pencil, no. 2

ruler

washi tape

watercolor paints

The freedom of doodling and the joy of sunshine light up our walk with Christ—and our journaling Bible. Many verses refer to the sun, but don't neglect a word study on "Son of God" to find a verse that speaks the truth of who Jesus really is.

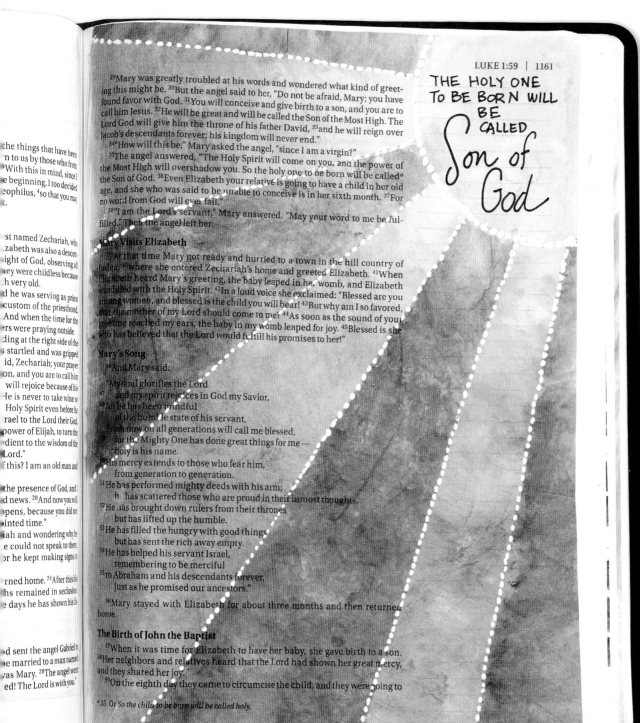

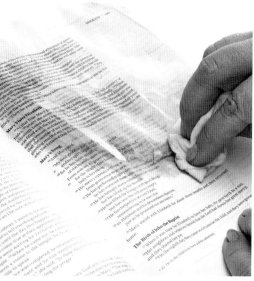

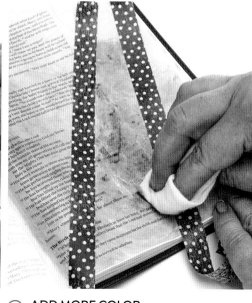

1 SKETCH THE SUN
Draw a circle for the sun, and mark the very center with a pencil. With a ruler, draw the rays emanating from that point.

2 CREATE THE BACKGROUND
Place copier paper under the Bible page. Apply color to the whole page using a baby wipe. Use yellow around the sun, and orange and red furthest from the sun. Allow the page to dry.

3 ADD MORE COLOR
Press washi tape to your skin to reduce the stickiness, then use it to mask off the rays. Add more pigment in an alternating ray.

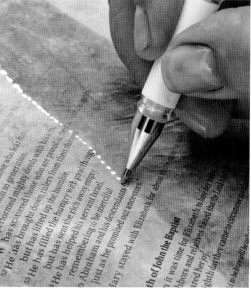

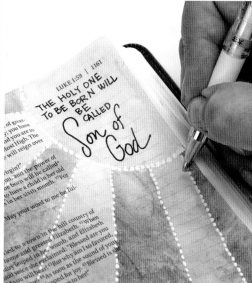

4 REMOVE THE TAPE
Once the page is dry, remove the tape very gently. You can leave the lines sharp, or dab at the pigment with a baby wipe to create loose edges. Let dry and iron if needed.

5 OUTLINE THE RAYS
Add doodled lines with a white gel pen to outline the rays.

6 ADD TEXT
Add text and journaling, as desired. See another example of a doodled design on page 133.

Tips for Other Mediums

Watercolor pencil also works for masking sun rays and spreading color with baby wipes. Colored pencil provides even more control, but takes more time; consider a sun cascading just down the margin instead.

Minitutorial: Light Bulb

The glow of man-made light is what we modern students of the Bible use more often than candles with flames. However, the glow is the same from a lightbulb: the hottest light is often white or light-colored, with darker colors elsewhere.

A simple round lightbulb consists of a circle on a base of rectangles. A playful version might have a heart or other design for filaments. Remember the lesson on bubbles on page 108, and leave white inside the outlined edge to make it look like glass.

Refine the shape of the glass for a realistic bulb. A quick online search can inspire fancy highlights for the adventurous Bible journaler.

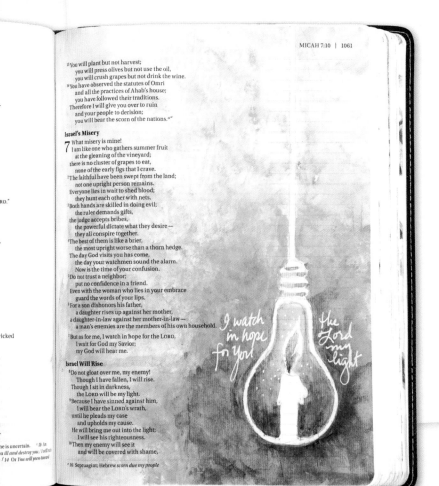

Micah 7:7
Watercolor

On this Bible page, the bulb is turned upside down, and a candle is placed inside, just to turn the idea on its head. See a creative use for lightbulb filaments on page 116.

Suggestions for *Study*

While working on this chapter, I was doing a study on joy in my Fruit of the Spirit journey and hope looking for joy in a concordance to the Bible lifts your heart in joyful praise too!

As in the previous chapter, the variety of meanings possible for light and fire in the Scriptures allows you to use each of the techniques from this chapter while journaling different themed Bible verses. Below are a few suggestions for your study.

GOODNESS
Genesis 1:34, Proverbs 15:30, Ephesians 5:9, James 1:17, 1 John 1:5

DARKNESS INTO LIGHT
2 Samuel 22:29, Psalm 18:28, Psalm 27:1

GOD'S PRESENCE AND GLORY
Leviticus 9:23–24, Exodus 3:2–6, Exodus 24:17, Deuteronomy 4:11–12, Psalm 36:9, Psalm 89:15, Psalm 118:27, Isaiah 2:5, Isaiah 9:2, Isaiah 60:1, 2 Corinthians 4:6, 1 Timothy 6:16

THE WORD IS LIGHT
Psalm 19:8, Psalm 119:105, Psalm 119:130, Proverbs 6:23, Matt 4:15–16, John 1:4, John 8:12, John 9:5, John 12:36, John 12:46, 1 John 1:5-7

BELIEVER'S STATE OF LIFE
Psalm 56:13, John 3:21, Romans 13:12, 1 Corinthians 3:13, Colossians 1:12, Ephesians 5:8–9, 1 Thessalonians 5:5, 1 Peter 2:9, 1 John 2:10

BE A LIGHT-BEARER
Isaiah 42:6, Isaiah 49:6, Matthew 5:14–16, Matthew 10:27, Ephesians 5:8, Philippians 2:15

BAPTISM, HOLY SPIRIT
Matthew 3:11, Luke 3:16, Acts 2:3–4

This candle sketch can be copied to use in your Bible. See the finished piece on page 120.

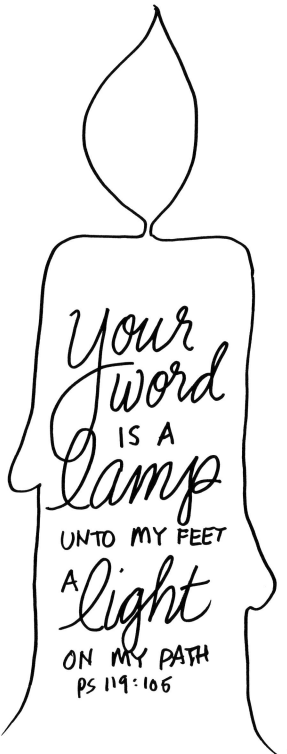

your word IS A lamp UNTO MY FEET A light ON MY PATH
PS 119:105

10 | *Always Keep Growing*
Advanced Applications

DISCIPLINE AND SELF CONTROL

Years ago, I led worship at an evening prayer and healing service. My team sang from the rear of the dark sanctuary, providing soft harmonies that soared through the rafters.

Suddenly, I heard a voice close behind my right ear say, "Sing 'Jesus loves me.'" I turned to see who spoke—no one was there. I shook my head a little; not only had I never heard God audibly, but that song was not on our play list. The urge to stick to the rehearsed plan was strong, but then the Holy Spirit repeated the command.

Puzzled but willing to obey, I gestured for our current song to end, and led the simple refrain, "Jesus loves me, this I know . . . " My team, bewildered, joined in, " . . . for the Bible tells me so."

At the end of that single phrase, one of the participants at the front of the sanctuary cried out and began to sob aloud. Others gathered around her to pray. God did a mighty healing at that very moment, surrounded by that song.

What's Your Story?

- Do you practice spiritual disciplines that lead you to hearing from God?
- Have you heard audibly or otherwise from the Lord?
- Did you journal or otherwise document that experience, or share it with others?

Romans 12:2
Watercolor pencil

While praying over Romans 12:2, a dirty fish tank became Bible journaling inspiration! God pointed to the connection between the dirty water and the dirty world around me—and the need to leap into His clean arms with gusto. The fish lights up in rainbow colors through the transformation, just as we do.

shoot, have been grafted in among the others and now share in the nourishing sap from the olive root, [18]do not consider yourself to be superior to those other branches. If you do, consider this: You do not support the root, but the root supports you. [19]You will say then, "Branches were broken off so that I could be grafted in." [20]Granted. But they were broken off because of unbelief, and you stand by faith. Do not be arrogant, but tremble. [21]For if God did not spare the natural branches, he will not spare you either.

[22]Consider therefore the kindness and sternness of God: sternness to those who fell, but kindness to you, provided that you continue in his kindness. Otherwise, you also will be cut off. [23]And if they do not persist in unbelief, they will be grafted in, for God is able to graft them in again. [24]After all, if you were cut out of an olive tree that is wild by nature, and contrary to nature were grafted into a cultivated olive tree, how much more readily will these, the natural branches, be grafted into their own olive tree!

All Israel Will Be Saved

[25]I do not want you to be ignorant of this mystery, brothers and sisters, so that you may not be conceited: Israel has experienced a hardening in part until the full number of the Gentiles has come in, [26]and in this way[a] all Israel will be saved. As it is written:

> "The deliverer will come from Zion;
> he will turn godlessness away from Jacob.
> [27]And this is[b] my covenant with them
> when I take away their sins."[c]

[28]As far as the gospel is concerned, they are enemies for your sake; but as far as election is concerned, they are loved on account of the patriarchs, [29]for God's gifts and his call are irrevocable. [30]Just as you who were at one time disobedient to God have now received mercy as a result of their disobedience, [31]so they too have now become disobedient in order that they too may now[d] receive mercy as a result of God's mercy to you. [32]For God has bound everyone over to disobedience so that he may have mercy on them all.

Doxology

> [33]Oh, the depth of the riches of the wisdom and[e] knowledge of God!
> How unsearchable his judgments,
> and his paths beyond tracing out!
> [34]"Who has known the mind of the Lord?
> Or who has been his counselor?"[f]
> [35]"Who has ever given to God,
> that God should repay them?"[g]
> [36]For from him and through him and for him are all things.
> To him be the glory forever! Amen.

A Living Sacrifice

12 Therefore, I urge you, brothers and sisters, in view of God's mercy, to offer your bodies as a living sacrifice, holy and pleasing to God—this is your true and proper worship. [2]Do not conform to the pattern of this world, but be transformed by the renewing of your mind. Then you will be able to test and approve what God's will is—his good, pleasing and perfect will.

Humble Service in the Body of Christ

[3]For by the grace given me I say to every one of you: Do not think of yourself more highly than you ought, but rather think of yourself with sober judgment,

[a] 26 Or *and so* [b] 27 Or *will be* [c] 27 Isaiah 59:20,21; 27:9 (see Septuagint); Jer. 31:33,34
[d] 31 Some manuscripts do not have *now.* [e] 33 Or *riches and the wisdom and the*
[f] 34 Isaiah 40:13 [g] 35 Job 41:11

More *Inspiration*

This chapter is filled with additional inspiration and ideas that will help you expand on the tutorials from this book. If you've completed all the lessons, you may be ready for a bigger step in your Bible journaling adventure. Does God want you to start a group? If you've participated in one to work through this book, does He want you to be part of a continuing group? Or to teach a new one? Pray about His next steps for you.

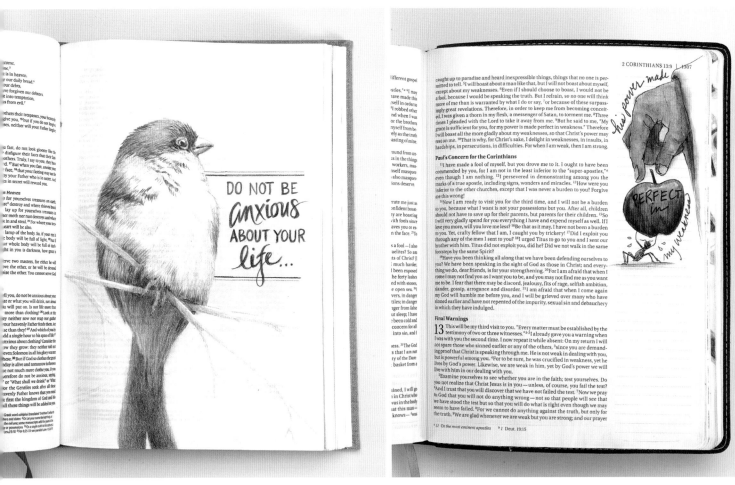

Matthew 10:31
Colored pencil

A sparrow illustrates this passage about God's care for even a tiny bird: "So don't be afraid; you are worth more than many sparrows." The full page shown is empty for drawing because it's in the Interleaved Bible mentioned on page 31. A full page is great for a big idea.

2 Corinthians 12:9
Watercolor pencil

God's power is made perfect as we turn over our weakness to Him. A tiny ant, desperately trying to bear its burden, is a fitting demonstration. Think of other tiny things that can lift large burdens and sketch them to illustrate any passage about our own condition without the grace of God.

Some explanations in the captions explain a little about the technique, and others focus primarily on the reason for choosing your idea.

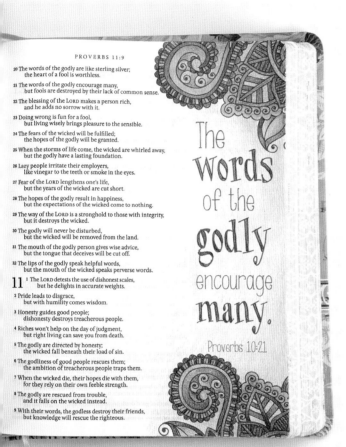

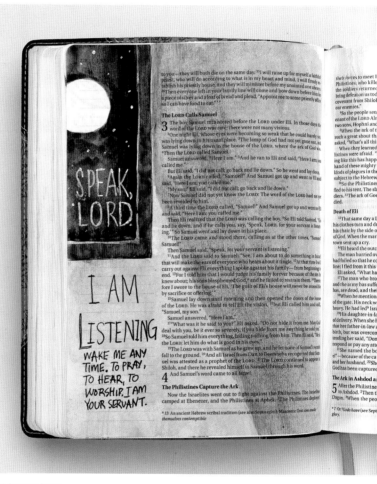

Proverbs 10:21

Colored pencil

The Inspire Bible, discussed on page 30, offers beautiful illustrations to occupy the hands with pencils while the heart ponders the Scripture. This Proverbs passage wants us to pray about words spoken recently and assess whether they were encouraging or discouraging. Are apologies in order? Are there people who need encouragement from you? While coloring, make a plan to call a friend who needs a boost.

1 Samuel 3:9

Watercolor paints

Insomniacs may appreciate this idea: When awakened at night to stare at the moon, ask the Lord what He would like you to do or to pray for, then journal it in your Bible when morning comes. Use watercolor to paint a rectangular window, a night sky and some cascading light to provide room to capture God's instructions in your heart.

 Web content available

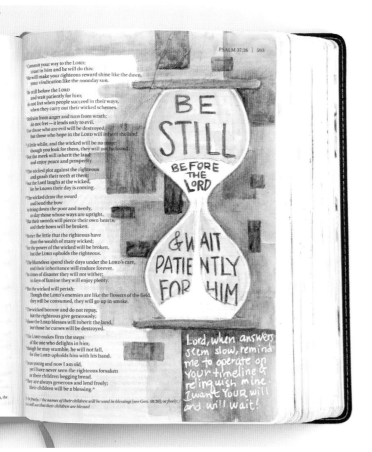

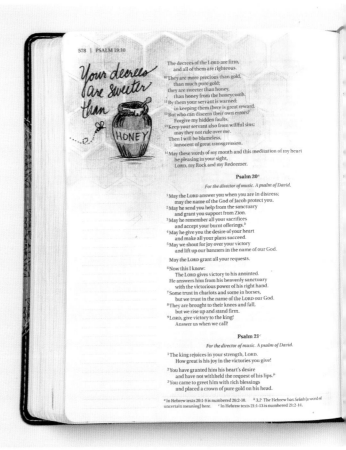

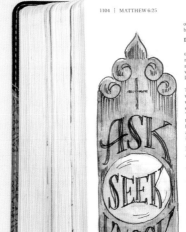

(top left)

Psalm 37:5–7

Watercolor pencil

Add a background to an image using one of the pattern techniques in this book, like blocks of color on page 50. The hues selected here are tints and shades of the same green. The blocks have been overlapped, which provides a peaceful yet detailed background that doesn't detract from the main image.

(top right)

Psalm 19:10

Watercolor pencil

To create this sweet page, cover the top section in light watercolor pencil, then move the color around with a baby wipe. Use a honeycomb stencil to color darker colors, and sketch a tiny honey pot after the page dries. To keep it even simpler, draw only the little bee.

(right)

Matthew 7:7

Watercolor paints

Fancy doorknobs and plates are fun to draw. Find both simple and complex knobs via online searches. Watercolor the basic image, then sketch with a black bleedproof pen. Add journaling below; perhaps make a list of what you are asking the Lord for right now.

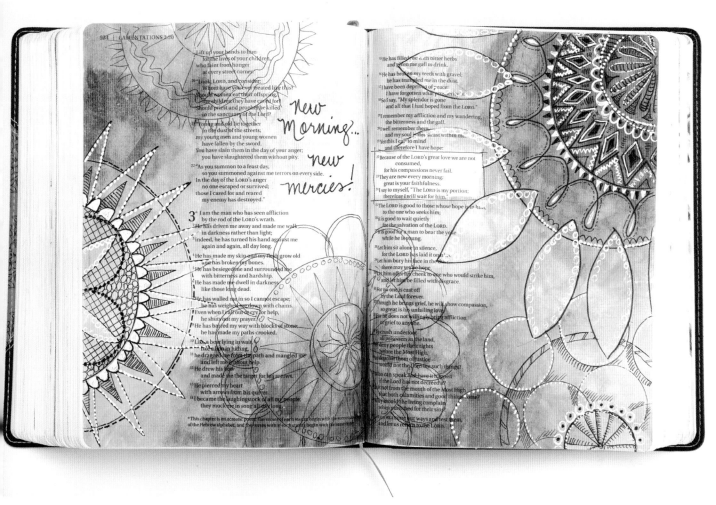

Lamentations 3:23

Watercolor paints

A double page filled with suns—or flowers—starts with a full background of paint applied with a baby wipe (see the Watercolor Stone demonstration on page 52). After the page is dry, have fun doodling with white and black pens. Circles can be drawn by tracing glasses and plates, and doodling is a great occupation for meditation time. Try this with hearts or other shapes, too.

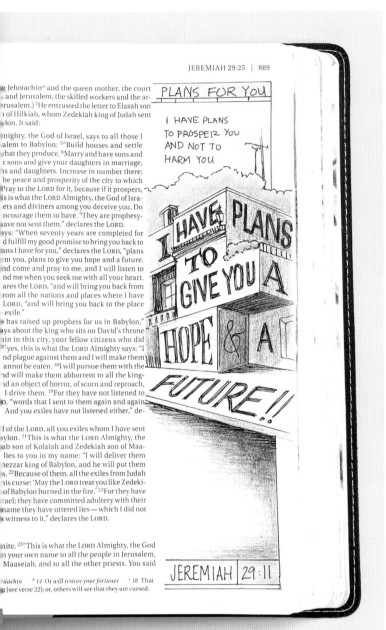

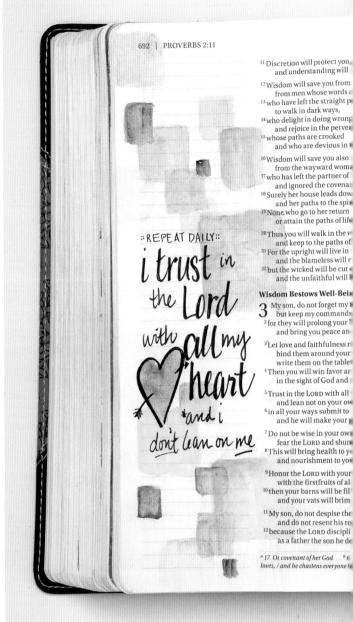

Jeremiah 29:11
Colored pencil

Plans. Plans. Plans. God has plans! That keyword led to the idea to make an architectural-style drawing with text on the buildings. A simpler version could be a floorplan with rooms laid out. Do an online search for floorplans to get visual inspiration, and label the rooms with the Scriptural plans God has for your future.

Proverbs 3:5
Watercolor paints

This is a simpler and looser version of the tutorial on page 50 that doesn't require any masking. Loosely paint watercolor blocks to accent the journaling on the page. Keep the colors soft, and they can cover the whole page, drawing attention every time the Bible is flipped through.

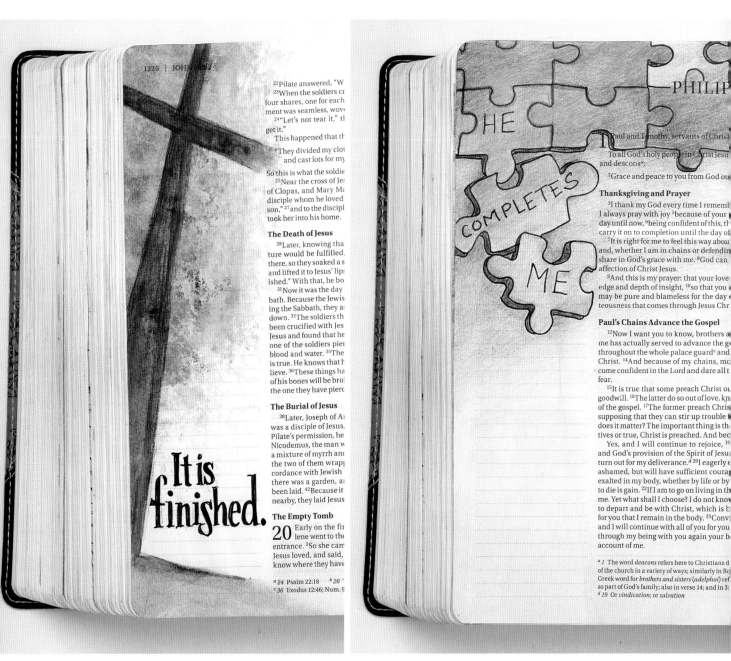

John 19:30
Watercolor paints

A simple verse. A powerful truth. It's kept simple by adding a dramatic sky with red paint and a baby wipe, then a cross with dramatic perspective looking up from the ground. Just imagine sitting at the foot of that cross on that awful, wonderful day.

✱ *Web content available*

Philippians 1:4
Colored pencil

Jigsaw puzzle pieces are a suitable visual for many Scripture verses about completion and finishing. Draw a grid of rectangles first, then the tabs that interlock, or as I called them as a kid: "innies" and "outies." Leave a piece or two missing from the picture, and scatter a few pieces for the text on the page.

✱ *Web content available*

odicea write:

en, the faithful and true witness, the ruler
deeds, that you are neither cold nor hot. I
other! [16]So, because you are lukewarm —
t to spit you out of my mouth. [17]You say, 'I
and do not need a thing.' But you do not re-
ul, poor, blind and naked. [18]I counsel you
he fire, so you can become rich; and white
your shameful nakedness; and salve to

and discipline. So be earnest and repent.
nd knock. If anyone hears my voice and
d eat with that person, and they with me.
I will give the right to sit with me on my
d sat down with my Father on his throne.
r what the Spirit says to the churches."

ore me was a door standing open in heaven.
peaking to me like a trumpet said, "Come up
t take place after this." [2]At once I was in the
rone in heaven with someone sitting on it.
appearance of jasper and ruby. A rainbow
d the throne. [4]Surrounding the throne were
ted on them were twenty-four elders. They
ns of gold on their heads. [5]From the throne
s and peals of thunder. In front of the throne,
e the seven spirits[a] of God. [6]Also in front of
e a sea of glass, clear as crystal.

were four living creatures, and they were
ck. [7]The first living creature was like a lion,
had a face like a man, the fourth was like a
g creatures had six wings and was covered
wings. Day and night they never stop saying:

y, holy, holy
' God Almighty,'[b]
is, and is to come."

glory, honor and thanks to him who sits on
d ever, [10]the twenty-four elders fall down
d worship him who lives for ever and ever.
ne and say:

d,
power,

ed

m who sat on the throne a scroll with writ-
seven seals. [2]And I saw a mighty angel pro-
thy to break the seals and open the scroll?"

n 6:3

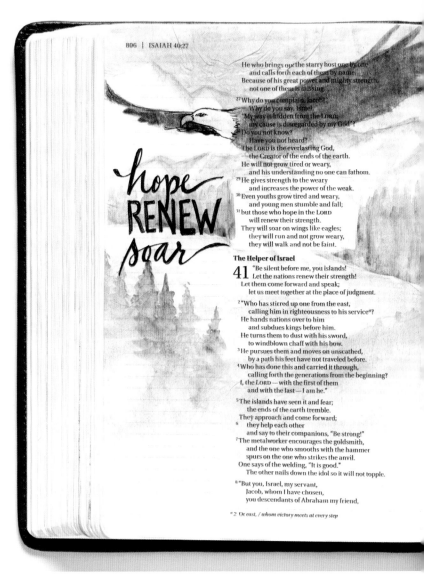

He who brings out the starry host one by one
and calls forth each of them by name.
Because of his great power and mighty strength,
not one of them is missing.

[27]Why do you complain, Jacob?
Why do you say, Israel,
"My way is hidden from the LORD,
my cause is disregarded by my God"?
[28]Do you not know?
Have you not heard?
The LORD is the everlasting God,
the Creator of the ends of the earth.
He will not grow tired or weary,
and his understanding no one can fathom.
[29]He gives strength to the weary
and increases the power of the weak.
[30]Even youths grow tired and weary,
and young men stumble and fall;
[31]but those who hope in the LORD
will renew their strength.
They will soar on wings like eagles;
they will run and not grow weary,
they will walk and not be faint.

The Helper of Israel

41 "Be silent before me, you islands!
Let the nations renew their strength!
Let them come forward and speak;
let us meet together at the place of judgment.

[2]"Who has stirred up one from the east,
calling him in righteousness to his service[a]?
He hands nations over to him
and subdues kings before him.
He turns them to dust with his sword,
to windblown chaff with his bow.
[3]He pursues them and moves on unscathed,
by a path his feet have not traveled before.
[4]Who has done this and carried it through,
calling forth the generations from the beginning?
I, the LORD — with the first of them
and with the last — I am he."

[5]The islands have seen it and fear;
the ends of the earth tremble.
They approach and come forward;
[6] they help each other
and say to their companions, "Be strong!"
[7]The metalworker encourages the goldsmith,
and the one who smooths with the hammer
spurs on the one who strikes the anvil.
One says of the welding, "It is good."
The other nails down the idol so it will not topple.

[8]"But you, Israel, my servant,
Jacob, whom I have chosen,
you descendants of Abraham my friend,

a 2 Or east, / whom victory meets at every step

Revelation 3:20
Watercolor paints

The words along the top of the doorway were cre-
ated with the technique on page 100. Create the
words first, then the blocks and then the outline.
The verse attribution can be incorporated into the
sign on the door. Always consider unique ways to
add verses to your pages.

✳ *Web content available*

Isaiah 40:31
Watercolor pencil

The feet of this soaring eagle may defy the ability to
draw them, so rather than fight them, tuck them behind
the focal verse, fading that area in soft color. The whole
scene is so soft, it looks like it was meant to be.

Acts 17:28
Colored pencil

Colored pencils are one of my favorite mediums for coloring preprinted Bible pages. They can be sharpened well and are able to get into the tiny lines of text and design. When using soft layers, they can also create beautifully soft, blended backgrounds as well.

James 1:27
Watercolor paints

James reminds us that our faith is intended to be lived, not just spoken, and we are to care for "the least of these"—His children. Hands can be used for many verses. Trace a hand, an adult's or a child's, on any verse about being a child of God or created in His image.

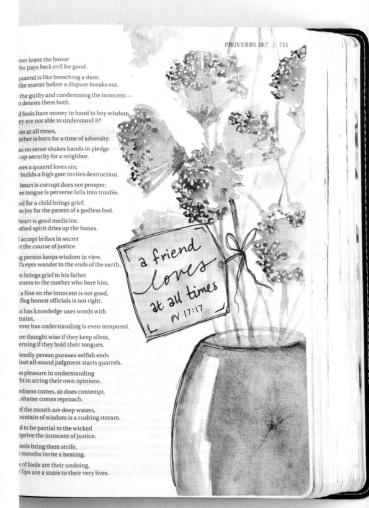

Hebrews 12:1–3
Watercolor pencil

Races can be symbolized by checkered flags, race tracks or running shoes . . . but why not a medal? The ribbon can be any color and width, and it could also be contained within the side border. The medal itself can be complex or simple. This one is extra large, hanging off the page to emphasize its size. Even the words fall off the edge, but the mind still fills in the completed phrase.

✳ *Web content available*

Proverbs 17:17
Watercolor

Friends give friends flowers. The thistle tutorial on page 86, translated into watercolor, creates a big, beautiful vase full of flowers and with the sentiment written across a tied-on tag. The bouquet can be large if the side of the page isn't a constriction. Create some images that go beyond the border to increase their presence on the page.

John 10:11
Watercolor pencil

The borders of the page can focus attention on one part of an image. The sheep is easier to draw than the face of Jesus, so the drawing zoomed in on the part more easily accomplished. The fabric folds are covered with a banner to house part of the text. This was also a big enough idea to warrant a full page piece in an Interleaved Bible.

Loved by THE GOOD SHEPHERD

Index

a content + ecommerce company

Other fine North Light books are available from your favorite
bookstore, art supply store or online supplier. Visit our website at
fwmedia.com.

22 21 20 19 18 5 4 3 2 1

Distributed in the U.K. and Europe
by F&W Media International LTD
Brunel House, Pynes Hill Court, Pynes Hill, Rydon Lane, Exeter, EX2
5AZ, United Kingdom
Tel: (+44) 1392 79680
Email: enquiries@fwmedia.com

ISBN 13: 978-1-4403-5333-8

Edited by Noel Rivera
Production edited by Jennifer Zellner
Designed by Clare Finney
Production coordinated by Debbie Thomas

METRIC CONVERSION CHART

To convert	to	multiply by
Inches	Centimeters	2.54
Centimeters	Inches	0.4
Feet	Centimeters	30.5
Centimeters	Feet	0.03
Yards	Meters	0.9
Meters	Yards	1.1

ABOUT THE AUTHOR

Sandy Allnock is an artist and crafter who has been journaling
in her Bible since 2015.

She was an artist even as a young child, skipping her
homework to spend time in her sketchbook. As a young girl,
her dream was to be an art teacher one day.

Sandy grew up in a family with a dad and the rest
women—two sisters, one younger and one older—in a
household of faith. She attended Catholic school for many
years where deep seeds of faith were planted to bear fruit
much later in her life.

At Frostburg State University, Sandy studied art, originally
with the intention of getting a degree in Art Education. As
schools were rapidly losing funding for the arts, her pro-
fessors convinced her to pursue a more fruitful future as a
graphic designer, and she proceeded to get her Bachelor of
Arts in 1986.

Sandy spent decades of her career in graphic design
for agencies, then for nonprofit organizations. She started
and ran a charity from 2007–2015, serving deployed heroes
by making beautiful, blank handmade greeting cards they
could send home to loved ones. This organization, which she
treated as a ministry, sent over three million cards, affecting
the lives of millions of service members and their families,
before drawing to a close.

In 2013, Sandy became a full-time artist, producing art
videos on YouTube and art classes on her own website. A few
years into this new adventure, she realized God had granted
that childhood dream: she was now an art teacher! Along
with her steps into Bible journaling, her art instruction has
combined with ministry, leaving her feeling doubly blessed by
the Lord she loves so much.

Sandy currently lives near Seattle, Washington, with her
pups, enjoying God's beauty in the Pacific Northwest.

Dedication

To my Lord for the unending grace He has shown me.

ACKNOWLEDGMENTS

I would like to express my gratitude to the many people who saw me through this book; to all those who provided support, talked things over, read, wrote, offered comments and assisted in the editing, proofreading and design.

To the team at North Light Books who put their faith in me and helped this project come together: Noel, Clare, Christine and everyone on the team who provided insightful feedback to help polish my efforts.

To the angel sent by the Lord to jump-start my adventure in creative worship.

To my pastor, Dr. Steve Schell, to whom I am indebted for years of life-changing Bible teaching and his encouragement to remain steeped in the Word.

To my sisters in Christ who prayed the book into existence. And to all of my Bible study groups throughout the years who have been patient with my endless questions.

To Kristie for her incredible photography gifts, Matt for his digital magic, and Debbie for believing God would accomplish all of this.

To my team of online supporters with their unending support and encouragement.

To the students at Art-Classes who inspire me with their insatiable desire to learn.

To my family, who rooted me in faith from childhood, planting the seeds that took a lifetime to sprout. To Mom, who encouraged me to carry on her artistic gifts; Dad, who shared my honest faith questions; Linda, for her invaluable editing assistance; and Debbie, my limitless cheerleader from across the pond.

To Vienna and Giallo, who kept me sane by sitting patiently next to me for months, reminding me that life is nothing without walkies.

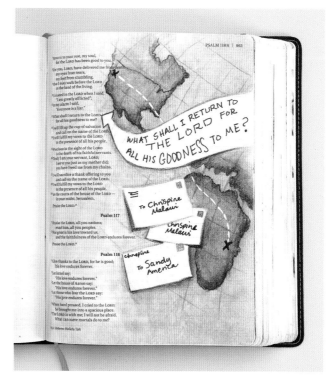

SHARE YOUR LIFE WITH A CHILD

God's calling to His church is to serve the least of these: the poor, the stranger, widows and orphans in their distress. By reaching out through child sponsorship, we can live out the Gospel and help bring God's kingdom to Earth, one child at a time.

World Vision child sponsorship is a beautiful opportunity to give a child the chance to grow up to fulfill their God-given potential. Choose a child who shares your birthday or who lives in a place that tugs at your heart. Visit worldvision.org and share your life with a child—and find yourself changed as you do.

On page 93, read Sandy's story of child sponsorship. Her life has been forever changed by the eight children she has been blessed to learn about and help.

Ideas. Instruction. *Inspiration.*

Receive FREE downloadable bonus materials when you sign up for our free newsletter at artistsnetwork.com/Newsletter_Thanks.

Artists network
ARTISTSNETWORK.COM

These and other fine North Light products are available at your favorite art & craft retailer, bookstore or online supplier. Visit our websites at artistsnetwork.com and artistsnetwork.tv.

Find the latest issues of *Cloth Paper Scissors* on newsstands, or visit clothpaperscissors.com.

Get your art in *print*!

Visit artistsnetwork.com/competitions for up-to-date information on Splash and other North Light competitions.

Follow North Light Books for the latest news, free wallpapers, free demos and chances to win FREE BOOKS!